709.2 ALY

FRANCIS
ALŸS

CUAUHTÉMOC MEDINA
RUSSELL FERGUSON
JEAN FISHER

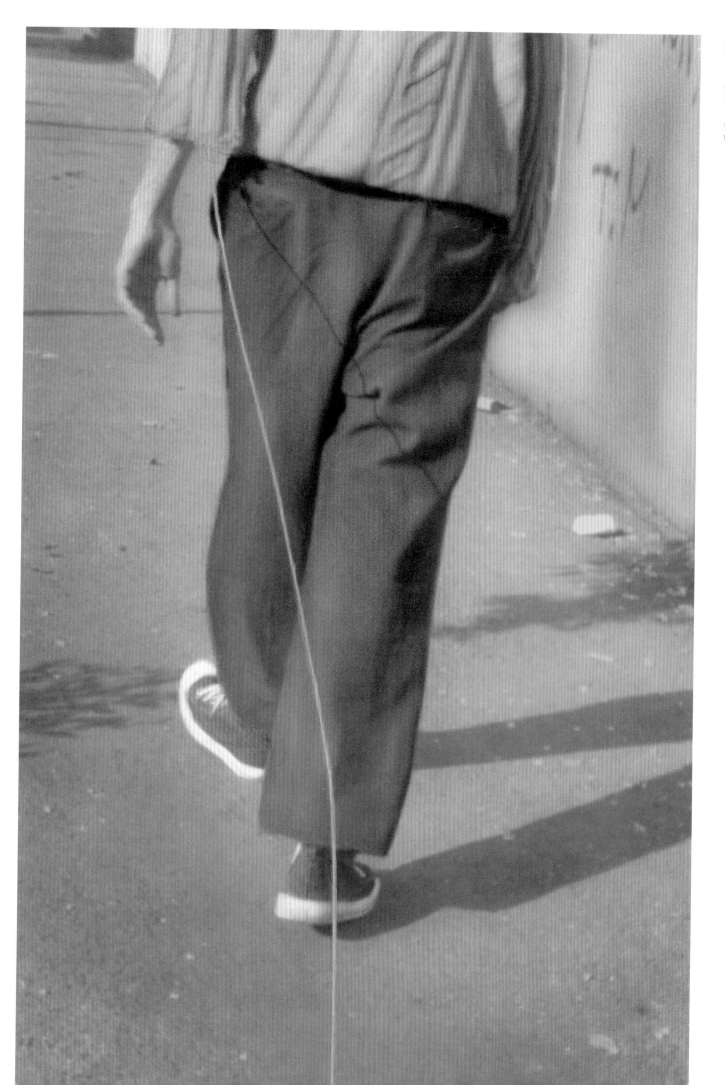

FAIRY TALES, 1995
PHOTOGRAPHIC DOCUMENTATIO
OF AN ACTION, MEXICO CITY

Whereas the highly ratior
societies of the Renaissa
felt the need to create
utopias, we of our times
must create fables.

CONTENTS

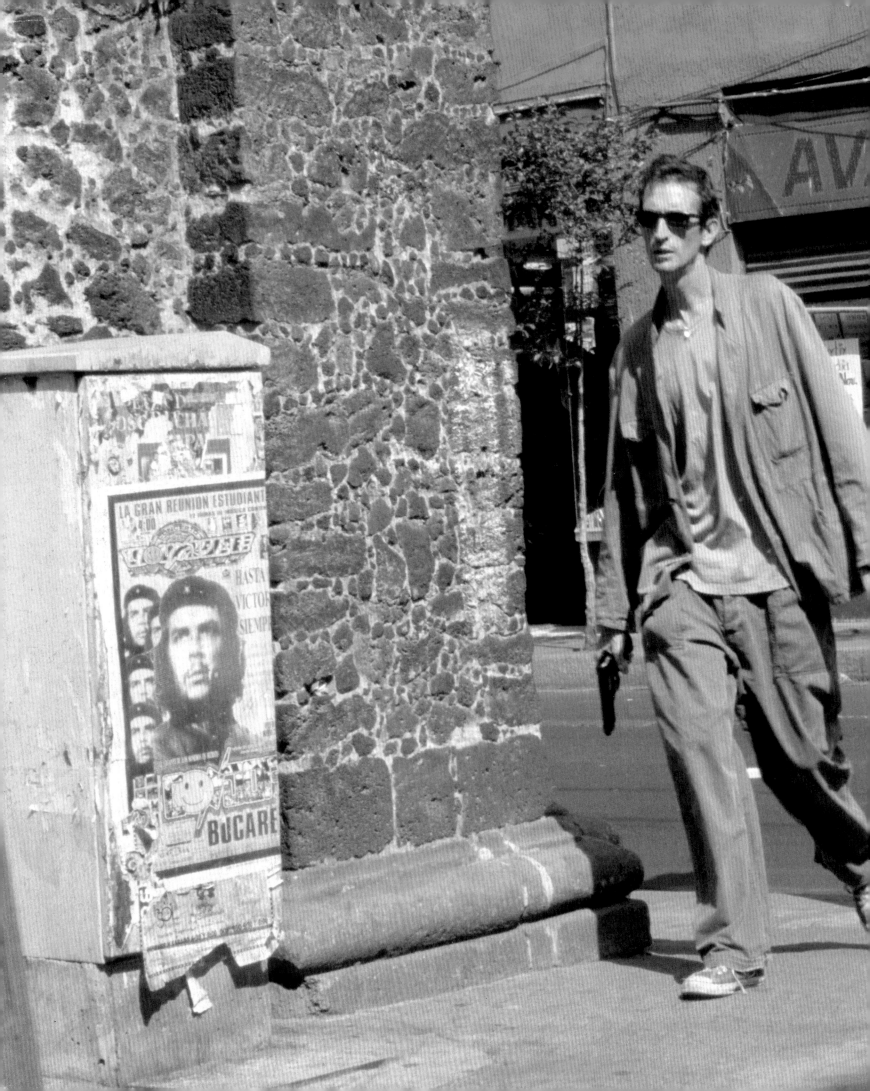

previous pages,
RE-ENACTMENTS, 2000
IN COLLABORATION WITH
RAFAEL ORTEGA, MEXICO CITY
TWO-CHANNEL VIDEO
5 MIN. 20 SEC.
PRODUCTION PHOTOGRAPH

RUSSELL FERGUSON: *When did you first come to Mexico?*

FRANCIS ALŸS: In February 1986, in the aftermath of the earthquake. Before that I had been studying and working as an architect in Venice. I was drafted by the Belgian army, and to fulfill that commitment I went to the south of Mexico to work as an architect for non-governmental organizations. In the summer of 1989, because of a number of personal and legal matters, I found myself stuck in Mexico City. My contract had ended and I couldn't go back to Europe. Nor did I really want to. In front of me I suddenly had this enormous amount of free time, like an imposed sabbatical, and I decided to give a chance to something that had always interested me from an outsider's point of view: art practice. Although by then I had been in Mexico for over three years, I had never really considered living here, and I found it quite difficult to accept the move. The first works – I wouldn't call them works – my first images or interventions were very much a reaction to Mexico City itself, a means to situate myself in this colossal urban entity.

FERGUSON: *What was it about the city that was difficult for you compared to other cities?*

ALŸS: The immensity of it, also the culture shock, I suppose, and how dysfunctional the whole thing seemed. I could not decipher the city's codes. I had no entry point. In short, I could not understand how the whole society functioned. I had never lived in a megalopolis. Mexico City was also going through a series of major changes after the earthquake – in its urban shape, obviously, but also in its perception of itself.

Mexico City has a very crude and raw side, very much in your face, and it can easily beat you. When you are confronted with the dizzying complexity of a city whose nature is to overwhelm you, you have to react to that complexity somehow. I think the first stage was a period of observation, to see how other people managed to function within this urban chaos. I was living in the old Centro Histórico, where there were all these characters, for lack of a better word. I saw how they felt the need to make up an identity, to invent a role for themselves, a ritual that would justify their presence on the urban chessboard – like this guy in his mid-forties I would see every morning walking up and down the Zócalo with a metal wire bent into a hook with a circle at the end of it, kind of like a bicycle wheel without spokes. Starting from the top left corner of the plaza he would follow all the little cracks between the stones of the pavement, methodically pacing the entire plaza. That was the role he had invented for himself. That was his way of being there, of being part of the life of the city. Encountering such people has often been the entry point to my walks or interventions, the crude and poetic entry point.

FERGUSON: *What did Mexico offer you that Europe didn't?*

ALŸS: Retrospectively, I think I was very lucky in my timing with Mexico. They say that certain people can only find their place within a specific historical or geopolitical context. There was something in the chemistry between my Belgo-European upbringing and the Mexican culture that triggered a whole field of investigation. I think also that my status as an immigrant freed me from my own cultural heritage – or my debt to it, if you like. It provided me with a kind of permanent disjunction, a filter between myself and my being. Maybe what I have been looking for since then is this moment of coincidence between the experience

LA MALINCHE, 1997
PHOTOGRAPHIC DOCUMENTATION
OF AN ACTION, MEXICO CITY

'La Malinche' is the popular
nickname given to Marina, the lover
and translator of Hernán Cortés
during the time of the Spanish
conquest. Her name contains all
the ambiguity that 'foreign' means
to Mexican culture: the terror of
seduction and the unknown, and the
idea that mixed races are the result
of female betrayal.

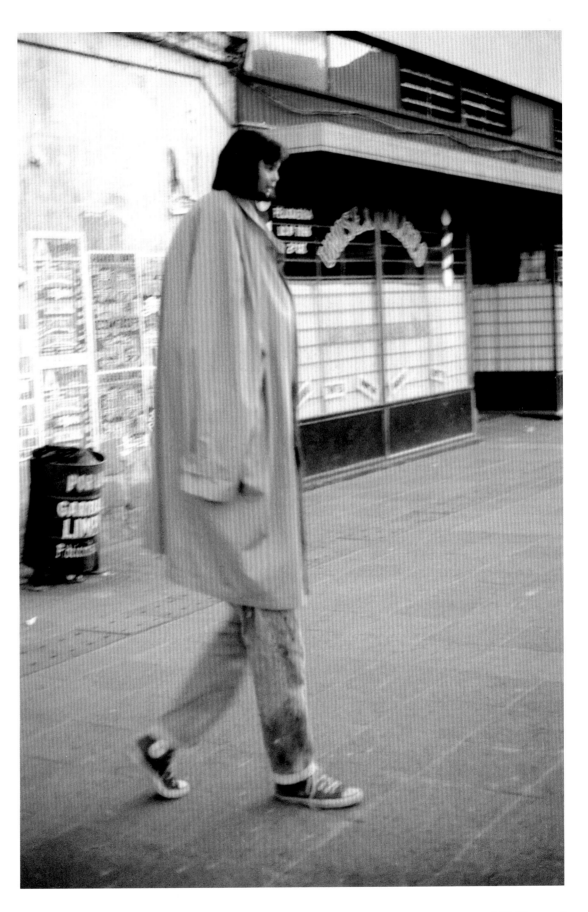

On 10 March 1994 I went to the Zócalo
and stood in the middle of a line of
carpenters, plumbers and house painters,
offering my services as a tourist.

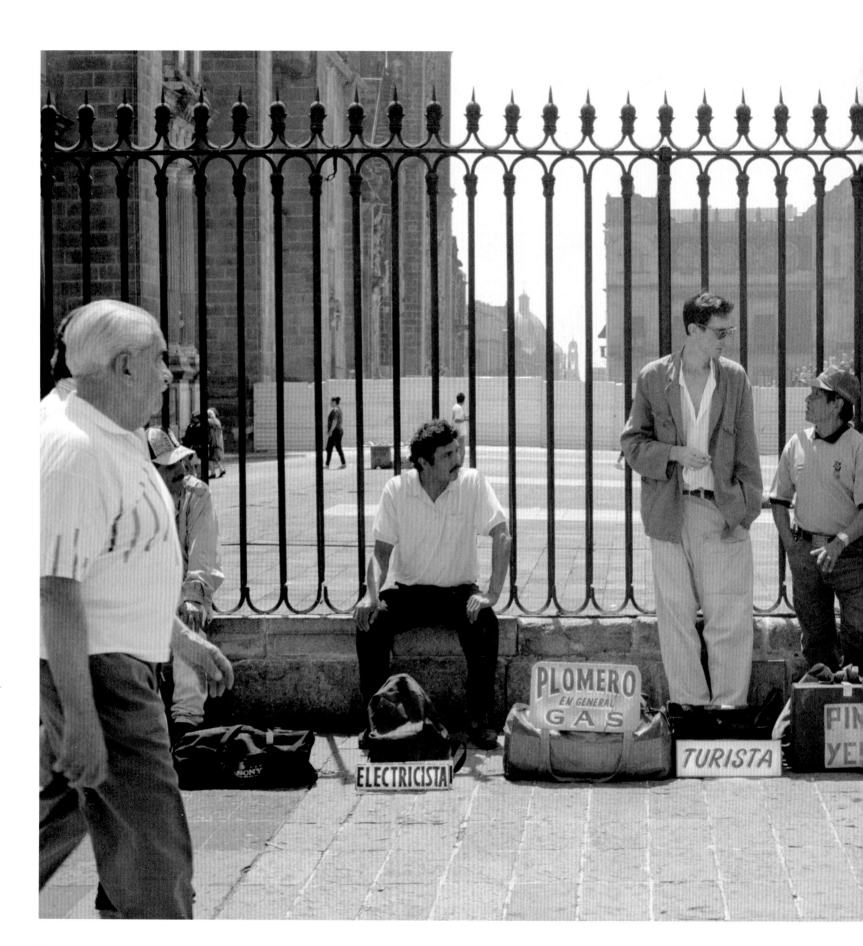

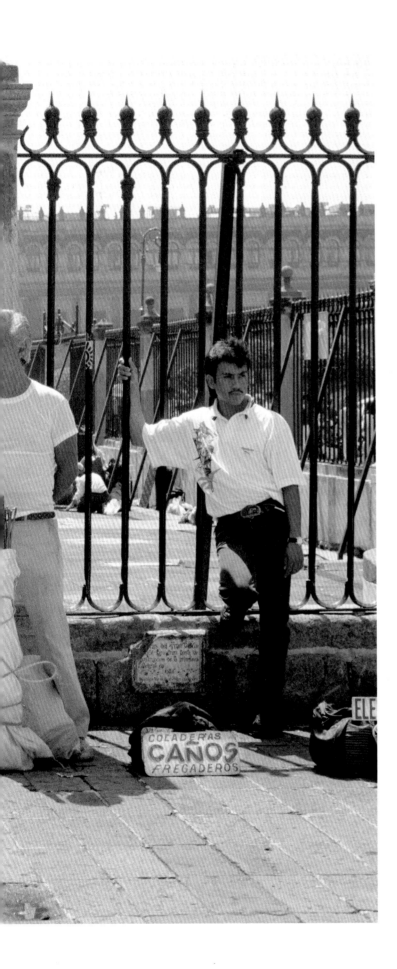

of living and the consciousness of existence. The city turned into an open laboratory for testing and playing and experimenting in all kinds of contradictory directions. I was new in town. Nobody cared. I had nothing to prove to anyone but myself. It gave me an enormous sense of freedom and an open-ended time frame to build a language, an attitude, away from a world and culture that I saw as saturated with information. I think Europe has an extraordinarily rich culture, but I see it more as a place of consumption – of arts, food, architecture and so on. Here there were things to do, things to say, and urgently. Eventually I lost the distance, but at first it was what helped me make the jump.

FERGUSON: *At what point did you realize that you were not going back to being an architect?*

ALŸS: I worked in parallel as an architect and artist for a couple of years, but I dropped architecture altogether around 1993. I got hooked very quickly by the new game, the art game, and early on I met people like Ruben Bautista, Guillermo Santamarina, Cuauhtémoc Medina, Gabriel Orozco, Abraham Cruzvillegas, Melanie Smith and many others. The contemporary art scene was very open at the time. There was a lot of collaboration and discussion going on. But then again, I was younger. Now I think the rules are different.

FERGUSON: *Do you think that individuals work in more isolation from each other now?*

ALŸS: Well, there was no real market at the time. Artists were making art to show to their artist friends, and things were moving faster. You would not wait for a curator to come. You had to show it immediately.

FERGUSON: *There is a lot more infrastructure now.*

ALŸS: The infrastructure is better, yes, and there is much more curiosity from abroad about the emerging scene, the younger generation, which is good. But it can also lead to some generational gaps, to the point that sometimes production can be aimed towards export rather than trying to function first in its context of fabrication, whether its local or national context. The link with the older generations is somewhat broken.

FERGUSON: *So now, after almost twenty years, to what extent are you a Mexican artist?*

ALŸS: It's clear that the place has imprinted itself on the making of my work and probably on the perception of my work abroad. Retrospectively I can see that there have been different steps in my relationship to Mexico.

When in 1994 I went and stood outside the cathedral next to the Zócalo with a sign at my feet saying 'turista', I was denouncing but also testing my own status, that of a foreigner, a *gringo*. 'How far can I belong to this place? How much can I judge it? Am I a participant or just an observer?' By offering my services as a tourist in the middle of a line of carpenters and plumbers, I was oscillating between leisure and work, between contemplation and interference.

FERGUSON: *People do think of you as an artist from Mexico. How do you feel about representing the country?*

CUENTOS PATRIÓTICOS
(PATRIOTIC TALES), 1997
IN COLLABORATION WITH
RAFAEL ORTEGA, MEXICO CITY
VIDEO
24 MIN 40 SEC

In the midst of the social upheaval of 1968,
thousands of bureaucrats were herded into the Plaza
de la Constitución (Zócalo) to demonstrate in favour
of the government. Showing their frustration in an
act that was both rebellious and ridiculous, they
turned their backs on the official tribune and began
to bleat like a vast flock of sheep.

00 00 30

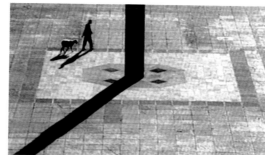

00 00 45

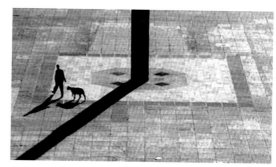

00 00 52

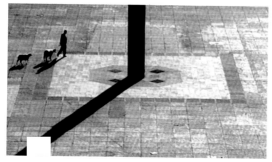

00 01 00

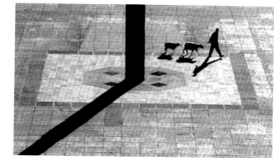

00 01 07

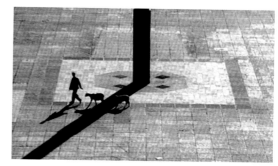

00 01 18

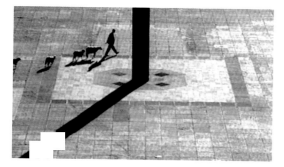

00 01 25

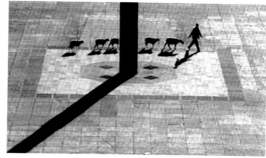

00 03 38

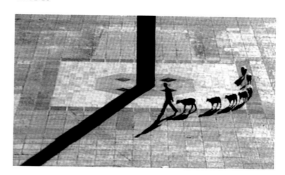

00 05 05

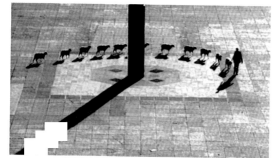

00 08 34

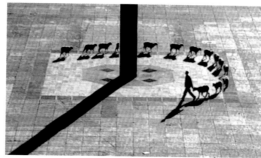

00 10 19

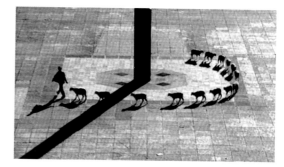

00 10 25

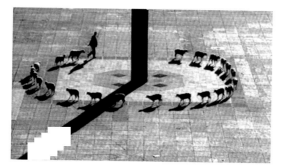

00 12 30

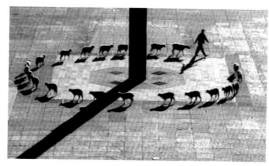

00 13 10

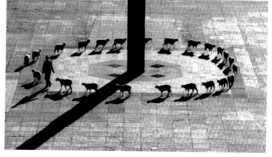

00 13 50

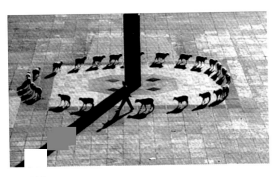

00:14:10

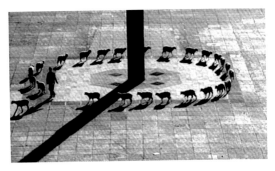

00:14:15

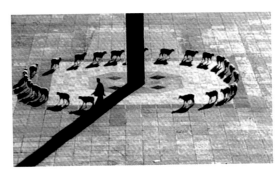

00:15:05

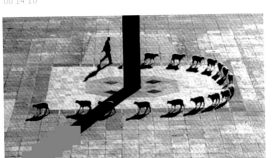

00:16:30

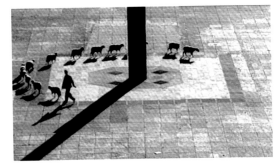

00:17:05

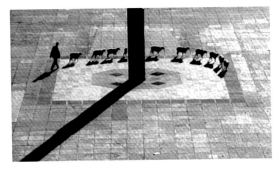

00:17:54

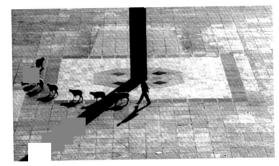

00:18:05

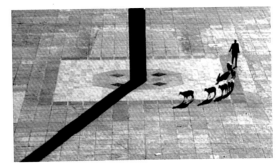

00:19:59

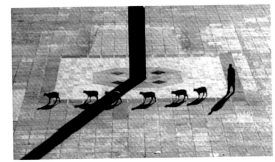

00:20:05

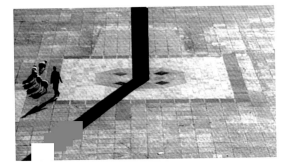

00:21:50

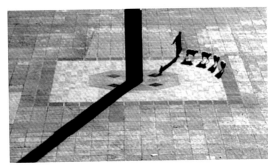

00:22:05

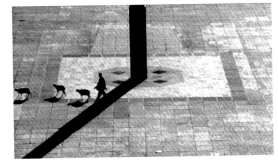

00:22:50

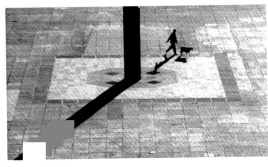

00:22:30

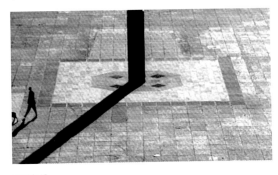

00:23:40

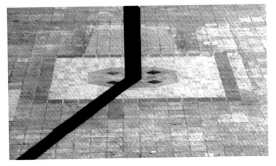

00:23:54

ALŸS: I think I am quite local but I'm not. Or I'm not but I am. It's a trap. It's
funny, you have to leave the place you come from to be asked if you belong to it.
In 1998 when Rina Carvajal invited me to participate in the São Paulo Biennial, she
asked a straightforward question: 'How do you position yourself – as a European
or Westerner – in relation to your host country, with the place and culture where
you choose to live and develop your practice?' To address that issue I looked into
one of the West's most controversial exports, the model of modernization (as
moving away from tradition), in order to analyse Mexico's complex relationship
to that imported ideology, and to investigate in particular how the syndrome of
progress and the dogma of productivity are lived and understood south of the
US border.

FERGUSON: *You referred once to your 'disguise' as a foreigner. Did you feel you
dropped the disguise at some point?*

ALŸS: I wish I could, but I can't. I am a misfit. I am too tall, too pale and too *gringo*
looking. But things are not always that schematic. In the building where I live in
the city centre the population is very young. I have been around for much longer
than most of them, so in a way, for them, beyond my foreignness I have become
a sort of local reference. I suppose I may be even a character for some of them.
When – very occasionally – a big-shot collector comes to visit the studio, he shows
up in a limo with black smoked windows and two carloads of bodyguards. So,
as everyone in the building deals some kind of shit, they must think I'm doing
big-time deals for these big-time mafiosos to come here and visit me. So it gives
me some kind of status in the hood after all.

FERGUSON: *And what came after* Turista? *You continued to work around the
Zócalo, I know.*

ALŸS: A couple of years later I put together a short film called *If you are a typical
spectator, what you are really doing is waiting for the accident to happen* (nicknamed
Bottle). I say 'put together' because I went back to some discarded video footage,
stuff I had kind of absentmindedly filmed on the Zócalo in early 1996, while I was
waiting for the flag-raising ceremony to take place. It turned out that the material
perfectly illustrated a preoccupation I had in mind. The camera was following
an empty plastic bottle being blown around by the wind. There was to be no

interaction between the camera (that is, me) and the protagonist (the bottle). The camera would just follow the bottle, record its *dérive* and wait for an accident to happen to it. Ultimately what happened turned out to be quite different. First, passers-by felt provoked or stimulated by the camera, and they started interacting with my subject, kicking the bottle around and jumping over it and so forth, and later on, as I was filming with my eye glued to the viewfinder, the bottle left the main square and crossed a busy street. As I followed it hastily, I was hit by a car – nothing dramatic, but hard enough to send the camera flying into the air and crashing on to the ground. End of the take. I went back to that footage because I loved the fact that whereas one expects something to happen to the subject – the bottle – the accident actually happens to the observer of the bottle. The fact is that the act of observing had interfered with the course of things. My contemplative, non-interference contract was coming to an end.

FERGUSON: *So the bottle piece really marked a change in your status as an observer, from an outsider to someone a bit more directly involved.*

ALŸS: Something new was triggered. On the one hand, as there had been a shift in my relationship to the place, I started to produce a series of works reflecting on the state of local politics. *Cuentos Patrióticos (Patriotic Tales)* (1997) was directly inspired by a political episode that had happened on the Zócalo in 1968, and its disguised re-enactment on the same location nearly thirty years later was a direct comment on the current state of politics, the way history was repeating itself, and how the whole political scene was frozen by a corrupted and dysfunctional political apparatus. On the other hand I continued questioning the mechanics of artistic production and the status of production itself with a piece called *Paradox of Praxis 1* (1997). It was composed of two symmetrical, though opposing, principles: 'sometimes making something leads to nothing' and 'sometimes making nothing leads to something'.

In parallel I started working on my first animated movie, *Song for Lupita* (1998), in which a woman endlessly pours water from one glass into another and back. I wanted to demonstrate the Mexican saying 'el hacerlo sin hacerlo, el no hacerlo pero haciendolo' – literally 'the doing but without doing, the not doing but doing'. It staged a kind of resignation to the immediate present by inducing a complete hypnosis in the act itself, an act which was pure flux, without beginning or end.

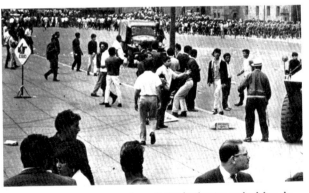

Los mismos burócratas se burlaban de las disposiciones gubernamentales y en la supuesta manifestación de "desagravio" denunciaron que eran obligados a asistir bajo amenazas de índole económica y luego externaron su apoyo a los estudiantes...

NEWSPAPER CLIPPING ABOUT THE 'CEREMONIA DE DESAGRAVIO', 28 AUGUST 1968, ZÓCALO, MEXICO CITY FROM THE ARTIST'S ARCHIVE

GRINGO, 2003
IN COLLABORATION WITH RAFAEL ORTEGA,
EPAZOYUCAN, HIDALGO, MEXICO
VIDEO
5 MIN
PRODUCTION PHOTOGRAPHS

Protagonist: the camera

Object of conflict: a narrow
passageway at the entry to
a village

Agents of the conflict: the dogs

Plot: the camera tries to break
its way through a pack of dogs
blocking the passageway.

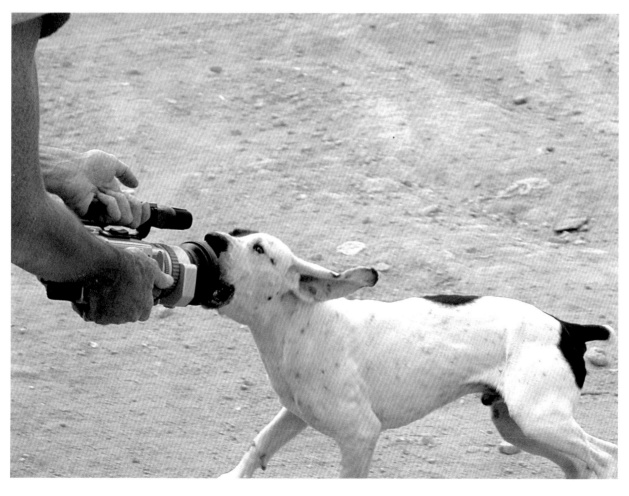

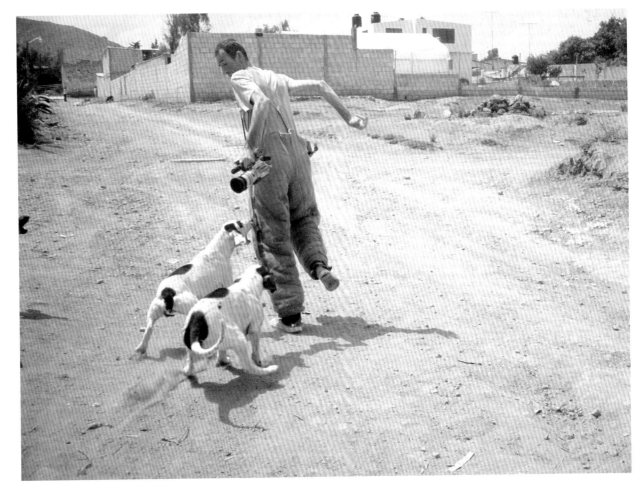

SONG FOR LUPITA, 1998
DRAWING FOR ANIMATION
PENCIL ON TRACING PAPER
EACH 35 X 29 CM

Mañana, mañana
Is soon enough for me.

Animation is all about timing, and I think it was around this moment that I realized that Latin America's relationship to modernity and the dogma of efficiency could be explored from that angle. I understood that through films, events or performances the *mise en scéne* of certain time schemes could render the time structure I had encountered here in Mexico. From then on I started developing what would become over the following years a discursive argument composed of episodes, allegories or parables that staged that experience of time .

FERGUSON : *What was the first attempt?*

ALŸS: My first trial was a video installation called *Cantos Patrióticos (Patriotic Songs)* (1998-99). It was based on a story I had heard of a ferryman who, while transporting people from one side of a river to the other, gets blinded by the sun in the middle and loses his sense of orientation. No longer knowing which side to row to, he gets lost – as they say here, 'entre dos aguas' (between two waters) – and rows around in circles. The story is interpreted by several singers, with the narration in a mirror construction – the last verse is the first, the penultimate is the second, and so on – and the singing is chopped up by a series of stops that also rule a game of musical chairs on the opposite screen. The interruptions of the lyrics produce a progressive disarticulation of the narrative, and soon any understanding of the story becomes lost in the assemblage of words and syllables, notes and bars, and the attempt to tell the story takes the lead over the story itself. I was looking at Latin America as a kind of broken mirror, a single reality constituted by a multiplicity of dispersed fragments.

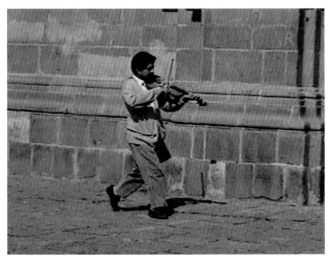

Something quite ironic happened during the long making of *Cantos*. Over time, like my ferryman lost his orientation, I lost what I was trying to say, and the more the piece progressed, the less I could remember why I was doing it. The only thing that brought the piece to completion was the energy of all the people involved in the film and my responsibility to them as its instigator. The experience taught me a lot about collaboration, how it is about letting the original scenario go, letting it be translated by others and bounced back and forth. If the story is good enough, it will get back to you or achieve its shape by itself. If it isn't, then it's better for it to die away.

(REFRAIN)
With the current and against it
Don't know where you're rowing to
Is it backwards is it forwards
Is it forwards is it back

(VERSES)
It's the serpent of the story
Who is swallowing his tail
Listen well and do not hurry
So you'll understand my tale
Where the end is the beginning
And the start is the finish is

Over the Rio Grande waters
Luis the boatman ferried folk
On his craft and with the current
From one shore to that in front
And then the other way about
South to north day in day out

Right in the middle of the river
Listen to what happened next
As his course he tried to set
He sighed and gazed ... up at the sun
Lost was Luis he knew no whither
By the sun he started at ... dazed.

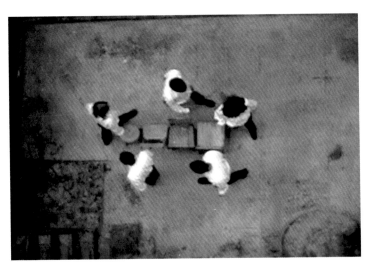 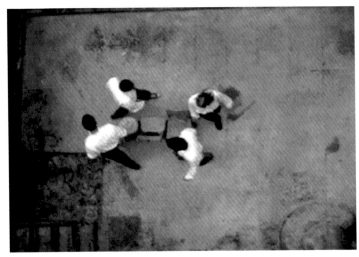

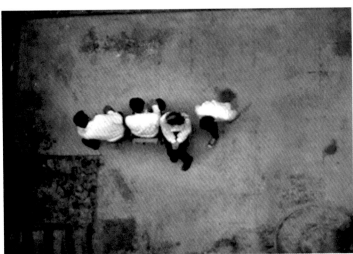 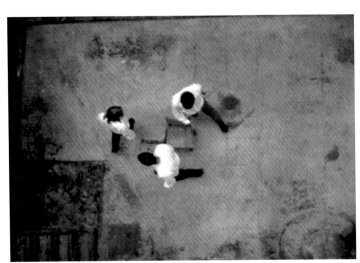

 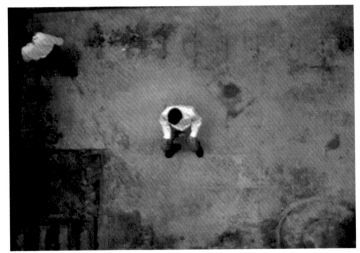

There in the middle of the river
Listen to what happened next
Trying once more to set his course
Sighing at the sun he gazed
His orientation was restored
Though by the sun's light he was dazed

By the sun he stares at ... dazed
Lost was Luis he knew no whither
He sighed and gazed ... up at the sun
As his course he tried to set
Listen to what happened next
Right in the middle of the river

South to north day in day out
Then the other way about
From one shore to that in front
On his craft and with the current
Luis the boatman ferried folk
Over Rio Grande waters

And the start the finish is
Where the end is the beginning
So you'll understand my tale
Listen well and do not hurry
Who is swallowing his tail?
It's the serpent of the story.

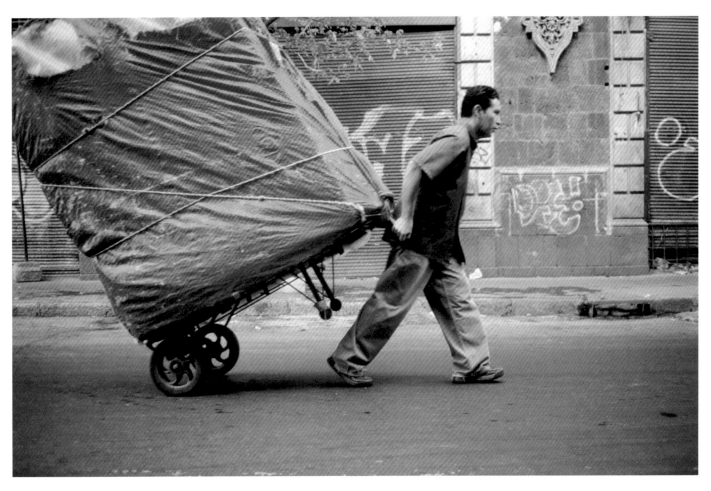

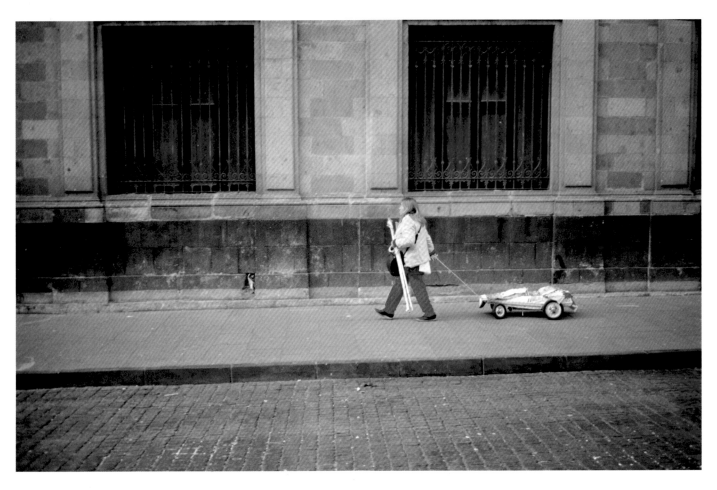

FERGUSON: *One of the things that seems very characteristic about Mexico City – at least from the outside – is a constant pushing back and forth between the embrace of modernity and a resistance to it.*

ALŸS: It probably happens in other places too, but this is the one I know the best. It seems particularly palpable in this part of town, the old city centre with all its anachronisms. Its three layers – pre-Hispanic, colonial and modern – co-exist more than overlap. I think you could say that all the ingredients are present for Mexico to enter modernity, but there is this inner resistance. Somehow it's a society that wants to stay in an indeterminate sphere of action as a way of defining itself against the imposition of modernity.

It's this capacity of flirting with modernity without giving in that fascinates me. I suppose that in our age of the global market economy you could argue about whether that modernity was ever even achieved. But what matters now is the memory of it, whether it was a reality or a fiction. You can have a nostalgia for something that never really happened.

FERGUSON: *I noticed a cartoon pinned to your studio wall with an old man saying, 'Of course, it was a long time ago, but at the time it seemed like the present.'* [laughs]

ALŸS: I think there is a whole aspect of my practice that just tries to deal with all these anachronisms, to represent and to document them. I have seen some urban activities disappear from one day to another because of a radical change in city policies. When I first went to Lima, the Old Centre was very much like the Centre here, with street sellers everywhere. A year later there was not one street seller to be found. From one visit to another a whole culture had been wiped out. What I am saying, simply, is that to have witnessed those kinds of drastic evolutions in the life of a city makes you want to document more systematically the manifestations of these parallel, informal economies that are the obligatory components of the Latin American megalopolis.

The style of the documentation series is influenced by August Sander's *People of the Twentieth Century* or the eighteenth-century prints *Cries of London*. My method of shooting is always systematic and tries to respond technically to the encountered situations. *Sleepers* (1999-2006) will always have the camera at ground level. *Beggars* (2002-04) takes a quasi-hypocritical high viewpoint. *Ambulantes* (1992-2006) is always shot perpendicularly to the passing subject at a distance of five metres or so. In that sense it is as neutral a register as can be, and it is that which might give it its archival value over time.

FERGUSON: *You once referred to yourself as 'a former European'. Earlier I asked you if you were a Mexican artist. Are you a Belgian artist in any sense?*

G VENDRAMINI
(AFTER FRANCIS WHEATLY)
HOT GINGERBREAD FROM
CRIES OF LONDON, C. 1772
ENGRAVING
43 X 33 CM

AUGUST SANDER
BRICKLAYER'S MATE, 1928
GELATIN SILVER PRINT
29 X 23 CM

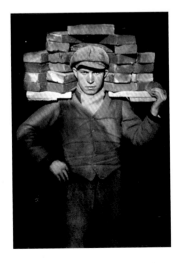

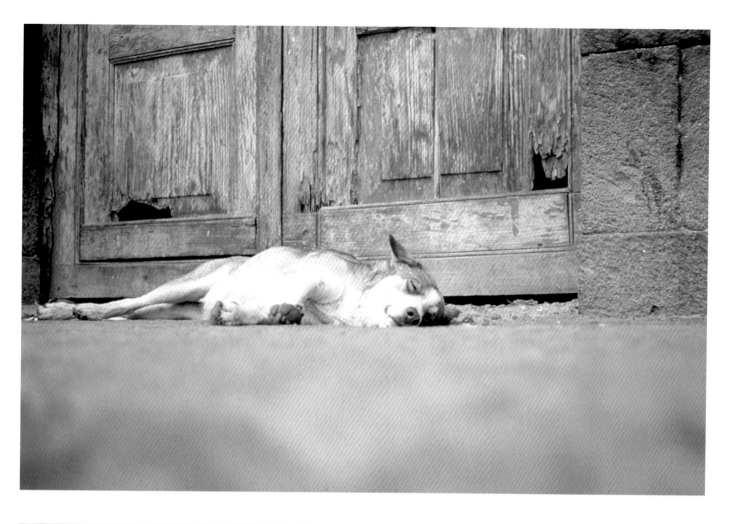

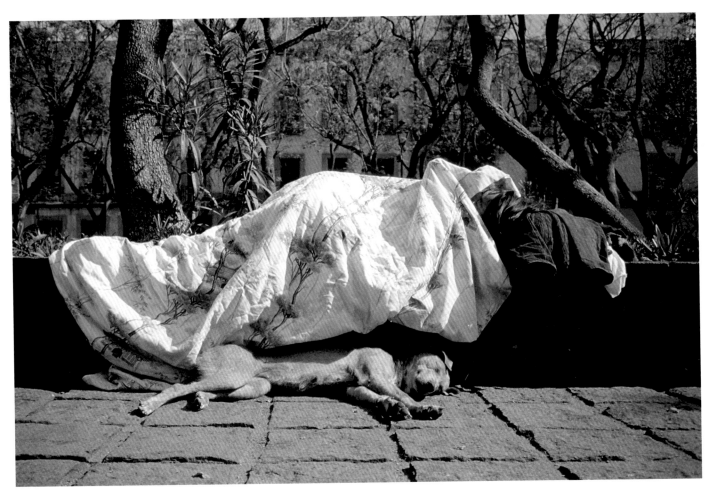

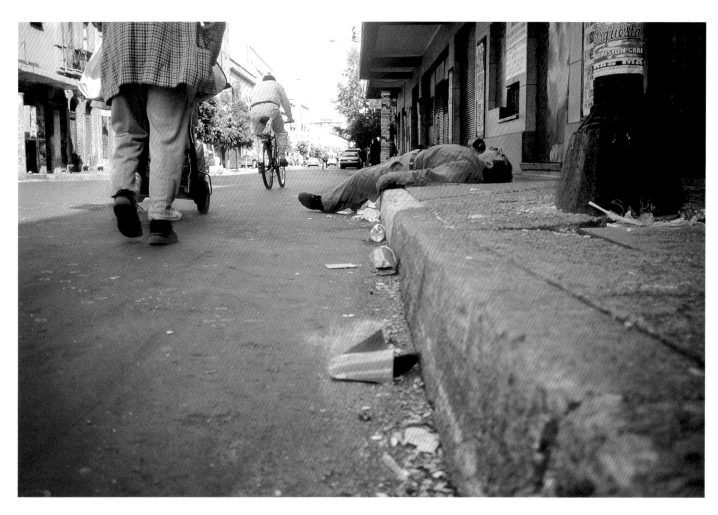

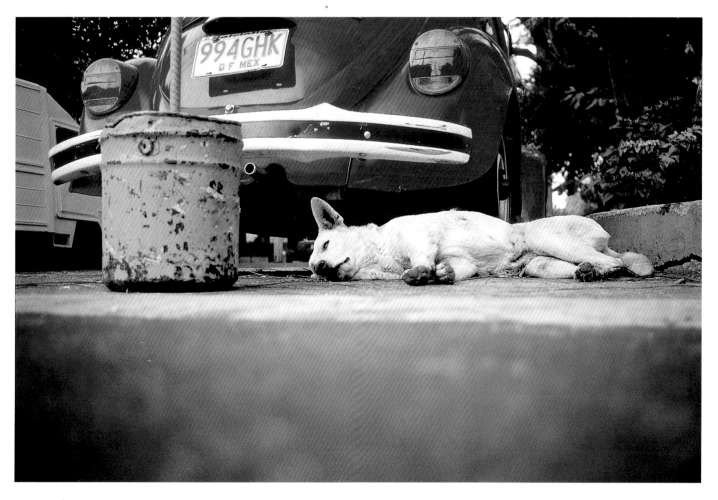

```
Given:
A generic situation - for example, a small
town where many people cross paths.

If somebody were to say something to someone,
and that someone were to repeat it to someone
else, and that someone were to repeat it to
someone else ... then, at the end of the day,
something is talked about, but the source has
been lost along the way.

Premise:
- The rumour is instigated and spread
  verbally by one or several agents.
- The rumour is fed until any physical
  evidence appears as a direct consequence
  of the rumour.
- The rumour attempts to infiltrate a given
  situation without adding or subtracting
  any physical element to it.
```

ALŸS: As you know, since you are Scottish, Belgium has certain imprints that you can't wash away. And being a Flemish-born French speaker doesn't help.

FERGUSON: *Do you see a continuation of your work as an architect in your art?*

ALŸS: Beyond the obvious fascination with urban phenomena, there's the fact that methods and practice of architecture are based on collaboration. It's a team product.

FERGUSON: *There is a stereotype of the architect as an egomaniac who collaborates out of necessity but at the same time attempts to exert total control. In a lot of your projects you have worked collaboratively with a variety of other people. I'm wondering to what extent you are attracted by the possibility of surrendering some control, and to what extent you need to retain control personally over what you produce.*

ALŸS: Perhaps you should ask my collaborators. [*laughs*] The collaboration process is to watch an idea bounce back and forth, and eventually develop its own course in that bouncing (*el rebote*). The project starts with a mess of notes and drawings, incidental quotes and documents, and usually out of that process the medium defines itself spontaneously. At that stage I start looking for specialists in that specific medium to enter the project, and their translation of the plot automatically reshapes the original concept. The more the project evolves, the more this bouncing back and forth between myself and the collaborators intensifies, and it can lead to a final shape sometimes quite far from the original intention. It's in that process that the project takes on its own life and develops. The more ambitious the logistics of the project, the more I will turn into a producer or a coordinator of the project and, when it happens, a spectator of my own fantasy.

And then there are all the other ingredients of the live event. Once the axiom has been posed and the location set, the development and outcome of the piece happen within an open field of possibilities, in the sense that any outcome of the event becomes a valid answer to the premises of the piece. Once the action is launched, there is no longer any strict or unilateral plan to be followed. Only the actual course of the action itself will provide a response to the preliminary axiom.

The only constant rule I have witnessed is that if the storyline – the plot proposal – is clear and strong enough, it will resist all these mutations. The situation will unfold in a way not unlike what your intuitive expectations were. It is the test of the scenario. If the scenario does not hold, the action will deviate and become something else.

FERGUSON: *Despite the inevitable collaborative element in architecture, it is also about making something that is very fixed and with very clear boundaries. It seems that perhaps one of the things that led you away from architecture is an interest in where those boundaries are more permeable, or where there are spaces between fixed entities.*

ALŸS: You mean the cracks in the system?

FERGUSON: *Yes. I'm also thinking about the man in the Zócalo who spends his time scraping the gaps between the flagstones with a wire hook. I thought of that figure as in a way a self-portrait of you, in the sense of this interest in exploring the spaces in between.*

ALŸS: When I stepped out of the field of architecture, my first impulse was not to add to the city, but to absorb what was already there, to work with the residues, or with the negative spaces, the holes, the spaces in between. Because of the immense amount of material produced on a daily basis by a huge city like Mexico City, it is very difficult to justify the act of adding another piece of matter to that already saturated environment. My reaction was to insert a story into the city rather than an object. It was my way of affecting a place at a very precise moment

of its history, even just for an instant. If the story is right, if it hits a nerve, it can propagate like a rumour. Stories can pass through a place without the need to settle. They have a life of their own. If the script meets the expectations and addresses the anxieties of that society at the right time and place, it may become a story that survives the event itself. At that moment, it has the potential to become a fable or an urban myth.

I'll try to always keep the plot simple enough so that these actions can be imagined without an obligatory reference or access to visuals – the story of the mouse that was freed in the storage space of the largest collection of contemporary art in Mexico (*The Mouse*, 2001), or of the guy who pushed an ice block until it melted down completely (*Paradox of Praxis 1*) – something short, so round and simple that it can be repeated as an anecdote, something that can be stolen and, in the best-case scenario, enter that land of minor urban myths or fables I mentioned.

FERGUSON: *You're making it clear that the source of a lot of your work lies in things observed in the real environment, and yet, at the same time, I feel that there is a strong element in your work of the dreamlike.*

ALŸS: What do you see as dreamlike?

FERGUSON: *There are certain elements singled out that defy conventional rationality, and for me that has something of a dreamlike quality in the sense that everything seems very real and convincing yet at the same time somehow irrational. This is perhaps especially true of the paintings.*

ALŸS: I think a lot of what is happening in this world is way more irrational than what I am illustrating. But it's true, when it comes to images, painted images in particular, the rules are different. What justifies my recourse to painting is that it's the shortest way – or the only way – to translate certain scenarios or situations that cannot be said, that cannot be filmed or performed. It's about entering a situation that could not exist elsewhere, only on the paper or canvas. They are images, and I want for them to live as such – like in a children's book.

Also, painting allows me to retreat from the sometimes hectic rhythm of the performances and film productions, and to distance myself from them without losing contact with them. Painting functions as a sort of therapeutic space in the middle of the rat race. When I am translating an ongoing film plot into an image, I'll try to create an image that reflects the intention behind the plot rather than illustrating the facts of the film. It functions more like a correspondence.

And of course, last but not least, painting has freed me from some economic pressure by allowing me to finance numerous projects that proved not to be very lucrative. Now I remain my own master, and up to the last moment I can change, postpone or cancel any ongoing production.

FERGUSON: *I guess I see what I'm calling the dreamlike aspect of your work also in some of your performative works, not just your paintings – for example, the loose thread on the sweater that unravels further and further and further (Fairy Tales, 1995/98). It is a real thing that takes place in the world, yet it also –*

ALŸS: Yes, but it can also travel as an anecdote or fable.

FERGUSON: *So you see them as fables or parables rather than as dreams, or even daydreams. Like the man whose sweater catches on something and who doesn't notice for a mile.*

THE MOUSE, 2001
PHOTOGRAPHIC DOCUMENTATION
OF AN ACTION, MEXICO CITY

On Saturday 3 March 2001 at 5 p.m. I entered the Jumex Collection with a mouse in my pocket. At 5:10 p.m. I freed the mouse.

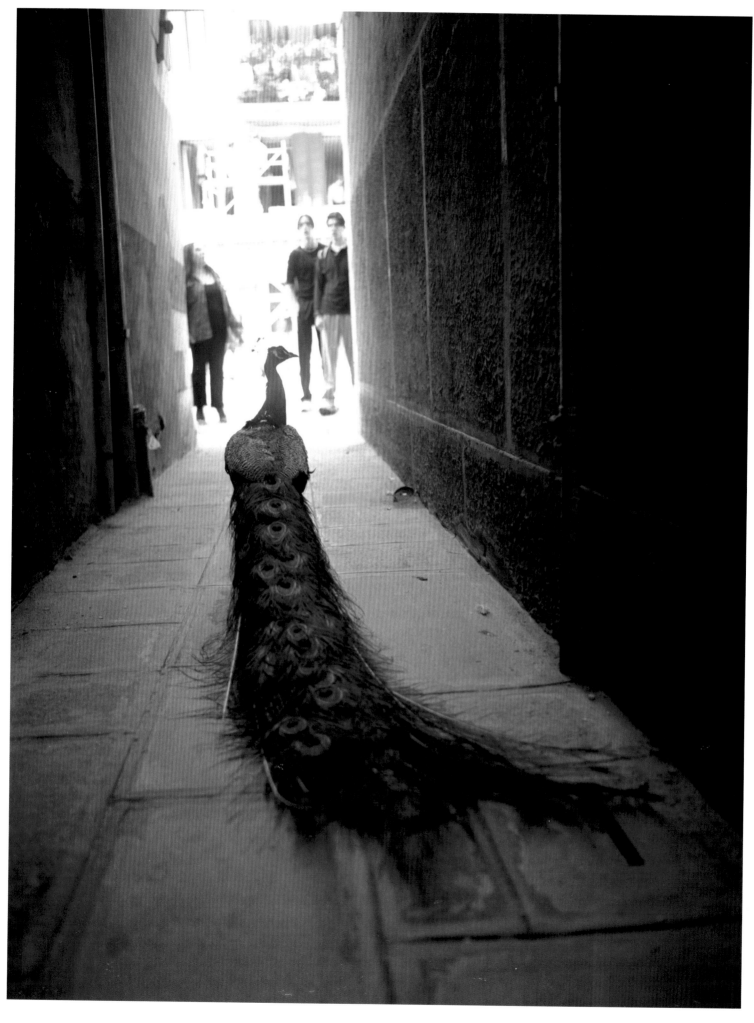

ALŸS: Until someone else notices. In Stockholm, once the walk was done and the sweater unravelled I retraced my steps to document the journey, following the long blue thread on the street and in the park. Midway back I ran into this old lady who was patiently rolling a ball of blue yarn under her arm, carefully gathering up the wool of my unravelled sweater – maybe to knit a similar one at home.

FERGUSON: *Is the passing on of the story where humour comes in? In some of your projects there is a pungent humour that contributes to its persistence as a story.*

ALŸS: Humour helps to catch the spectator's attention. It's a way of trapping him in the narrative. You make me think of something else. My iconography has often been described as naïve, flatly figurative, two-dimensional, but that simplicity can sometimes help seduce the viewer's eye. It's the direct language of the sign painters, where communication for any audience comes first. That's what fascinates me about Magritte. His painting is so flat and somehow physically disappointing, yet it is so performative and communicative. Magritte himself was coming from the world of advertising. There are billions of images around us, and they move fast and are extremely persuasive and efficient. Painting works against that speed effect. It is slow, very poor in a way, so if you can make that little contact, provoke that little spark in someone's head, it is a small miracle amid the speed of our digital age.

FERGUSON: *Sending a peacock to the opening of the Venice Biennale (*The Ambassador, *2001) is very funny, but it also has an element underneath that is critical. People who are there see the peacock and think it is funny, but the peacock is also functioning as a critique of all the preening people who are attending the opening.*

ALŸS: Humour has a critical dimension. To laugh can be a way of abstracting yourself from a situation, a way of negating its reality. When the public first saw Manet's *Olympia* their reaction was to laugh, because they could not understand it and maybe they did not want to understand it, and laughter was the only answer they could give to its physical presence. Humour is a double-edged weapon.

FERGUSON: *It can be attack and defence. It can be both the sword and the shield.*

ALŸS: *The Last Clown* (2000) was trying to illustrate that situation, with the artist and the curator in their ultimate roles: the great entertainers, the acrobats, the ones expected to fall.

FERGUSON: *I guess the other side of my suggestion that there is a kind of dream element in the work is that there is also a lot of work in the work. Just looking around the studio it seems that there is a lot of work going on here, a lot of production.*

ALŸS: The studio is a bizarre place. Some of the things you see lying around have been here for years.

FERGUSON: *It gives the impression there's a lot of work.*

ALŸS: There is and there isn't. The images build themselves in layers over a long period of time, with all the moods and accidents that can happen in between. It's the great receptacle of all complaints and illusions, the purgatory space for all projects. My studio has become something in between a sentimental refuge, a logistical base and a storage space. It is a place I need to go back to on a regular basis, but only to recharge batteries and leave again.

0:00:12

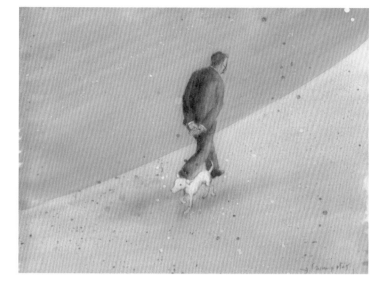

0:01:09

0:01:05

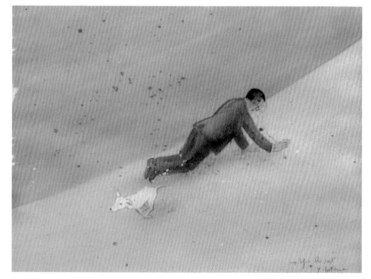

0:01:10

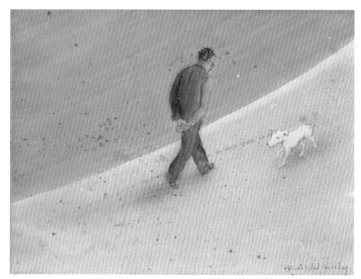

0:01:07

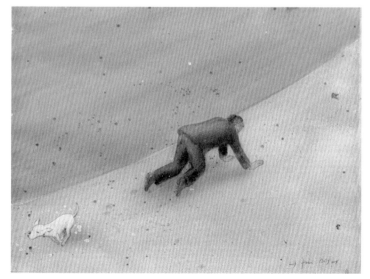

0:01:11

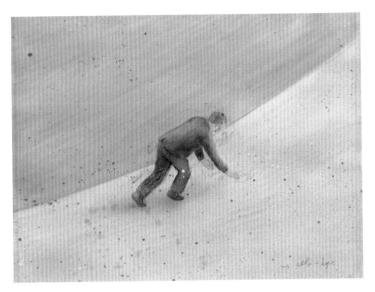

0 01 12

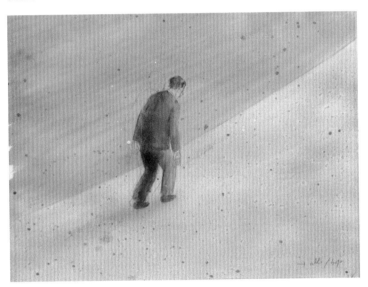

0 01 13

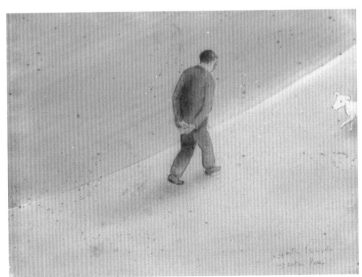

0 02 10

FERGUSON: *So the work is not really generated primarily in the studio?*

ALŸS: Not so much any more. In the days of the sign paintings project, yes, because we were all working here. But now the mechanics are more complex. The studio is where the raw material is processed and passed on to others. It's the relay point. I think most of the creative process happens in the spaces in between – in between home and the studio, the studio and the lab, in between conversations with collaborators, and also, as I am always working on several projects in parallel, in between different states of mind over the course of a day. And bouncing back and forth between these different scenarios is the only way for me to have a critical distance with any of them and for me to progress. I am never exclusively in one narrative at the time. Rather, I am always linking data from different sources. Recently this aspect has exploded geographically, but it could easily go back to just one location when the time comes. Again, all these parallel stories try to be part of a single narrative.

It's like when you walk in the city. Walking here from the Zócalo there have been fifty different situations happening, with fifty incidental noises, smells and images. They've all just been furtive glimpses, bits of incidental information, but while walking lost in your thoughts you have somehow integrated them all, and they have shaped your thoughts at the arrival point.

FERGUSON: *But you're a fast walker.*

ALŸS: Because, unlike a few years ago, I wouldn't want to be confused with a tourist. [*laughs*] In Mexico City only innocent tourists go slowly.

FERGUSON: *I wanted to ask you about the importance of walking in your work, starting with walking around your neighbourhood here, but also more generally about walking as a generator of projects and ideas and stories.*

ALŸS: Walking, in particular drifting, or strolling, is already – within the speed culture of our time – a kind of resistance. Paradoxically it's also the last private space, safe from the phone or e-mail. But it also happens to be a very immediate method for unfolding stories. It's an easy, cheap act to perform or to invite others to perform. The walk is simultaneously the material out of which to produce art and the modus operandi of the artistic transaction. And the city always offers the perfect setting for accidents to happen.

There is no theory of walking, just a consciousness. But there can be a certain wisdom involved in the act of walking. It's more an attitude, and it is one that fits me all right. It's a state where you can be both alert to all that happens in your peripheral vision and hearing, and yet totally lost in your thought process. I see the slide carousels series as an attempt to reproduce those furtive meetings, those side glimpses I mentioned earlier, when you look at someone or something for two seconds while walking on the street and yet it is enough time to fully capture the tragic dimension of the situation.

FERGUSON: *In* Ambulantes *all of the people shown have a very defined purpose to their pushing and pulling. They are walking in the city because they need to move something from one place to another. There seem to be two kinds of walking in your work. There are pieces that have a set script or set of things that will happen during*

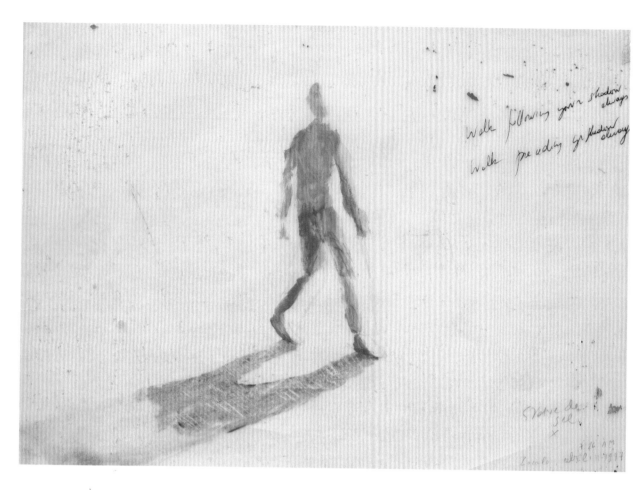

the course of the walk, and there are others that are aimless or drifting. Maybe
Narcotourism *(1996) is the most aimless of all your walks.*

ALŸS: *Narcotourism* responded to a very specific invitation. For the first time, after
having been in Mexico for nearly ten years, I was asked to do a work in Europe, in
Denmark. Copenhagen is for me a real archetype of the bourgeois European city.
I realized I had no desire to be there, so my response was to be physically present
but mentally absent. The drugs became a means of escaping the reality of a return
I was not ready to face.

FERGUSON: *Does the model of the* flâneur *interest you?*

ALŸS: The *flâneur* is a very nineteenth-century European figure. It goes with a
kind of romanticism that does not have much space in a city like Mexico. The city
is too crude and too raw, and everything seems to happen in an immediate present.
There is no space for nostalgia.

FERGUSON: *Certainly to attempt to re-enact that model is to participate in a
kind of nostalgia or romanticism. Of course, at the time of Baudelaire the* flâneur
*was the essence of modernity. 'It was a long time ago, but at the time it seemed like
the present.'*

There is, even in the earliest conception of the flâneur, *a detachment from the city as
well. The* flâneur, *modern or passé, is someone who observes the city but is never a
participant in the action of the city. I think your walks, wherever they are, at least*

WALKING A PAINTING, 2002/04
PHOTOGRAPHIC DOCUMENTATION
OF AN ACTION, LONDON

A painting is hung on the gallery wall.
As the gallery opens its doors, the carrier takes the
painting off the wall and walks it through the city.
As night and closing time approach, the carrier brings
the painting to the gallery, hangs it on the wall
and covers it with a veil for the painting to sleep.
The same action is repeated the following day.

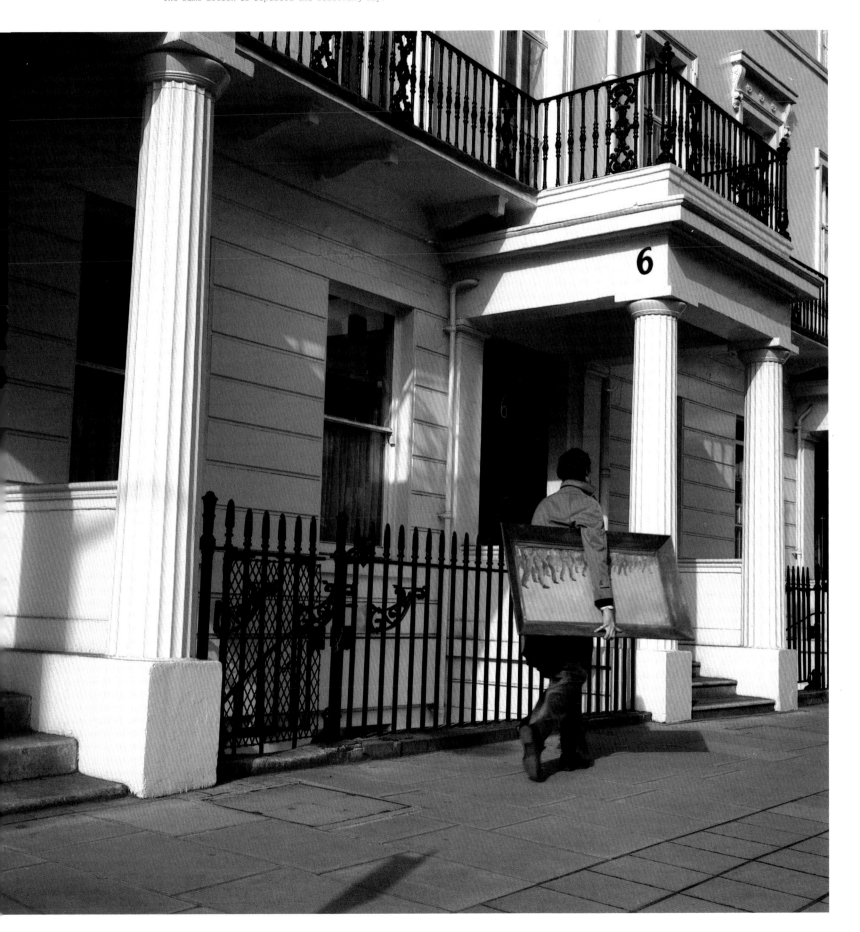

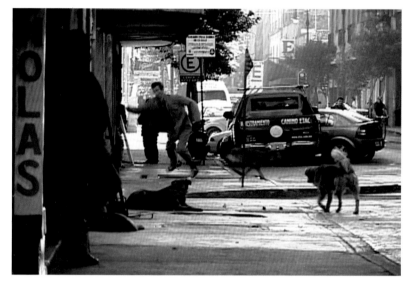

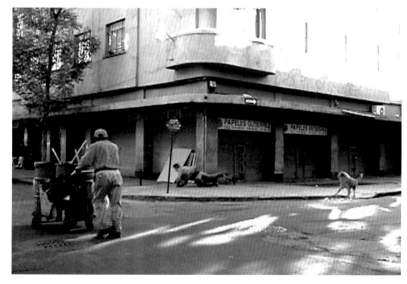

CHOQUES, 2005
MEXICO CITY
9-CHANNEL VIDEO

Nine hidden cameras record
nine points of view of an
accident on the corner of
Calle del cincuenta y siete
and Calle república de Cuba.

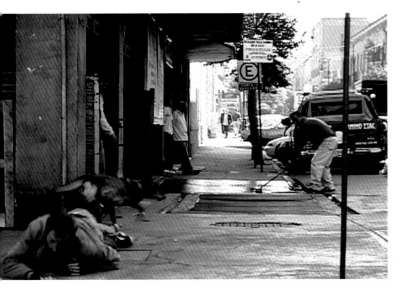

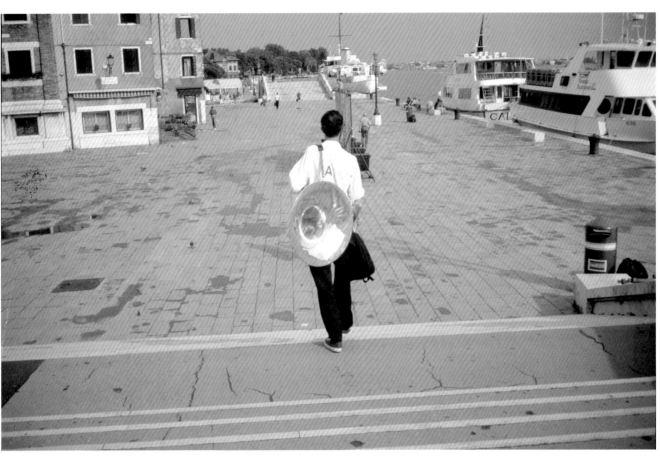

(moderato)
A and B arrive at opposite
ends of Venice. A is
carrying the upper part
of a tuba helicon. B is
carrying the lower part.

(andante)
A and B wander through the
city looking for each other.

(crescendo)
Upon meeting, A helps B
re-assemble the tuba.

(vibrato)
With one breath B plays
a note for as long as he
can. A claps for as long
as he can hold his breath.

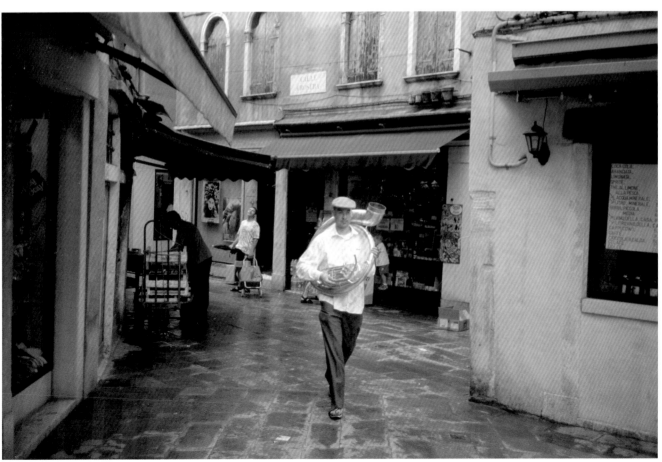

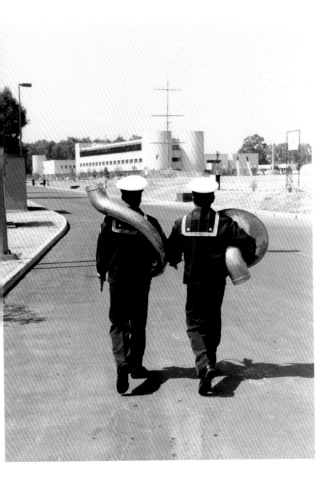

hold out the possibility of participant action that will have an effect – or, as you say, an echo – that will persist afterwards. Perhaps the true flâneur *in your work is* The Ambassador, Mr Peacock. *He conducts a kind of* flânerie *around the gardens of Venice and is admired but does not participate in events. So perhaps Mr Peacock is your surrogate* flâneur.

ALŸS: Yes, absolutely. He could be a real nineteenth-century gentleman. [*laughs*] He should be doing this interview.

FERGUSON: *You have made other works in Venice.*

ALŸS: In June 1999 I did this sort of homage to Fluxus with a musical piece, a walk titled *Duett*. It was inspired by Plato's speech of Aristophanes, which in short is that it is in our nature to be incomplete, to be bisexual. I entered Venice by the train station, while a friend of mine, the Belgian artist Honoré d'O, arrived on the same day via Marco Polo Airport. We started wandering, looking for one another in the labyrinth of Venice, each of us carrying one half of a tuba, hoping that we would be led to one another. There was a simple dramatic construction to the piece, with A and B needing to find each other. Eventually, there was a happy ending, maybe even a moral to the story, with the physical reunion of the two halves and the resulting production of a sound.

Last year with the help of Artangel and Rafael Ortega I orchestrated an event in London based on similar mechanics but introducing a different dimension (*Guards*, 2004-05). I re-staged the plot with a regiment of sixty-four Coldstream Guards. Each soldier entered the City of London walking normally. When he heard the steps of another soldier he would join in, fall into step, and the two would start marching together. They would eventually meet another soldier or group of soldiers and repeat the same protocol, continuing until the full formation was complete. It was like the spreading of a rumour, but also the progressive building of a square, as the final figure to be formed by the full company was an eight-by-eight soldier square. You have to imagine the whole thing performed by this perfect machine of synchronization of a British regiment. In *Duett* when two people were looking for one another it had a kind of sexual dimension, but when the number of participants grew to sixty-four what had been a love story turned into a social allegory.

FLUXUS SYMPHONY ORCHESTRA
PERFORMS PHILIP CORNER'S
4TH FINALE, CARNEGIE RECITAL
HALL, NEW YORK, 27 JUNE 1964

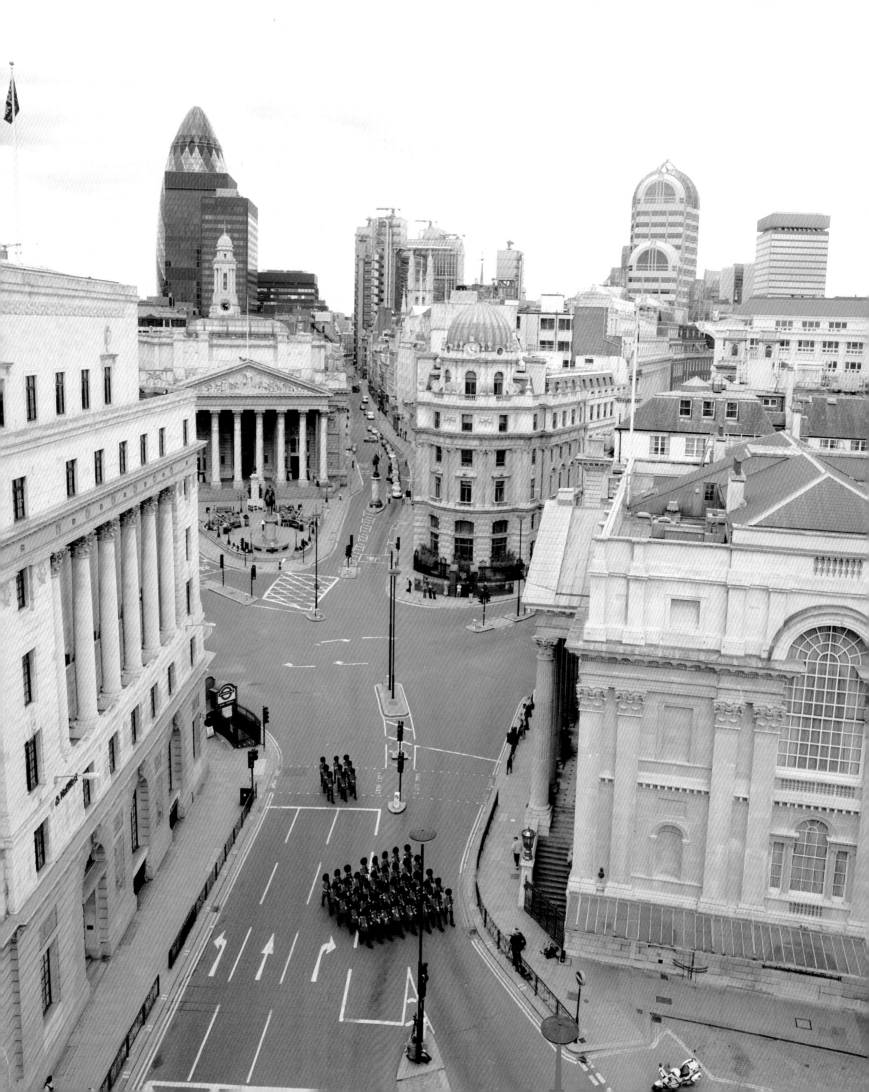

GUARDS, 2004-05
IN COLLABORATION WITH RAFAEL ORTEGA
AND ARTANGEL, LONDON
VIDEO
30 MIN

UNTITLED (STUDY FOR GUARDS), 2004
LONDON
PENCIL ON TRACING PAPER
38 X 26 CM

Sixty-four Coldstream Guards walk
separately in the City of London,
entering through different streets
and unaware of one another's route.

The guards wander through the City
looking for one another.

Upon meeting, they fall into step and
march together, looking for more guards
to join up with.

When a square measuring eight by eight
guards is built, the complete formation
marches towards the closest bridge.

As they step on to the bridge,
the guards break step and disperse.

FERGUSON: *If we extrapolate from there, to what extent do you see your work playing an instrumental role in the political sphere? Do you think your art, or art in general, can produce change in the world?*

ALŸS: I wish. [*laughs*] Political could be read in the Greek sense of 'polis', the city as a site of sensations and conflicts from which the materials to create fictions or urban myths are extracted. I think being based in Mexico City, and functioning in Latin America, the political component is an obligatory ingredient to address the situation. But it would be very hard to say to what extent your act can have a real echo, and even more to what extent there is any relevance for a poetical act to take place in a location going through a political, military, religious, social or economic crisis.

Back in the summer of 1995 in São Paulo I performed a walk with a leaking can of paint (*The Leak*) that was described as a poetic gesture, a *beau-geste*. More recently, on the fourth and fifth of June 2004, I re-enacted that same performance by tracing a line through the city of Jerusalem (*The Green Line*). Whereas the original walk belonged more to what you called the drifting category, the second walk strictly followed the section of the Green Line that runs through the municipality of Jerusalem. By re-enacting the same action but now performing it in a completely different context, I was questioning the pertinence of an artistic intervention in a context of political, religious and military crisis.

FERGUSON: *This question of what art can achieve in a politically charged context is a very complex question.*

ALŸS: Society allows, and maybe even expects, the artist – unlike, say, the journalist, the scientist, the scholar or the activist – to issue a statement without any demonstration. This is what we call 'poetic licence'. Fine. But this condition leads to a series of questions. Can an artistic intervention truly bring about an unforeseen way of thinking, or is it more a matter of creating a sensation of 'meaninglessness', one that shows the absurdity of the situation? And can an absurd act provoke a transgression that makes you abandon the standard

Sometimes doing something
poetic can become political,
and sometimes doing something
political can become poetic.

'During the months from December 1947 through June
1948, there was heavy fighting in Jerusalem and
its immediate vicinity. The city was divided in
two by the front lines. The statutory basis on
which the partition of Jerusalem rested was the
cease-fire agreement signed on 30 November 1948
between Moshe Dayan, "commander of all the Israeli
forces in the Jerusalem region", and Abdullah
al-Tal, "Representing the Arab Legion and all
the other forces in the Jerusalem area". The lines
were sketched on a mandatory 1:20,000 scale map.
Moshe Dayan drew the Israeli line with a green
grease pencil, while Abdullah al-Tal marked his
front line with a red one.'

(Meron Benvenisti, City of Stone, University
of California Press, Berkeley, 1996)

assumptions about the sources of conflict? Can an artistic intervention translate social tensions into narratives that in turn intervene in the imaginary landscape of a place? And finally, can those kinds of artistic acts bring about the possibility of change? In any case, how can art remain politically significant without assuming a doctrinal standpoint or aspiring to become social activism?

FERGUSON: *In general with your work, even if it is an echo rather than a statement, do you see it in a broader sense as a kind of resistance to political power as it is currently constituted?*

ALŸS: Considering the present state of politics in a good part of the planet, yes absolutely.

FERGUSON: *A straight answer.* [laughs] *Are you aspiring to make something that is both poetical and political?*

ALŸS: In Jerusalem the axiom behind the walk was, 'Sometimes doing something poetic can become political and sometimes doing something political can become poetic.' I tried to confront a situation that I might have dealt with more obliquely in the past, like in Lima for example. I had reached a stage where I could no longer hide behind the ambiguity of metaphors or poetic licence. What I try to do really is to spread stories, to generate situations that can provoke through their experience a sudden unexpected distancing from the immediate situation and can shake up your assumptions about the way things are, that can destabilize and open up, for just an instant – in a flash – a different vision of the situation, as if from the inside.

Poetic licence functions like a hiatus in the atrophy of a social, political, military or economic crisis. Through the gratuity or the absurdity of the poetic act, art provokes a moment of suspension of meaning, a brief sensation of senselessness that reveals the absurd of the situation and, through this act of transgression, makes you step back or step out and revise your prior assumptions about this reality. And when the poetic operation manages to provoke that sudden loss of self that itself allows a distancing from the immediate situation, then poetics might have the potential to open up a political thought.

FERGUSON: *There is a certain amount of repetition that is integral to your work. Certain motifs are repeated, and the whole idea of repetition itself is quite present. Is that a way of tying different storylines together or just of letting a particular storyline develop through time?*

ALŸS: I think that there is only so much one has to say.

FERGUSON: *What about* Re-enactments *(2000), in which a certain sequence of events are repeated?*

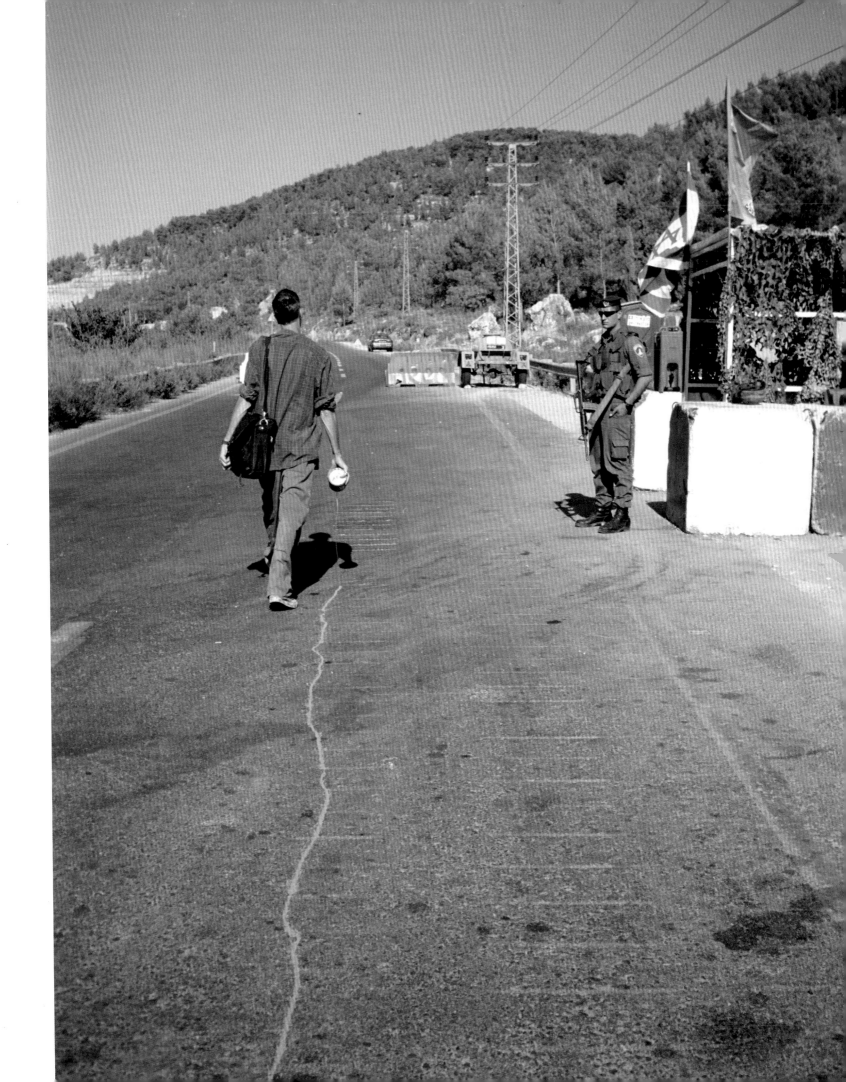

ALŸS: *Re-enactments* belongs more to the drifting category, although the scenario is very linear, following the seven steps of a classical dramatic construction. I think I was looking for a 'round' scenario, and the one in which I buy a gun and start walking down the street waiting for something to happen was likely to have all these steps: a context (the city), a protagonist (me), a cause for the conflict(I buy a gun), a conflict (I walk with the gun on the street), a response to the conflict (the reaction on the street), a climax (the arrest scene), and a moral (I am taken away by the police).

Retrospectively I think I made a fundamental mistake. Whereas I could have chosen a number of other scenarios, I got entangled in one that responded too well to the general expectation, the image of Mexico City that was exported at the time, with its ingredient of urban violence. And that last aspect seems to be the one that prevailed in the public's memory. I forgot a basic rule. When a work is produced within a very local context, it can easily acquire a totally different reading later, so the parameters for the piece need to take into account its possible life as an export. I had a similar problem with the sign-painting project. It was often reduced to an exotic exercise of style, conveniently bypassing the market proposal I had projected.

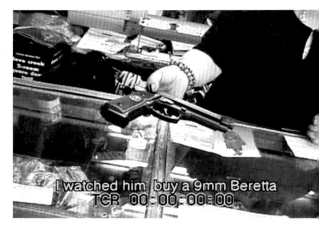

More than anything I was looking for an action whose dramatic construction could be easily re-enacted, which is what occurred, since the next day the exact same action was filmed again, but this time with everything pre-arranged. The people on the street were warned. The police were accomplices and even played themselves. Everything was staged. The idea was to juxtapose two films, each presenting an identical action, except that one would be the documentary of a real event, of 'the way it happened', and the other would be a scrupulous re-creation of the course of events as they appeared in the first film, thereby fictionalizing the reality of those events. I wanted to question the rapport we have today with performance and the ways in which it has become so mediated, particularly by film and photo, and how media can distort and dramatize the immediate reality of the moment, how they can affect both the planning and the subsequent reading of a performance. What is supposed to be so unique about performance is its underlying condition of immediacy, the imminent sense of risk and failure. At the time I needed to re-address my relationship to that medium.

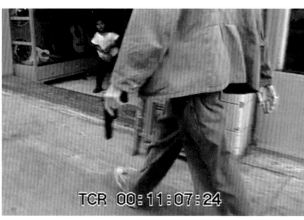

FERGUSON: *That was echoed in an institutional way with* The Modern Procession *(2002), to mark the Museum of Modern Art's temporary move to Queens. In the end the Public Art Fund commissioned the procession, and the Museum of Modern Art commissioned the film of the procession, insisting on the distinction between the event and the record of it in a way that, to outsiders, might seem arbitrary.*

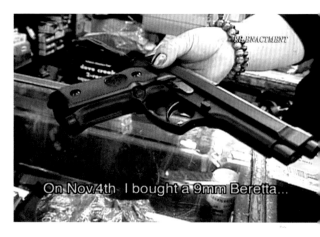

ALŸS: Yes. It was the necessary legal trick to make it all happen.

FERGUSON: *Do you see the possibility of a further move into the realm of the cinematic, where you could pursue a more complete story, rather than a fragment or an iconic image that functions as an echo. Is that a possibility for you in the future?*

ALŸS: It is tempting, of course, although I rarely deal with more than one idea per work, one situation at a time. In that sense, paradoxically, I am not a storyteller. Except if you look at a story as a succession of episodes. But if I were to make what you call a 'more complete story', a feature film, I would not start at the beginning or the end. I would need to work from some middle, because the middle point, the in between, is the space where I function best.

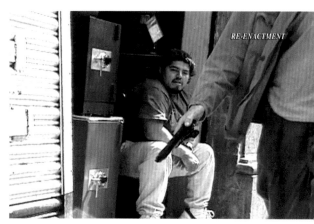

Real (monitor 1):
On 4 November Francis asked me to meet him downtown in a gun shop on Calle de Palma. I watched him buy a 9 mm Beretta, load it and leave the shop holding the gun in his right hand. I trailed him with my Sony Handycam and filmed the following scenes. (Rafael Ortega)

Re-enactment (monitor 2):
On 4 November I bought a 9 mm Beretta in a gun shop on Calle de Palma. At ten past one I left the shop holding the loaded gun in my right hand and started wandering downtown waiting for something to happen.

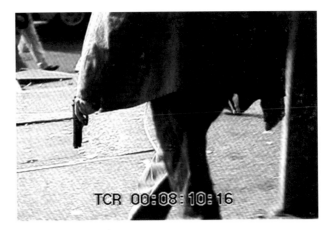

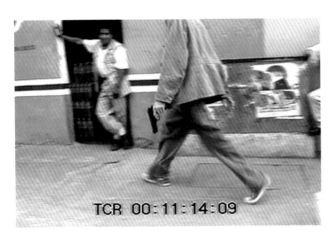
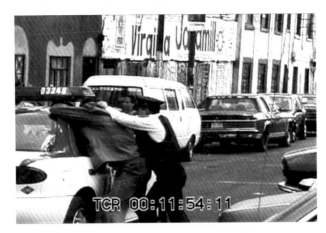

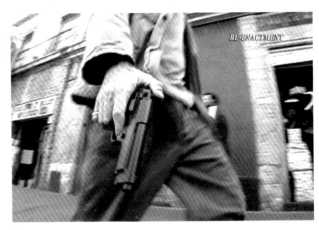

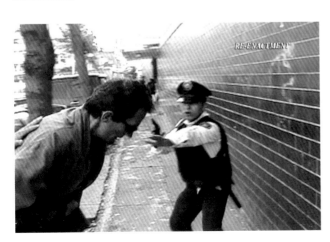
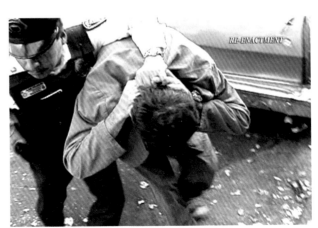

The Modern Procession announced the temporary move of the Museum of Modern Art from Manhattan to Queens, and celebrated the entry of its permanent collection into the periphery. The pilgrimage took the guise of a traditional procession. A selection of MoMA's masterpieces were carried on palanquins, a Peruvian brass band set the pace of the journey, and rose petals were strewn along the way while fireworks rose at street corners.

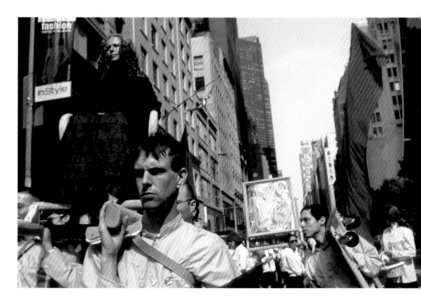

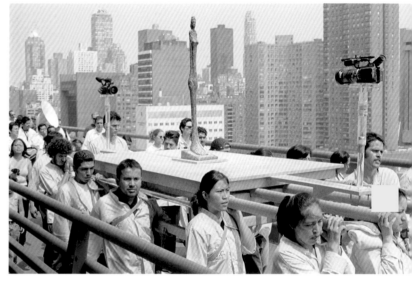
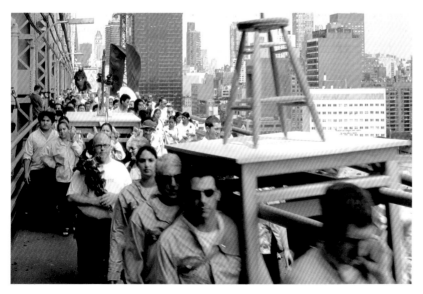
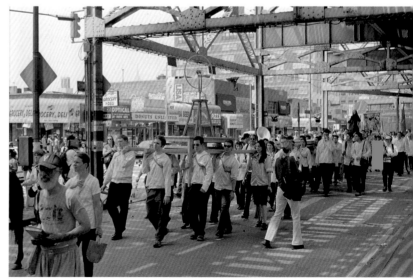

FERGUSON: *My understanding of the initial development of the* rotulista *work was that the cycle back and forth between you and the sign painters could potentially have continued endlessly with changes introduced by you or by them in each round.*

ALŸS: Like a visual version of Chinese whispers. But I think we were also trying to propose an alternative system to the market, one where we could impose our own rules.

FERGUSON: *Was there an element of making each one different so that it could carry a higher price, as a unique object?*

ALŸS: Yes and no. Yes, each of them was unique. Yet they all belonged to various series, as they were all referring to a similar model, so they depended on one another. It was their grouping or proximity that made them exist. As for their price, the fact that we were – and still are, for sure – maintaining copyrights on each image, allowed us to maintain a low market value, one that went against the idea of the unique and the rare – hence expensive – 'original' product. Retrospectively it was a naïve attempt to challenge the rules of the market, as recent resale prices in auction houses of some of these paintings have demonstrated, but for a moment it functioned. In the space of three years we produced a massive number of paintings, invading the market if you will, saturating the demand, which allowed us of course to maintain low prices but also to make a decent living out of it. Incidentally, the project acquired an unexpected documentary dimension. Over the last decade the sign-painting tradition has nearly disappeared. It has been driven out by computer-generated signage.

FERGUSON: *To me Mexico City still seems to have an enormous amount of hand-painted signage everywhere, compared to the United States at least.*

ALŸS: What really disappeared are its figurative elements. The signs are more text-based now. But then that could have a positive reading. It could mean that in the last couple of decades the literacy rate has increased enough that the figurative ingredients are no longer indispensable.

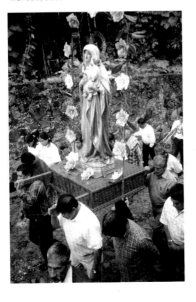

FERGUSON: *But in terms of repetition more broadly, not just vis-à-vis the sign painters, you have an ongoing interest in the idea of rehearsal. One of the key elements in a rehearsal is repeating something until you can do it properly. So there is a strong repetitive element in the idea of rehearsal as well.*

ALŸS: Yes, but it was another dimension that interested me, the way in which through repetition the narration could be indefinitely delayed, recalling the Latin American scenario in which modernity is always delayed. The recourse to the mechanics of rehearsal was more a method to physically render this constant postponement, the avoidance of the conclusion.

Sound and rhythm also have been key tools in that process, as a means to destabilize the perception of time, a way of diluting time. In animation you learn that true synchronization of sound and image is virtually impossible. An audio accent takes four frames, whereas a visual accent happens in just one frame. So in film you can only suggest the illusion of synchrony.

Again, the *Rehearsal* films are part of a more extended narrative, Latin America's

Sometimes making something leads to nothing.

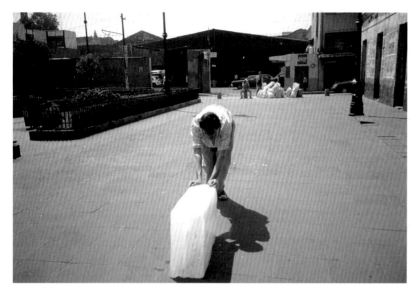

9:15 A.M.

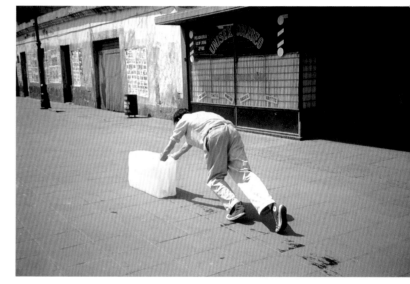

9:34 A.M.

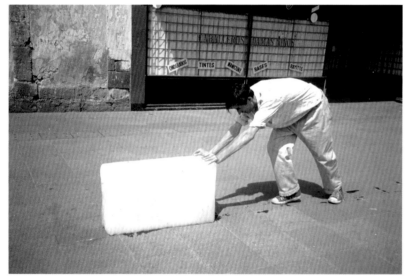

9:35 A.M.

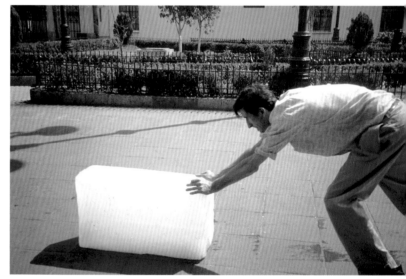

12:05 A.M.

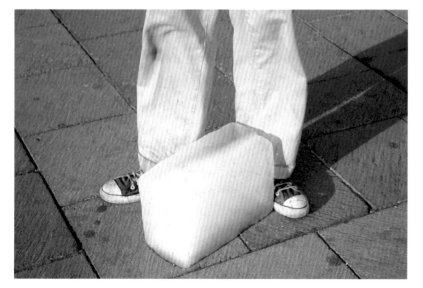

3:10 P.M.

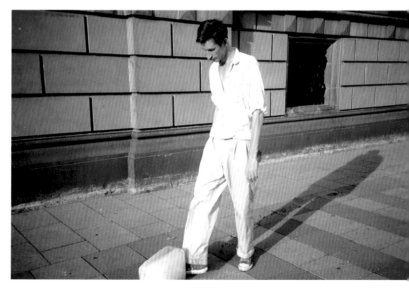

3:30 P.M.

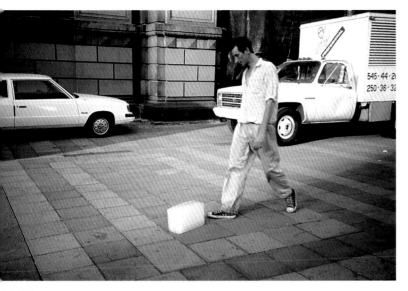

3 34 P M

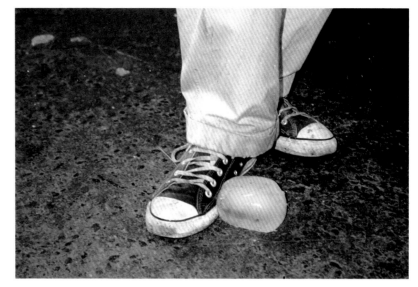

5 15 P M

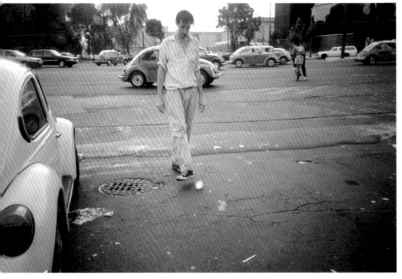

5 45 P M

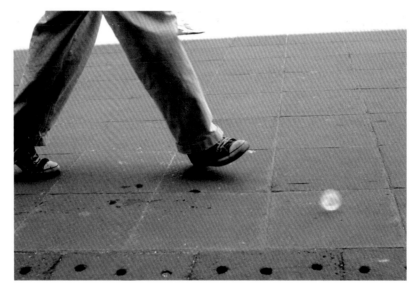

6 05 P M

6 32 P M

6 47 P M

REHEARSAL I, 1999–2001
IN COLLABORATION WITH RAFAEL ORTEGA,
TIJUANA, MEXICO
VIDEO
29 MIN 25 SEC
PREPARATORY SKETCH

ambiguous relationship to the concept of production and the dogma of efficiency. That investigation really started in the mid-1990s with the piece in which I pushed a block of ice during an entire day through the streets of Mexico City until it melted completely. It framed the debate by questioning the imminent contract of production: sometimes making something leads to nothing.

In the *Rehearsals* series there is a progression in the argument. In *Rehearsal 1* (1999-2001) the action is quite hypnotic, with the little VW going up and down the hill like a pendulum. After a while, the attention shifts form the finality of the action to the act itself, something I had played with already in the animation *Song for Lupita*.

In *Rehearsal 2* (2001-06) we have a scenario in which the development of a mechanics – such as two steps forward, three steps back, four steps forward, three steps back – and in which, although the progression is not linear and occurs in a different temporality, there is some kind of progress at the end of the day. It's just a different pace. Postponement or delaying does not mean stagnation. There is always a progression, but through a different mode.

FERGUSON: *Because it is something that nominally has a beginning and an end, if you keep starting it and stopping it again, the beginning and the end become part of a bigger process or story.*

ALŸS: Yes. You end up within this middle sphere. This aspiration to something that cannot be defined can also become a sphere for a society to function, a way of resisting an imported concept of progress. It's a story of struggle more than one of achievement, an allegory of process more than of synthesis.

FERGUSON: *I wonder how much repeating something prevents its resolution or its conclusion. How does that relate to a project such as* When Faith Moves Mountains *(2002), where there is an almost ridiculous, endless amount of work, but something was actually achieved, in that this giant sand dune mountain really was moved a few inches in one direction. On the other hand there is an inherent futility in the gigantic amount of labour it took to achieve that result. Do you see a connection between that piece and the idea of rehearsal and repetition?*

ALŸS: The motto of *When Faith Moves Mountains* is 'maximum effort, minimum result' – simultaneously stating the ridiculous disproportion between an effort and its effect, referring to a society in which minimal reforms are achieved through massive collective efforts. But the action also wants to suggest an alternative to imported models of development, to modernity's concept of linear progress.

Speaking of *When Faith Moves Mountains*, I always found it quite ironic that some people criticized the project for its gratuitousness, when voluntary collaboration was the *sine qua non* condition of the action. I suppose nowadays political correctness has moved on to economic correctness. But more to the point, I think today it's difficult to pass on an attitude that doesn't conform with the climate of scepticism or systematic criticism, an attitude that's more optimistic or even naïvely utopian. Words like 'change', 'faith', or 'bridge', when they are not coming out of the mouth of politicians or evangelical preachers, seem somehow out of place.

FERGUSON: *The idea of maximum effort and minimum result reminds me of* The Loop *(1997), in which you travelled from Tijuana to San Diego, basically by circumnavigating the globe, looping around the entire perimeter of the Pacific Ocean. You only had to go a few miles, maybe only a few metres, but you travelled tens of*

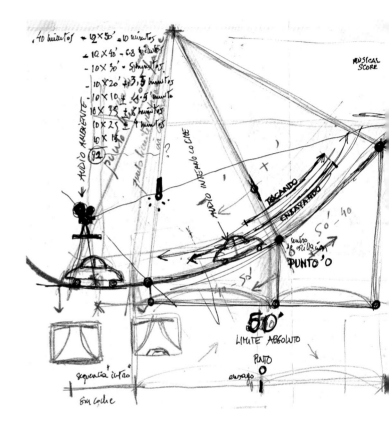

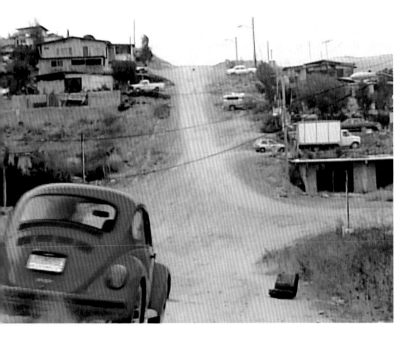
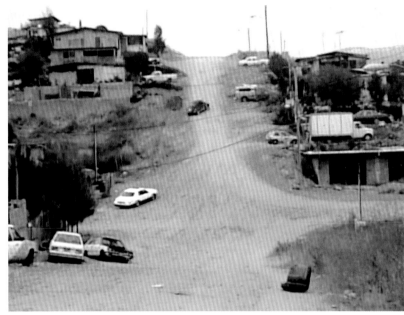
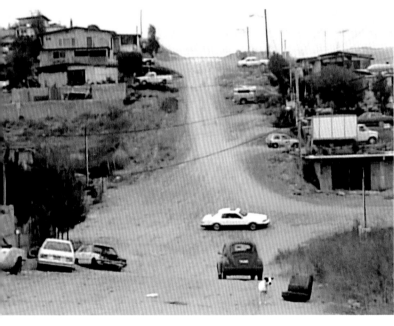
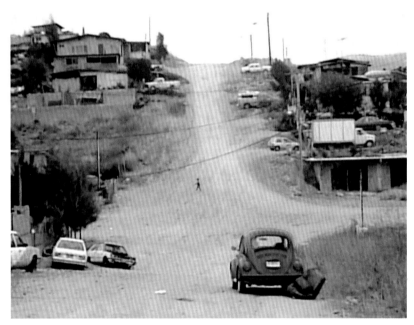

soundtrack: the rehearsal of a Danzon by a
brass band in Juchitan, Mexico.

image: a Volkswagen Beetle repeatedly tries to
ascend a hill without ever succeeding.

mechanics: the driver of the VW listens to a
tape recording of the rehearsal session.

while the musicians play, the car goes uphill.

when the musicians lose track and stop, the
car stops.

while the musicians are tuning their instruments
and are discussing, the car rolls downhill.

BARRENDEORS (SWEEPERS), 2004
IN COLLABORATION WITH JULIEN DEVAUX,
MEXICO CITY
VIDEO
6 MIN 36 SEC

A line of street sweepers pushes garbage
through the streets of Mexico City until
they are stopped by the mass of trash.

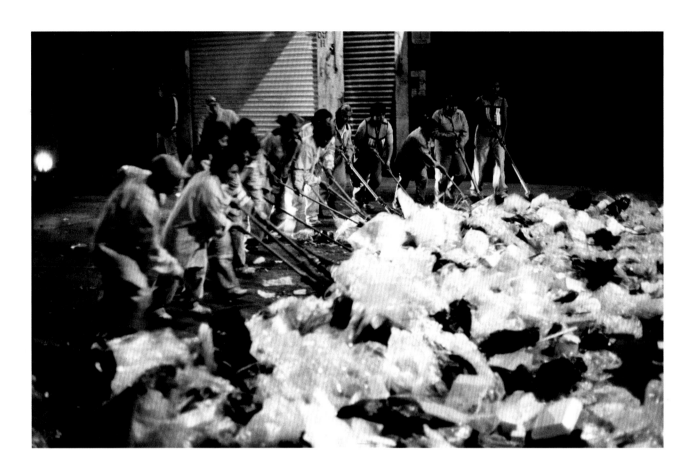

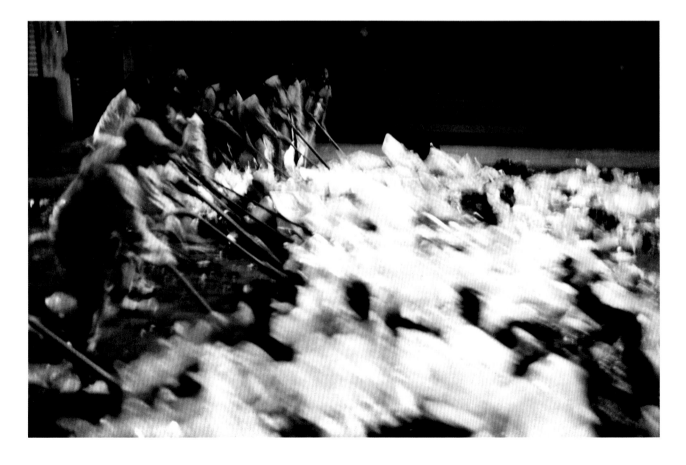

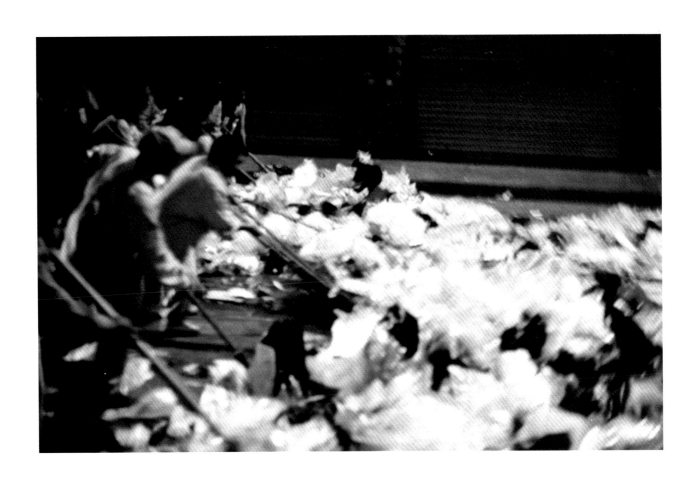

In order to go from Tijuana to San Diego without
crossing the Mexico/United States border, I followed
a perpendicular route away from the fence to
circumnavigate the globe heading 67° SE, NE and SE
again until I reached my departure point. The project
remained free and clear of all critical implications
beyond the physical displacement of the artist.

thousands of miles. The essence of a loop is that it can be repeated – you could go round again, even if in this case you probably would not want to. Equally, in Lima they could presumably move the sand dune another few inches, or even move it back.

ALŸS: As the action of the wind constantly does to sand dunes.

FERGUSON: *In a way it is also like the myth of Sisyphus, this desire to keep pushing the boulder up the hill.*

ALŸS: Apparently, yes, but, unlike in the Sisyphus myth, which is utterly fatalistic and doomed to repeat itself, there is a element of redemption involved here, a progress of sorts – even if it is different from the Western linear understanding of progress – but also a blind faith in the need for the action to happen. Though its arithmetic may be dreadful, it still needs to be carried out.

The impossible condition in which the vanity of the action is paired with its absolute necessity is addressed – heroically and ridiculously – in the tornado chase (*Tornado* [working title], 2000-present) or in a recent piece in which a 16 mm camera pursues mirages as they appear and vanish perpetually into the horizon (*A Story of Deception*, 2003-6). I found in that pursuit the perfect image of *fuite en avant*, of fleeing forwards. What immediately seduced me in the mirage's endless escaping was that it materialized the very Latin American scenario in which development programmes function in precisely the manner of a mirage, 'a historical goal that vanishes perpetually into thin air as soon as it looms into the horizon' (to quote my friend Cuauhtémoc). If you look into the larger cinematic or literary tradition, mirages have always been called upon in order to introduce scenes of apparition, like the one in *Lawrence of Arabia* in which Sherif Ali ibn El Kharish first appears. But I tend to see the mechanism of the mirage as exactly the opposite. While one approaches it, the mirage eternally escapes across the horizon line, always deceiving or eluding our progress, inevitably preceding our footsteps. It is a phenomenon of constant disappearance, a continuous experience of evasion. Without the movement of the observer, the mirage would be nothing more than an inert stain, an optical vibration in the landscape. It is our advance that awakens it, our progression towards it that triggers its life. It is in the obstinacy of our intent that the mirage comes to life, and that is the space that interests me. If there is disillusionment, it is because we want to catch it, to touch it.

When I refer, by way of the mirage metaphor, to the modernity that always seems to be within our reach but escapes us, I don't mean to say that modernity is the goal or what we should be pursuing. What interests me is the intent, the movement towards the mirage. For me, the emphasis is on the act of pursuing itself, in this escape forwards. I see the attempt as the real space of production, like the field of operations of a real or realistic development. Obviously you could reply that all this is purely a projection of mine, pure fantasy, that I've fallen into the mirage's trap.

FERGUSON: *We have come back over and over again in this conversation to the role of fiction and storytelling. Placing a story into circulation is very important in your work. But I am also interested in how the image relates to the story.*

ALŸS: I started making paintings because the street interventions and the three-dimensional objects I was making at the time were getting more and more hermetic. They were becoming art-world products, and I was losing contact with a wider audience, with the public. The images were a way of breaking that pattern.

Subject: SHANGHAI /23 June 1997
Sent: 6/23/97 10:11 AM
Received: 6/23/97 11:15 PM
From: FRANCIS ALYS, 110123.630@compuserve.com
To: Olivier Debroise, debroise@laneta.apc.org

Not much to do with the Tintinesque Shanghai of my childhood, but
exoticism still flourishes. Insignificant details transport me,
Is it just a matter of geography?
At this point, whether I travel east or west, it would take me a
week to reach a homeland.
As I become progressively unable to read the local codes, I'm
happily losing knowledge of my self.
At night I crash, emptied.
I don't even dare resist the vain romanticism which disguises the
crude reality of a mutating Shanghai.
Pure present.

Hardly any dogs around.
The few I saw are discreetly being walked late at night.
Most have been killed during a cleansing of the city.
They are the advance victims befe a three year plan of
"modernization" of the whole downtown area.

After a methodic packing ceremony, the morning's next ritual is the
quest for coffee.

500 volunteers were equipped with
shovels and asked to form a single
line in order to displace by 10 cm
a 500 m long sand dune from its
original position.

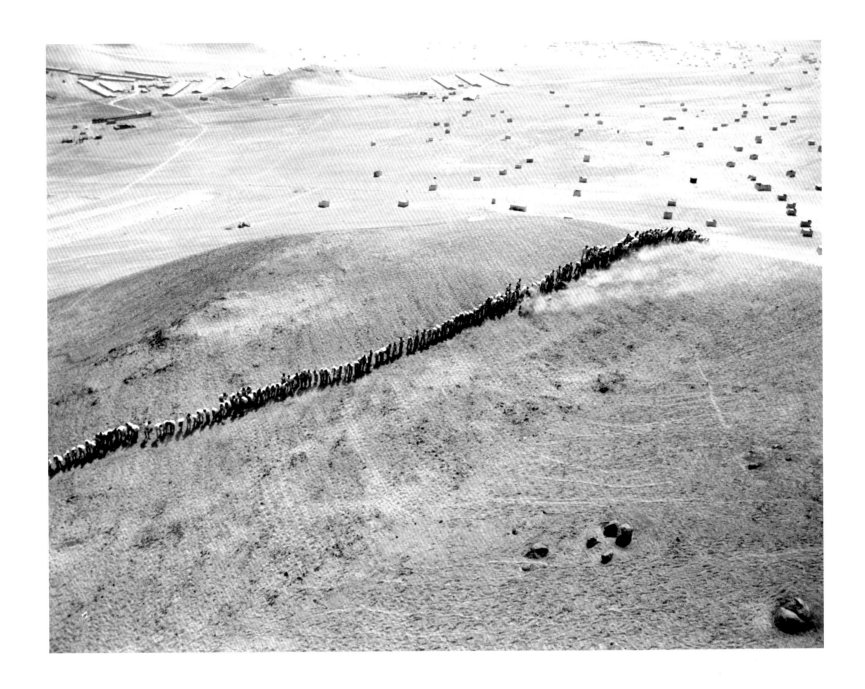

A STORY OF DECEPTION, 2003–06
IN COLLABORATION WITH RAFAEL ORTEGA
AND OLIVIER DEBROISE
16 MM FILM
4 MIN. 20 SEC
INSTALLATION, PORTIKUS, FRANKFURT, 2006

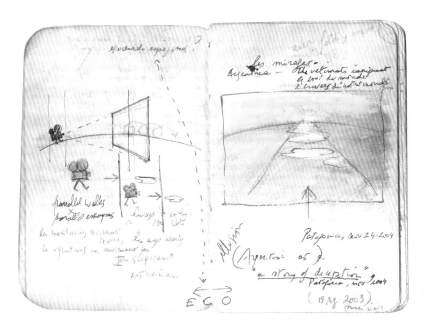

The language that I used at the time was directly borrowed from sign painters and their characters. The man in the suit was the main protagonist of those street advertisements. A lot of the situations that the paintings illustrated were echoes of actions that happened on the street but which had no reason to exist as a photo document. I called the sign painters, who ended up being the co-authors of those images, because the language they were using was the most direct and communicative I could think of. I was not a painter. I had no interest in style, and their iconography fitted my needs. Also, I try to make a clear distinction between what will be addressing the street and what will be directed to the gallery wall.

The sign painters' main skill lies in the aesthetic resolution of a visual plot or a situation. In the beginning I would give them quite resolved and elaborate images, but over time I began giving them just sketches. They would really be the ones proposing the way of communicating that situation at its maximum power.

FERGUSON: *Either the story or the image can work in your mind, or your collaborator's mind, or the viewer's mind, and generate some other event or image.*

ALŸS: Yes, it is always kind of bouncing or ricocheting.

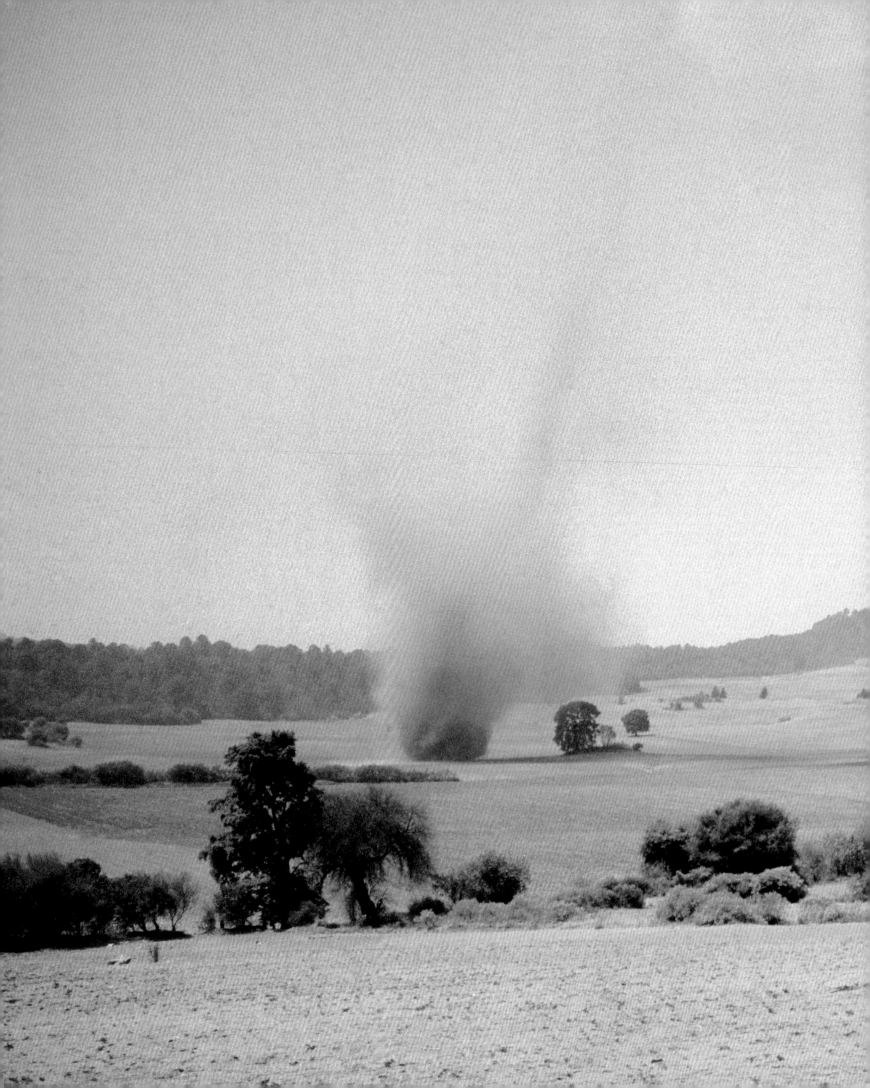

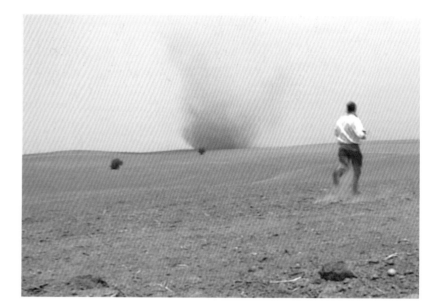

In the Eye of the Tempest

Every year since 2001, Francis Alÿs has eagerly awaited the month of March, the high point of the dry season, to drive his Volkswagen Beetle to the southeast edge of Mexico City, where smoky clouds rise from cornfields burning after harvest, and grey swirls of ash and sand loom against the horizon. Carrying his video camera, Alÿs runs towards these tornadoes, hoping to catch them as a surfer catches a wave. Upon reaching one, he penetrates its thick brown walls until he reaches the peaceful eye of the storm, intending to stay as long as possible inside the swirl. His nose and mouth protected by nothing more than a handkerchief, he films the monochromatic interior of the windy sanctuary, an indefinable colour field that ranges from violet to grey to yellow, before the aerodynamics of the whirl expel him back into the open. His sole purpose is to extract a few sublime instants from the entrails of this hostile metereological formation, to achieve a glimpse, as he puts it, of 'some kind of immediate, absolute present that reflects a society in which survival tactics elude any future further than the next rent to pay'.[1]

Alÿs's apparently absurd act forges a moment of bliss in the midst of chaos. As Don Quixote told Sancho Panza, 'Fortune doth address our affairs better than we ourselves could desire.'[2] What we usually see as an index of the growing ecological disaster around one of the biggest cities in the Third World – a form of pollution caused by a relatively archaic form of agriculture adding to the already greying skies of central Mexico – becomes an occasion for adventure. These are the things of which stories are made.

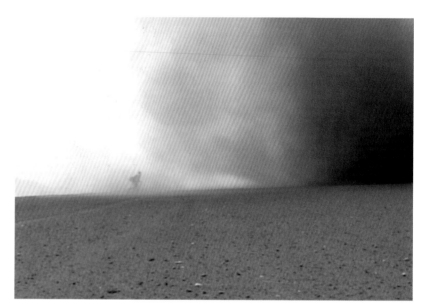

A Fable within a Fable

In the mid-1980s, Francis (Alÿs) de Smedt was living in Venice, writing a dissertation for a Doctorate in Urbanism at the Istituto di Architettura di Venezia. Reading historical accounts and documents, but above all closely studying the details of ancient paintings – from the famous *Allegory of Good Government* (1338-40) in the Palazzo Pubblico of Siena by Ambrogio Lorenzetti, to the Venetian city scenes painted by Gentile Bellini at the end of the fifteenth century – he intended to reconstruct the central processes involved in social control. One of

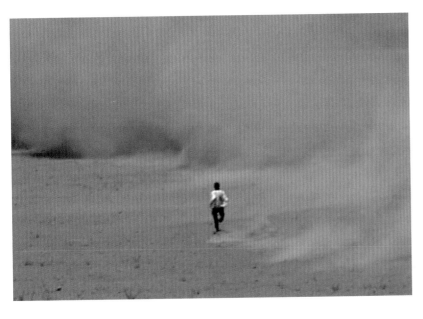
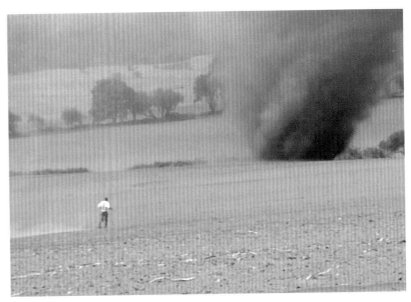
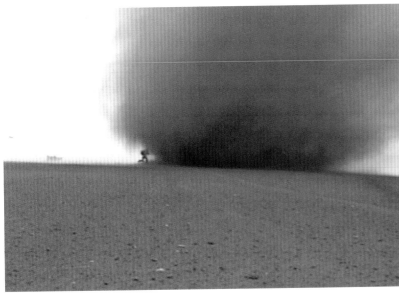
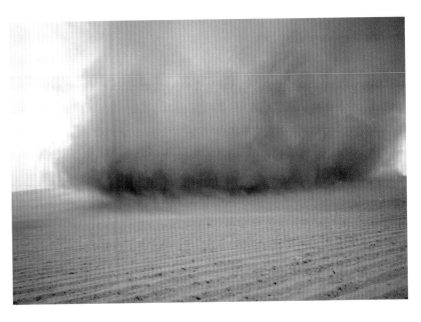

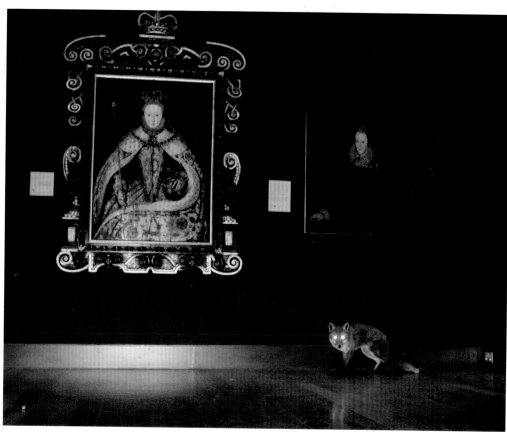

On the night of 7 April 2004, a fox was
freed in the National Portrait Gallery.
Its wanderings through the galleries
were recorded by the institution's
CCTV system.

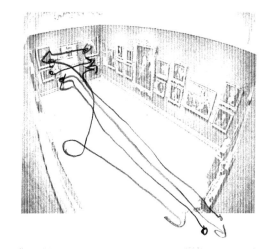

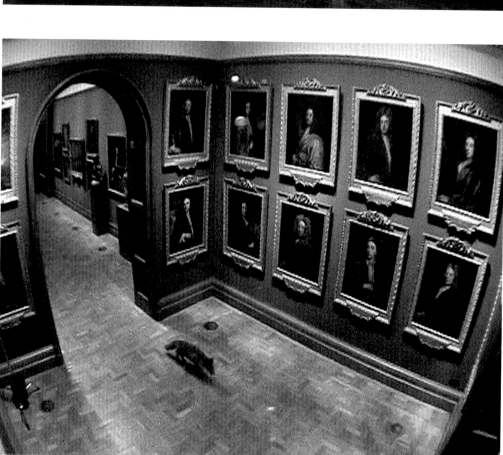

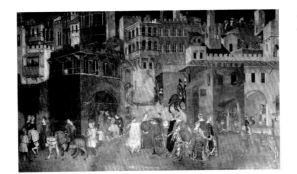

AMBROGIO LORENZETTI
GLI EFFETTI DEL BUONGOVERNO [DETAIL], C. 1348
FRESCO
SALA DEI NOVE, PALAZZO PUBBLICO, SIENA

these was the eradication of animals from early Renaissance cities – not only wild animals but also working ones – and their transformation into the 'leftovers of our society'.[3] This phenomenon had run in tandem with the first signs of the emergent modern era: the development of 'rational' scientific discourse, the colonization of the New World, the decay of medieval faith, the first notions of hygiene, and the development of perspective as a means to convey a mathematical and spatial world view.[4]

Alÿs came to conceive of animal life as a central index of the drive towards the transformation of the city from a concentration of historic practices to a space ruled by social administration and characterized by the pursuit of order and hygiene. For him, those misfits became a living metaphor for the forms of existence suppressed by the process of modernization. An important stage in the emergence of this way of thinking was a visit to the city of Palmanova around 1985, which offered him his first insight into how one might intervene in the imaginary of the city without assuming the role of the architect-master. Palmanova, the so-called 'star-shaped city', a town devised by the Republic of Venice in 1593 as an advanced military outpost against attacks by the Turks and the Austrians, is a remarkable example of an emergent baroque citadel that, from the sixteenth century onwards, was to become a prominent model of the new type of homogeneous and globally predetermined city with all its isolation and disenchantment.

Studying Palmanova, Alÿs was impressed by the desolation of this military and political utopia: 'When faced with this dysfunctional utopia, I could not think of any urbanistic, architectonic, nor artistic answer to shake off the apathy of the place. I could not convince myself that adding matter (an object, a sound or an architecture) to that site could in any sense alter its own inhabitants' perception or the outsider's. So my reaction was to try to affect its memory: I invented a fake episode that would have taken place at the heart of the place, hidden in the remote corners of its memory. Of course animals (as heroes of a recently negated era, the great misfits of the Renaissance imaginary and urbanism) became its protagonists. The format of the fable unfolded naturally as the only possible method of intervention.'[5]

With time, Alÿs turned this lesson into a leitmotiv that could be condensed into his succinct slogan: 'Whereas the highly rational societies of the Renaissance felt the need to create utopias, we of our modern times must create fables.'[6]

Lessons from the Rubble

In February 1986, after finishing his studies, De Smedt was drafted into national service. Disinclined to military life, he took the only possible escape: to join an aid project to regenerate Mixtec Indian towns in the southern Mexican state of Oaxaca. Although the

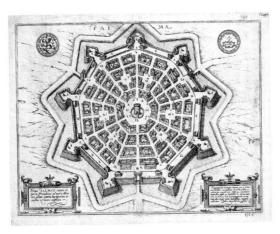

MAP OF PALMANOVA, ITALY, C. 1598

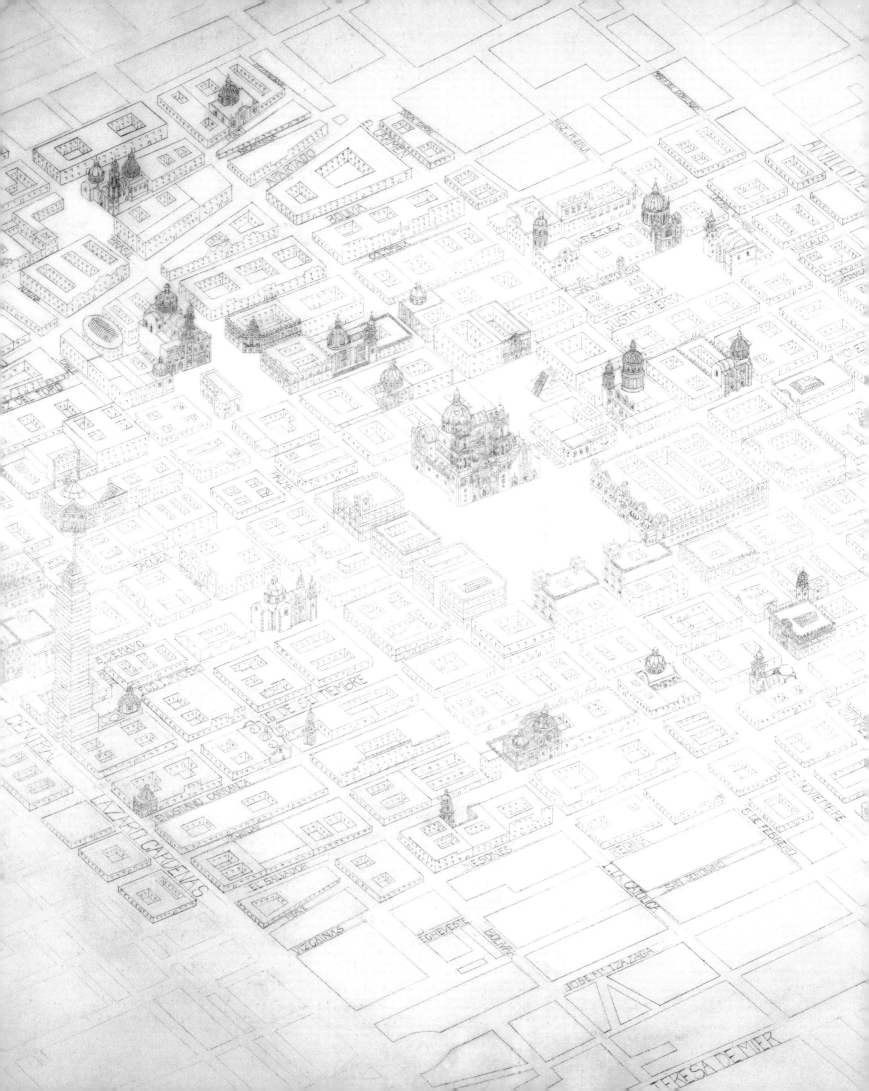

While walking around the centre
of Mexico City I placed pillows
in the frames of broken windows.

ANDRÉS GARAY NIETO
UNTITLED, 1985
BLACK AND WHITE PHOTOGRAPH

EARTHQUAKE DAMAGE ON THE EJE CENTRAL
LÁZARO CÁRDENAS IN MEXICO CITY

enterprise was relatively successful, it confirmed Alÿs's scepticism about the politics of urbanism, the cultural differences he experienced there underlining his distrust of the presumption of transforming other people's ways of living.

When legal problems forced him to stay in Mexico City, what started out as a temporary visit led to a permanent residency. He was not the only one who was trapped in the country's spider web; during those years a number of artists from England, Argentina, the United States and Cuba (including Melanie Smith, Thomas Glassford, José Bedia, Jimmie Durham) also found themselves living in Mexico and unable to leave. De Smedt's migration was marked by a change of both name and profession. He was still nominally in military service, so in order to avoid conflict with the Belgian authorities, he created a pseudonym. Thus 'Francis Alÿs' was born.

Very quickly, Alÿs fell under the allure of Mexico City. His fascination had nothing to do with the reasons foreign artists and intellectuals had traditionally gravitated to Mexico in the twentieth century; he was neither called by the dream of the southern revolutionary nor of the Indian utopia, and although he had used the country as a means to escape the army, he was not a political refugee as such. His eye was caught by a certain urban texture that fulfilled his questioning of the modern notion of city life, and by

the opportunity for creative experimentation that he found in the emerging artistic circles of the city. During the late 1980s and early 1990s, the improvisatory character of the local art world became a perfect setting in which to engage in his aesthetic self-training.

Even if Alÿs did not articulate it until years later, Mexico City stood as a sort of allegory for the failure of modernism. The city was undergoing a particularly critical moment in its history, but this crisis also opened up of a number of new possibilities. A year before Alÿs arrived, the megalopolis experienced a catastrophe. At 7:19 a.m. on 19 September 1985, Mexico City woke up to the worst earthquake of its history: a three-minute seismic event that registered 8.1 on the Richter scale. Like the student massacre of 1968, 1985 became a watershed in the history of the country. It symbolically toppled the last illusions of development, already seriously undermined by the 1976 and 1982 economic crises and the six-decade single-party rule of the Revolutionary Institutional Party (PRI). For a few weeks in September 1985, a spontaneous non-political revolution occurred in which ordinary people took control of the streets. Amid the ruins, thousands enjoyed a rare moment of collective autonomy. The ambivalence of those events (both murderous and liberatory) was to define the social and political climate of the following decades. These forces made living in Mexico City, where the

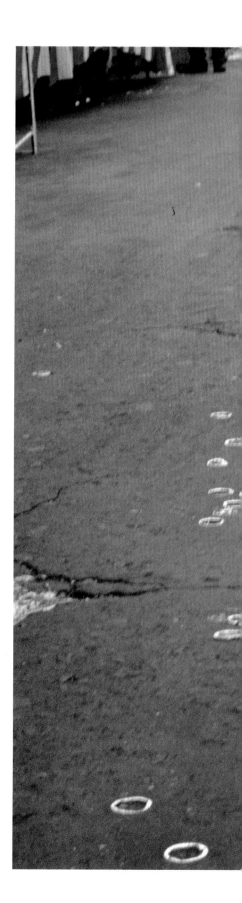

apocalyptic sight and rotten smell of the mountains of rubble combined with a widespread feeling of renewed social possibilities, a particularly intense experience. In the ensuing years any semblance of a central order in the city disappeared, turning a significant number of people into illegal street vendors and creating a parallel capitalist economy. Mexico City is one of the main forefronts of the strife between the neo-liberal modernization projects of the West and the diffuse but effective social resistance of entire populations who have taken control of the former space of colonial and national power as an arena for labour and survival. The 'deconstruction' of the city by the earthquake provoked a reconstruction of the vernacular, pre-modern neighbourhood, and the emergence of a non-administrative usage of the street. Interestingly to Alÿs, the city was densely populated by street dogs, animals that, unlike in Europe, had never been banished.

To Be Picked Up

Alÿs's early walks through Mexico City constituted an attempt literally to find a position: both a physical space and a form of activity. As a 'passer-by constantly trying to situate' himself in a 'moving environment',[7] he had left Europe both physically and symbolically – putting into brackets its modernist ideology of social hygiene, visual order, economic stability, architectonic harmony and cultural purity – to immerse himself in an unknown territory where he was conspicuously acting under the uncomfortable but sometimes convenient mask of 'foreigner'. In fact, it was impossible not to notice this very tall, slender,

white character strolling amidst the street markets in a densely populated, mixed-blood, Third-World city. With a camera Alÿs started recording what he saw in the streets – an array of pipes, old chairs, cord, bricks and buckets, for instance, used to reserve a parking space; an improvised plastic tent placed over an open sewage drain that functioned as street toilet; or the remarkable constructions that served as improvised canteens on the sidewalk. These structures and materials were examples of an endless bricolage, posed in direct confrontation with modern urban rationality, which spoke of parallel economies beneath the great ideological social systems. These 'street installations', as Alÿs called them, became his main visual referent. 'Street installations can be formal incidents – like a galaxy casually formed by hundreds of bottle taps stuck in the asphalt (*Milky Way*, 1995) – or more careful arrangements serving economical purposes – street-side commerce, storage, advertisements, etc. They can be directly connected to the urban structure – like the city drain converted into a toilet – or just be lying on sidewalks – displaced domestic items in search of a new function. What the street scene offers me is a whole range of situations and attitudes in which further developments are implied.'[8]

Sometime around 1989 Alÿs found his attention drawn to broken windows, many of them in houses abandoned after the earthquake. He placed pillows in these broken window frames, creating a place to dream fifteen metres above the street (*Placing Pillows*, 1990). This simple action was his first physical attempt to introduce a narrative dimension into the city fabric. With the utmost simplicity, he had both

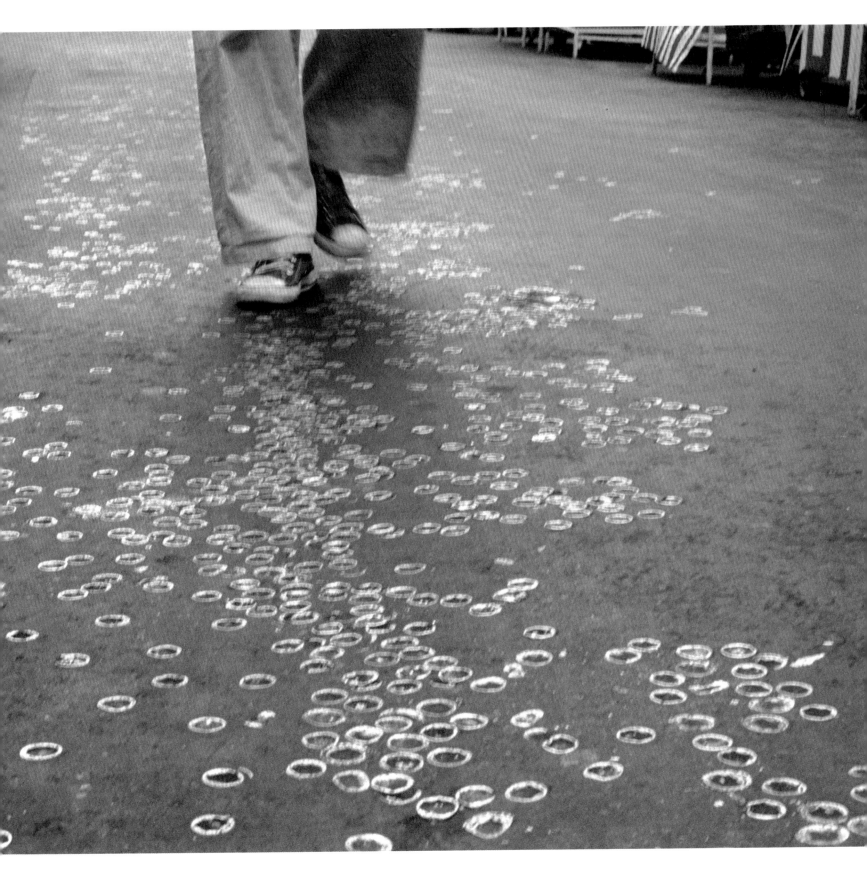

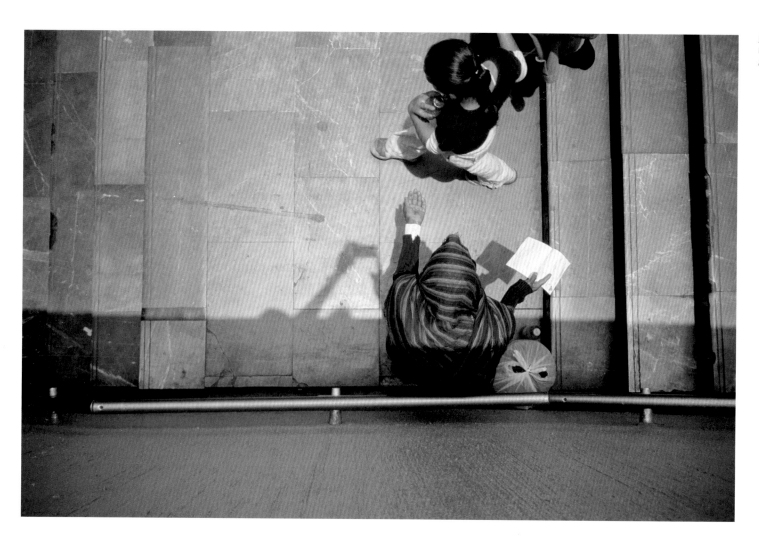

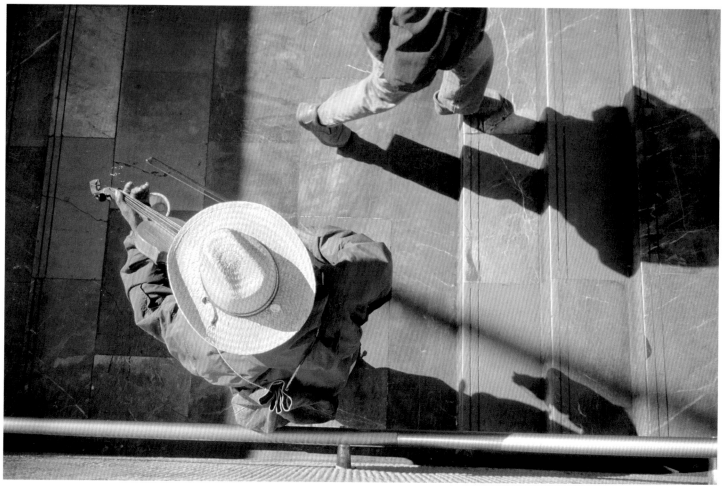

THE ARTIST AT MEL'S CAFÉ, MEXICO CITY, 1991

POSTCARD OF MEXICO CITY
FROM THE ARTIST'S ARCHIVE

preserved and covered the gap left by the broken glass in order to turn it into a place where the street and the domestic space intersect, a space for rest and a space for circulation, a bridge between somewhere and nowhere. In the meantime, *Placing Pillows* taught Alÿs how to turn his walks into sculptural operations.

The subtlety of those early street interventions was characteristic of a milieu born of a remarkably disenfranchized cultural practice. The main advantage that could be enjoyed by people like Alÿs in joining the emerging artistic network developing in Mexico City at the end of the 1980s was that it was as de-regulated as the activities of the illegal vendors on the streets. Venues like the Salón des Azteques (an independent art space run by artist and impresario Aldo Flores), Mel's Café (a Sunday restaurant started by Alÿs and artist Melanie Smith around 1990) and the impromptu curatorial projects of people like Guillermo Santamarina, Rubén Valencia or Maria Guerra were all defined by their belief in the polymorphic productivity of amateurism. No precondition of artistic stature, nationality, ideology or training was required; one could become an artist overnight. The lack of a market and the relatively low interest that audiences, journalists and academics showed in emergent artistic practices proved useful in the long term for nurturing forms of art directly linked with social critique and first-hand experience.

For Alÿs, research and imagination, representation and intervention became part of his movement through the city.

Over the years, Alÿs was to develop an archive of images that lay between the nineteenth-century genre of Costumbrista works (the famous lithographs of Mexico City characters by Claudio Linati or the drawings of Lima types by self-taught Peruvian artist Pancho Fierro) and the Neue Sachlichkeit (New Objectivity) photographic project that included August Sander's visual census of the German population in the 1920s and 1930s. Along with his compilation of the periphery still lifes, spontaneous sculptures and street installations he had encountered in Mexico City, Alÿs began a record of the social situations and people who use the street as a temporary shelter. *Ambulantes* (1992-present) shows peddlers pushing their trolleys full of commodities or immense bundles of garbage through squares and avenues; *Sleepers* (1999-present) features people and dogs lying on the streets; and *Beggars* (2000-present) depicts the ever-present panhandlers who expose their misery on the steps of the subway. In these works Alÿs has focused on uses of the street that contradict the strict separation of public and private space. Over the years he was to add further photographic series documenting other symbols of transit: a catalogue of the images of the green 'walk' men used in traffic lights around the

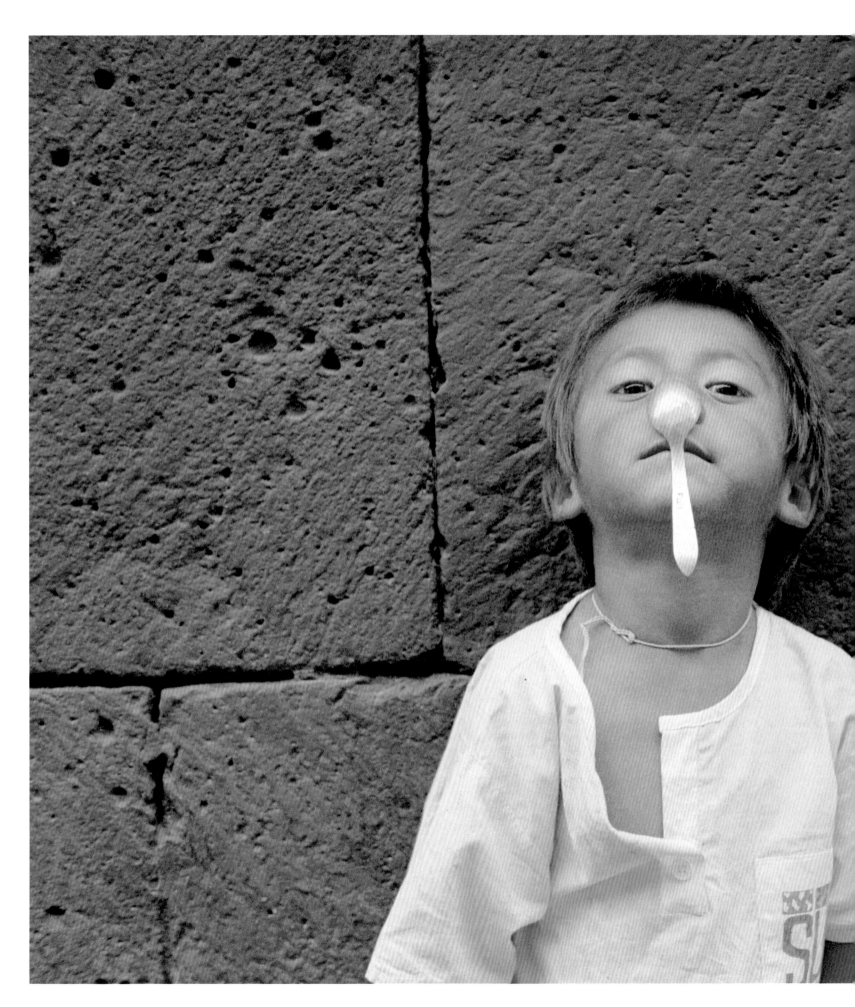

MEXICO CITY, 1991
COLOUR PHOTOGRAPH

world – surprisingly diverse, despite their conventional nature – or the quasi-pictorial arrangements to be found in the patterns of chewing gum stuck under bar tables or on walls and trees (*Untitled [Zicte/Chewing Gum]*, 1994-97).

The pursuit of such chance encounters was bound to become a matrix for performance. Alÿs began to turn his walks into conceptual games. In one work, for example, he looked for another pedestrian who vaguely resembled him (and who could have thus been him) and followed him like a shadow. These works (*Doppelgänger*, 1999) have a quasi-paranoid edge, as if the artist wanted to become his own persecutor. There are similarities between these actions and Vito Acconci's *Following Piece* (1969, part of his *Street Works* series), in which for twenty-three days Acconci followed different people in the street until they disappeared inside a building. The *Doppelgänger* series, however, is less about accepting somebody else's lead than about trying to put oneself in the mental landscape of a foreign place through surrogate means. In the artist's own words: 'I am usually trying to assimilate cities, and because I never really belong to them, I try to invent myself a role. I attempt to insert myself as another character to gain some kind of identity in a new neighbourhood.'[9]

Yet at times foreignness can also become a form of integration. In the early 1990s, Alÿs photographed himself wearing green shades and reclining against the railings of Mexico City Cathedral, a place where plumbers, electricians, carpenters, locksmiths, housepainters and any number of other tradesmen tout for business. A hand-painted sign lies at his feet, inscribed with the word 'turista' (tourist). This portrait (*Turista*, 1994) stands as a marker of identity; Alÿs pretends to have been absorbed by the downtown area of Mexico City to the point of becoming just another of its workers. As will be seen later, this conflation of the worlds of leisure and work suggests the degree to which his own wanderings as a visitor had become a way of life.

Moving Tales

'In my city everything is temporary', Alÿs has stated, meaning that his sculptural ideas are based on fleeting social and material occurrences. Works derived from walks, such as *Placing Pillows*, activated the street as a stage of displaced objects, suggesting the way in which people and activities are loosely connected in social composites. Alÿs advanced a mode of sculpture that dwelt in the encounter and articulation of objects and bodies, producing images that depended on the faintest possible material relation between things. For *Mexico City* (1991), he invited a child on the street to balance a spoon on the tip of his nose. The resulting photograph clearly represents a conception of sculpture made of moments of contact, attraction, friction and collision between objects and social formations. Throughout these works, Alÿs rejected both the authority of the notion of social and industrial design and the symbolic weight of sculpture understood as a permanent material erection above the ground. Instead of the ideology of construction, he explored physical and social connections that glowed like a magnetic field. Rather than dwelling on social and mental structures, he was inclined to investigate the cracks in the urban narrative.

Between 1990 and 1991, Alÿs devised the idea of staging a walking fable. His proposal had a certain homeopathic character, the hope of applying 'the hair

When arriving in a new city, wander,
looking for someone who could be you.
If the meeting happens, walk behind your
doppelgänger until your pace adjusts to
his/hers. If not, repeat the quest in
the next city.

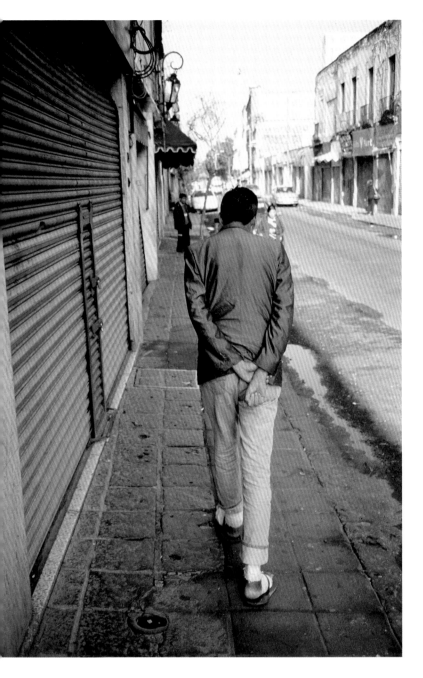

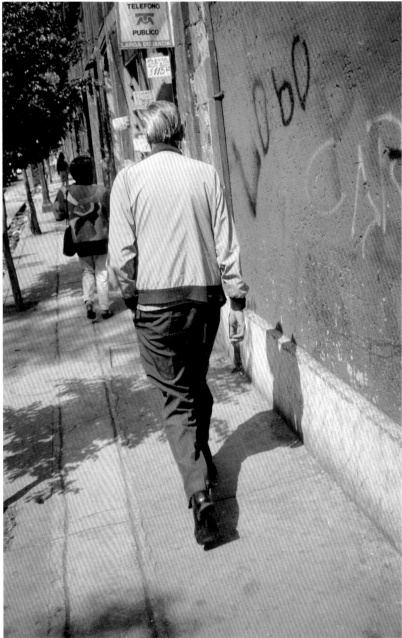

When arriving in a new city, wander,
looking for someone who could be you.
If the meeting happens, walk behind your
doppelgänger until your pace adjusts to
his/hers. If not, repeat the quest in
the next city.

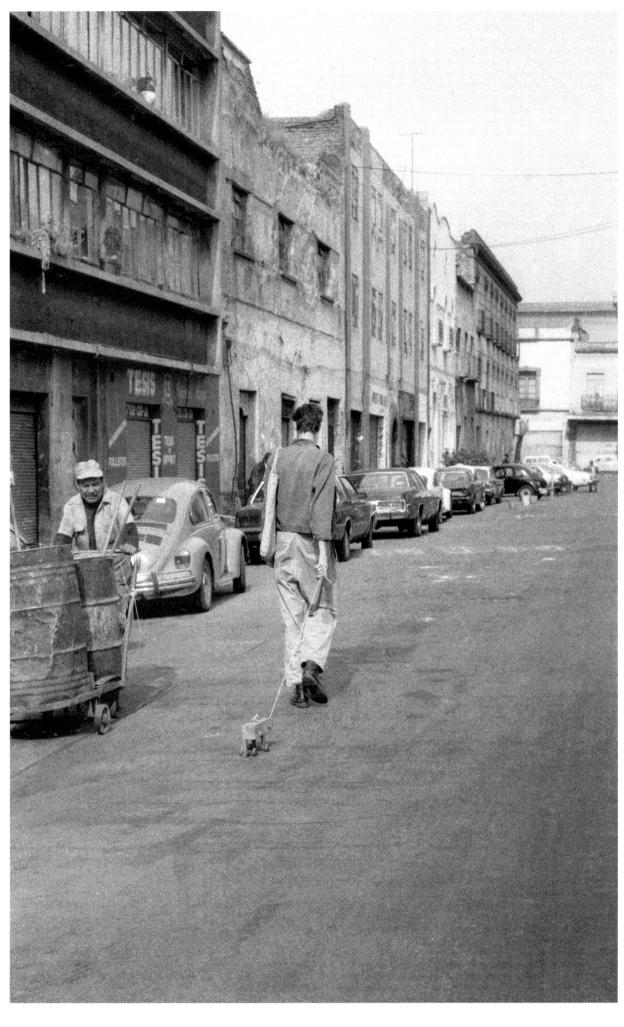

For an indeterminate period of time, the magnetized collector takes a daily walk through the streets and gradually builds up a coat made of any metallic residue lying in its path. This process goes on until the collector is completely covered by its trophies.

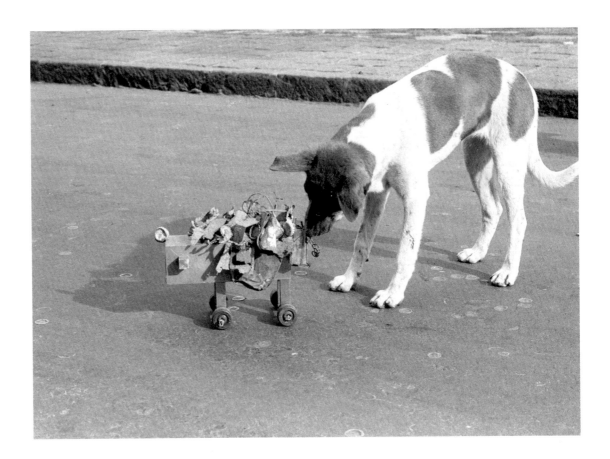

of the dog' to the urban malaise. He imagined the need for staging a return of the 'animal hero' (the urban parasite) to the centre of the polis. If the pursuit of modern utopias had banished animals, he felt the need to reinsert them metaphorically in the guise of an animated object able to gather leftovers, an animal collecting 'personal losses'.[10] This is how *The Collector* (1990-92) entered the scene.

The story of this project is significant in that it shaped the methodology of collaboration that Alÿs was to develop in the following years. After producing a number of wooden and metal models in 1990, during the summer of 1991 he started working with the small industrial workshop of Felipe Sanabria to produce a magnetic animal to be pulled through the streets like a child's toy. The wheeled magnet would attract all the scraps of metal lying in its path until they formed a coat of residue. Despite its simplicity, the project underwent a series of mutations. In the beginning, this 'urban toy' was to be an experimental application of what Alÿs called 'visible science'. But after several failed attempts to infuse a 'magnetic memory' in the metal object by means of an electric current, he finally filled the object with lodestone to ensure a permanent magnetic field. Finally, in the winter of 1991-92 he took *The Collector* on to the streets and walked with it until the prototype was entirely covered with a thick, rusty skin of crooked nails, bits of wire, bottle caps and scraps of metal.[11]

The Collector defined for Alÿs a whole new modus operandi. With this work he self-consciously confirmed walking as his main strategy of intervening in the urban space – exploring social narratives and institutions – and of settling accounts with the history of art. In understanding his actions as 'fables', Alÿs took the decision not to turn his strolls into performance art nor, indeed, any other established genre (painting, sculpture, architecture), instead inventing a creative matrix (and a new poetics) that, through a sense of affinity, develops into a self-evolving spiral of further interventions. His *dérives* were actions/fictions evolving into a series of variations and reverberations. For more than a decade since, Alÿs has lent his body and mind to the development of a new art of storytelling, an objective narrative that, whether recorded by a camera or disseminated through flyers or postcards, strove to remain in the viewer's mind as episodes of a new (though modest) brand of mythology.

One of the earliest and most poetic of those walks may be read as a reversal of the accumulation process employed in *The Collector* but also as an apt variation on the myth of Ariadne or the story of Hansel and Gretel. In *Fairy Tales* (1995) Alÿs perambulated the streets while unravelling the yarn of his sweater, leaving behind a thread that became both a trace and an urban drawing. In May 1994, he expanded the metaphor of his magnetic animal when he wore a pair

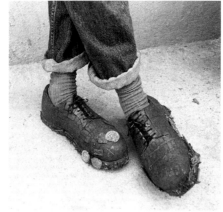

of *Zapatos Magneticos (Magnetic Shoes)* to walk through the streets of Havana during its fifth Biennial. The magic of those shoes was a symbol of recycling and survival, as well as a meditation on the allure of objects and commodities during the so-called 'special period' of Cuba's socialism-of-one-island system, in which materials were scarce. On that occasion Alÿs took a step further away from the traditional exhibition venue by displaying and producing the documentation of the event during the walk itself. While strolling in his shoes he wore a sandwich board, on which he gathered evidence of the action, from Polaroid photographs to route maps and any number of souvenirs picked up along the way.

Like traditional fables, most of Alÿs's walks have a subtle but nonetheless seductive moral; they tend to assume an Aesopian role as social and political satire. In the several versions of *The Leak* (1995), for instance, he took painting for a walk. Carrying a can of paint from which the pigment trickled through a

hole in its bottom, he set out from a gallery and wandered the meandering streets of the city, producing a kind of Jackson Pollock along the way, and finally returned to the exhibition space. If such a path symbolically indicates that his walks are not attempts to escape the artistic and commercial circuit as such, *The Leak* can also be seen as a variation on *Fairy Tales*. At the end of the day, it is a parable of the way in which artistic 'production' is made of loss.

Critique of the Flâneur

With his promenades Alÿs entered a long genealogy of practices that employ the artist's legs to intervene in the social and symbolic imaginary and to assert the right of the citizens to a social space devised for human beings, not for their machinery, traffic and policing systems. Whether because marching became the mode of mass politics in the twentieth century – the theme of Giuseppe Pellizza da Volpedo's *Quarto*

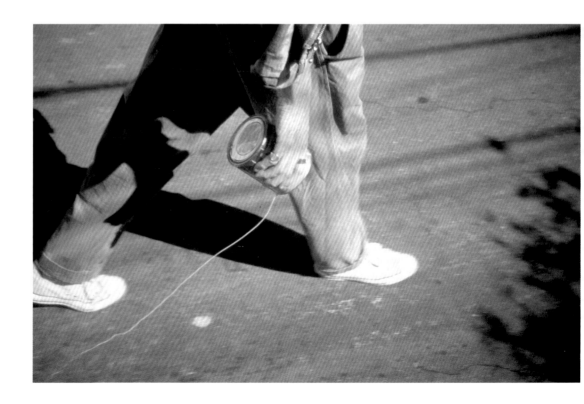

right and below,
THE LEAK, 1995
PHOTOGRAPHIC DOCUMENTATION
OF AN ACTION, SÃO PAULO

Having left the gallery, the
artist wanders through the
neighbourhood carrying a
leaking can of paint. His
dripping action ends when,
finding his way back to the
gallery thanks to the paint
marks, he hangs the empty
can on the wall of the
exhibition space.

NARCOTOURISM / KBH 5-11 MAY 1996

I will walk in the city* over the course of seven days, under the influence of a different drug** each day. My trip will be recorded through photographs, notes, and any other media that become relevant.

#the project is about being physically present in a place , while mentally elsewhere.

* *dosage:drugs were consumed in order to maintain a continuous effect for 14 h.a day.

May 5 ..Spirits (I)

May 6 ..Hashish (2)

May 7 ..Speed (3)

May 8 ..Heroin (4)

May 9 ..Cocaine (5)

May 10 ..Valium (6)

May 11 ..Ecstasy (7)

(8)

(I) Spirits.(due to practical problems in finding the stuff,I decide to start with local liquors and alcohol).Difficulties in connecting mentally with my physical state. Inner resistance. Inability to trust my reflexes or sight. I walk clumsily among many strange occurences.

(2) Hashish. Slow motion. Awareness of every muscle in action. Everything is enormously funny. Soundless speech. Walking with my eyes closed. A pastrami sandwich tastes heavenly.

(3) Speed. Deambulatory paranoia. Cold feet. I fear the signs of my own presence, and avoid encounters on the street. As I walk, I always keep a familiar spot in sight.

(4) Heroin. Feeling of inner warmth which helps me break the ice and feel attuned to the place. A sequence of frozen images as I walk along the Danube. The effects fade fast, but they return at the end of the day. Difficulty breathing at night.

(5) Cocaine. Awareness of a change of state, but not followed by a visual echo. Auditory acuity enhanced. Appetite gone Smoking diminished. At night, nausea and thirst.

(6) Valium. Weatiness. Aesthenia. Indifference to context. Regular smoking. Frequent pissing and occasional vomiting. While walking, bittersweet memories pop up at regular intervals.

(7) Ecstasy. Visual brightening and erotic impulses. My shoes move and I feel the urge to walk out. Everything I turn to moves, not physically but conceptually. I feel like the epicenter of the world.

(8)The journey was followed by a period of depression. I understood it but could not help sinking into it.

THE NAKED CITY
ILLUSTRATION DE L'HYPOTHÈSE DES PLAQUES
TOURNANTES EN PSYCHOGÉOGRAPHIQUE

GUY DEBORD
THE NAKED CITY, 1957
COLOUR PSYCHOGEOGRAPHIC
MAP ON PAPER
33 X 48 CM

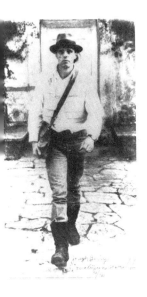

JOSEPH BEUYS
LA RIVOLUZIONE SIAMO NOI,
1972
DIAZOTYPE AND RUBBER
STAMP ON POLYESTER,
COMPOSITION AND SHEET
192 X 101 CM
COLLECTION, THE MUSEUM OF
MODERN ART, NEW YORK

Stato (1898-1901) and Joseph Beuys' *La Rivoluzione Siamo Noi* (1972) – or due to the search for new modes of visuality and mobility, walking has been one of the foremost catalysts of the modern imagination. Alÿs's political and poetical explorations of the city have frequently led to associations with two such strategies: the contemplative perambulations of the *flâneur*, as defined by Charles Baudelaire and Walter Benjamin, and the psychogeographic *dérive* practised by the members of the Situationist International.

If walking has become so central in art and politics, it is due to the way in which it goes against the grain of the social, physical and psychic development of modern capitalism. While industrial means of transport threaten to make our limbs and our senses obsolete – confining daily life to an oscillation between jobs, media indulgence and shopping – walking persists in defining human life as a matter of territorial and political activity. However, it would be entirely mistaken to subsume this remaining space of freedom into a flat or homogeneous practice. The way in which walking interlocks with living and thinking actually opens up a polemical field of alternatives.

In many ways, and despite common assumptions, acts like Alÿs's walks can be discussed as a critique of the Baudelairean and Surrealist *flâneur*. Despite the fact that he opted to ramble in the midst of one of the largest urban concentrations on the planet, Alÿs's actions are not a form of social voyeurism because, among other reasons, they call attention both to the acts of the stroller and to his interference with his surroundings, rather than to the mere social scenery. In fact, one of his most significant walks was aimed at distracting his sensibility from the 'civilized' living conditions of Copenhagen, which he saw as a veritable caricature of European bourgeois values. Intending to be 'physically present in a place, while mentally elsewhere', in May 1996 Alÿs drifted through that city for seven days, each of them under the influence of a different psychotropic drug. Rather than a mere experiment in intoxication, *Narcotourism* (1996) allowed Alÿs to point out his distance from the expectations of regulation and self-control in the developed world.

On the other hand, according to Baudelaire the *flâneur* is above all a spectator of modern mores and actions, someone who plunges himself into the midst of the crowd to absorb the magnificence of modernity, while cherishing his anonymity as a means of perfecting his voyeurism. His pleasure lies in

looking while avoiding the gaze of others for the sake of preserving the spectacle. He displaces his connoisseurship and eroticism – in a word, his fetishism – on to the beauty in the street. The views that the *flâneur* extracts from daily life are, of course, the fruits of his estrangement. 'His passion and profession is to marry the crowd. For the perfect wanderer, for the impassioned observer, it is an immense pleasure to find dwelling in the multitude, the shifting, in the movement, the fugitive and infinite. An observer is a prince who is everywhere in possession of his incognito. Life's lover makes his family of the world, the same way the fair sex lover composes it with all the beauties found, to be found or impossible to find, and the same way the art lover lives in the midst of an enchanted society of dreams painted on canvas.'[12]

As Benjamin argues, the *flâneur*'s task consists in 'botanizing on the asphalt',[13] gathering dead samples of life from the marketplace and the street, as if intending artistically to ameliorate the shock provoked by the brutal experience of living in the emerging metropolis. Small surprise that Benjamin compares the experiences recorded by the *flâneur* to 'the isolated "experiences" of the worker at his machine'.[14] The amusement of the *flâneur* is as fragmented as modern work, and above all it is to a great extent a means of adaptation to modernization rather than a questioning of its pace and direction.

Alÿs's rapport with the cityscape is not a compilation of typical characters but a research into (and an amplification of) those alternative moments that oppose the rationale of city planning and the understanding of modernization as social engineering. No doubt these concerns were not foreign to the Situationist International's critique of urbanism as the 'capitalist domestication of space'.[15] Since the mid-1950s a random and transient drifting (the *dérive*) that traverses the different psychogeographical ambiences of the city[16] was seen by the Situationists as the first step towards the development of a 'Unitary Urbanism'. This involved the construction of situations and 'participatory games' that would create a new social space in which to redress the increasing alienation of the inhabitants of the modern city.[17] The Situationists never thought of their *dérives* as specific artworks but as the founding experience of a new kind of architecture and urbanism that understood the city as a 'continuous *dérive* based on complete disorientation'.[18] Thus, even if they left some record of their *dérives*, it was simply meant to document a

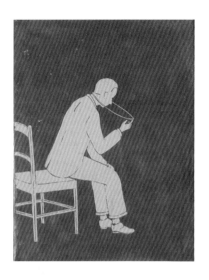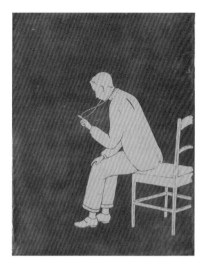

'gathering of ambiences' (both physical and psychical) as experienced by a handful of explorers.[19]

Alÿs's approach is not a programme to forge a new type of urbanism. Instead, it is better understood as part of the plurality of what sociologist Michel de Certeau called 'urban practices', the manifold social activities that directly oppose the regimentation of the city 'founded by utopian and urbanistic discourse'. From the beginning, Alÿs walked to criticize and even disturb the homogeneous, synchronic, universal and classified notion of urban space, as projected by an ideal spectator who conceives urban planning from above. Instead, his horizontal narratives, his attempt to disrupt the social grid by introducing new urban parasites, correspond to what Certeau calls 'the Concept-city', which is 'simultaneously the machinery and the hero of modernity'. Alÿs's walks were conceived on the assumption that they would be read, thought, seen, imagined and retold by others, and that their agency would depend on their dissemination as stories. 'The invention of a language goes together with the invention of a city. Each of my interventions is another fragment of the story I am inventing, of the city that I am mapping. In my city everything is temporary.'[20] This is similar to what Certeau had envisioned when suggesting that 'Physical moving about has the itinerant function of yesterday's or today's "superstitions". Travel (like walking) is a substitute for the legends that used to open up space to something different.'[21]

The notion of travelling as an escape from an apparently locked situation can be epitomized by Alÿs's contribution to the San Diego and Tijuana public art festival InSite 97. At a time of a particularly stringent prosecution of 'illegal aliens' from Mexico living in the United States, Alÿs physically circumvented the border by systematically travelling south from Tijuana until he had circumnavigated the globe in twenty-nine days. *The Loop* (1997) showed the extent to which his narrative actions could work as a means of both social and artistic critique. A trip that began as 'a vain arty joke' (to the extent that the artist blew the

production money on a vacation) eventually became 'a sentimental quest for redemption'.[22] However, this escapade was not an indulgent one. Confronted with the universality of anonymous airports, cheap hotels and banal Kodak beauty spots, unable to 'read the local codes', Alÿs found that his trip became a first-hand exposure to life pasteurized by the advance of globalization. Writing from Shanghai, Alÿs remarked, 'Hardly any dogs around. The few I saw are discreetly being walked late at night. Most have been killed during a cleansing of the city. They are the advance victims before a three year plan of "modernization" of the whole downtown area. After a methodical packing ceremony, the morning's next ritual is the quest for coffee.'[23] Alÿs took the self-sufficiency of the wish to travel (the essence of contemporary tourism) to a logical extreme in which (as critic Olivier Debroise has written) 'the trip has no other goal than the trip, a state of consciousness.'[24] It is due to this purity that the action embodies the notion of the artist as a social and cultural wanderer – in other words, the artist as the witness of a shrinking world.

Why Painting?

Painting and image-making have been complementary to the enactment of Alÿs's street fables. The works of artists from the Italian *trecento* and *quattrocento* such as Fra Angelico, the Bellinis and Ambrogio Lorenzetti, and particularly the small scenes featured on *predella* – the little paintings at the base of an altarpiece – helped develop his sensibility to the microscopic anecdotes of urban living. Christian imagery (and in particular paintings about holy miracles) shaped his understanding of the symbolic repertoire of the human body. Alÿs's interest in painting has little to do with questions of historical progression; in fact, it is mostly alien to modernist assumptions about the art of painting as a self-absorbed and autonomous practice. For Alÿs, the pictorial field is above all the surface for an apparition of images, bound to different forms of circulation and displacement, and involved in a number of social and economic relationships.

SET THEORY, 1996
IN COLLABORATION WITH
EMILIO RIVERA
DIPTYCH
ENAMEL ON METAL SHEET
EACH 160 X 110 CM

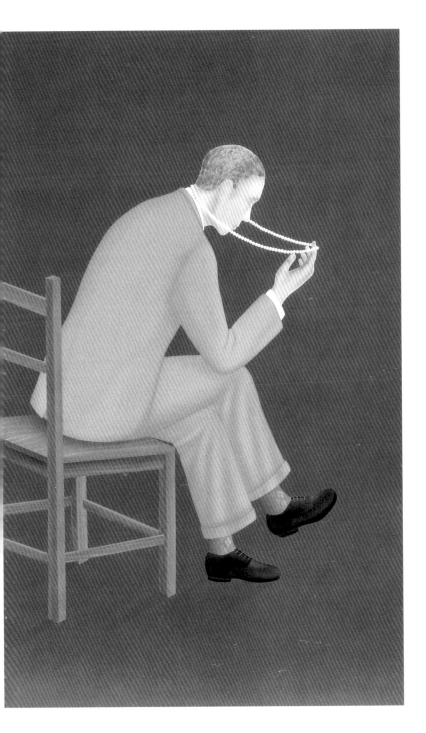
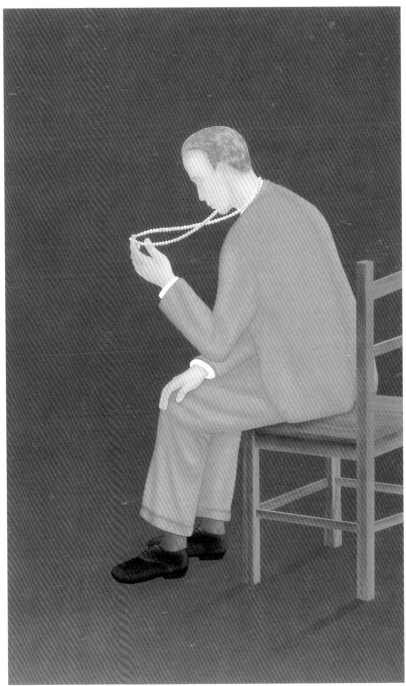

SET THEORY, 1996
IN COLLABORATION WITH
JUAN GARCIA
DIPTYCH
ENAMEL ON METAL SHEET
EACH 140 x 110 CM

JUAN GARCIA (right) IN A SIGN-
PAINTING STUDIO, MEXICO CITY

In the spring of 1993 I tried to break down my working methods and sculptural obsessions with a string of figurative scenes illustrating my interventions on the streets of Mexico City. Moving from sketches on paper to small canvases, I would combine a man in a suit with a piece of furniture or some other object, subjecting his body to a range of physically feasible arrangements of weight, balance and so on. The style of these paintings – and their male protagonist – was directly

orrowed from the painted metal street advertisements
encountered in the Centro Histórico, which impressed
e with the communicative power of their iconography.

y the summer of 1993 I had completed a first body of
aintings, and the temptation grew to return the images
o the people who had inspired them. I commissioned
arious sign painters to produce enlarged copies of my
riginals. Once several versions had been completed,

I produced a new 'model' that incorporated the most
significant elements of each painter's interpretation.

This compiled image was in turn used as the basis for
a new generation of copies made by sign painters, and
so on, ad infinitum, according to market demand. The
underlying intention behind this collaborative process
was to work against the idea of a painting as a unique
object and to reduce its market value by producing an

open edition of images while maintaining copyright on
each of them. As time went on, the elaboration of the
originals became increasingly influenced by the
prospect of the upcoming collaboration, and as mutual
dependency grew, considerations about authorship
arose. Further blurring the line between the model, the
copy and the copy of the copy, I began copying my own
models under the influence of the subsequent versions.

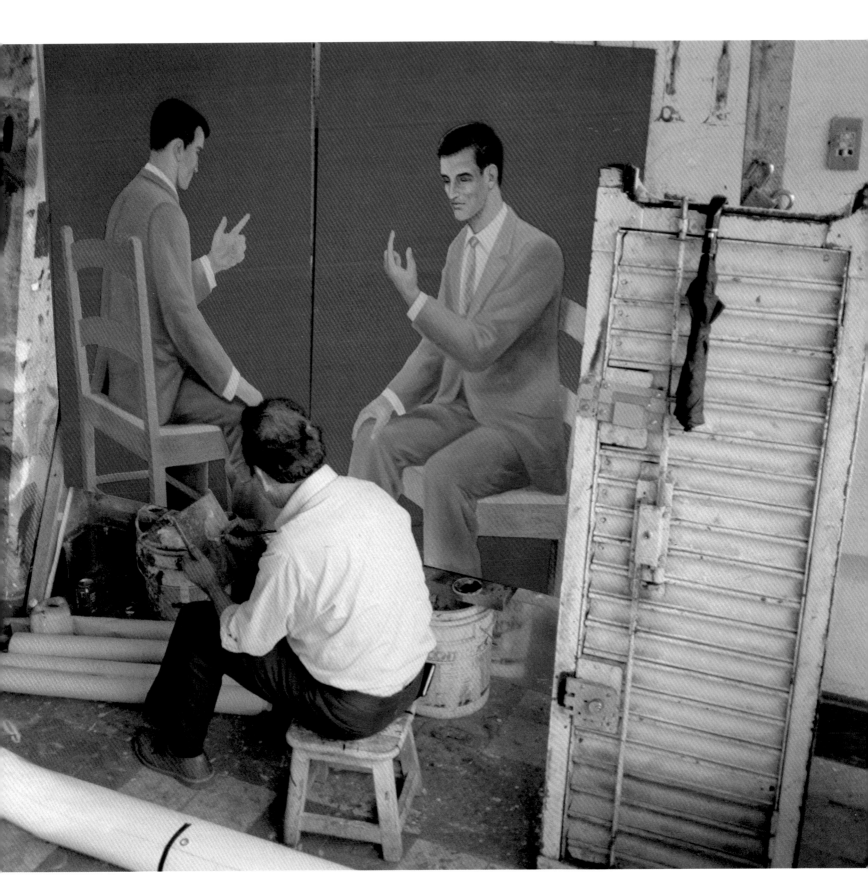

The canvas is for him an everyday artefact (a portable inner space) that is constantly interacting with its surroundings.

Thus, beginning with his early exercises in the medium in the late 1980s, Alÿs has played with the objecthood of painting, refusing to conceive of it as pure form. With his images of intriguing situations involving animals and domestic spaces, he produced objects that were halfway between sculptures, installations and paintings – canvas bent or rolled to reveal the stretcher and the painted wall behind it, or veiled with bubble-wrap to add an evocative, tactile quality. Almost paintings and almost sculptures, their seductiveness relied to a great extent on the precariousness with which Alÿs approached the issues of the artistic medium – a simplicity at that time related to his lack of technical mastery, to be sure, but which already suggested a graceful scepticism regarding the medium that has remained a feature of his work for almost two decades. As curator Kitty Scott once elegantly argued, 'Much of Alÿs's work eludes the medium it employs.'[25]

This avoidance of formalistic or disciplinary commitment was related not to a longing for a subcultural or raw authenticity but to a concern with the social location of art. Once he had started to work as a visual artist, Alÿs found himself concerned by a central paradox of contemporary art: the more art became enmeshed in everyday experience, refusing any attachment to specific media, the more esoteric it became for the majority of the audience. While the images and references of his art were in the street, his early installations and walks were unreadable except to the small circle of those 'in the know'. Once again, the street provided Alÿs with an answer to this conundrum. Wandering about downtown Mexico City in the early 1990s, he was struck by the widespread use of hand-painted signs to identify shops and workshops. Unlike in the industrial world, sign painters in Mexican society still had a significant role in the society, producing street advertisements, banners with political slogans and portraits of leaders and presidents that were prominently displayed at official rallies. Alÿs came to recognize that, in contrast to contemporary art, the language and media of the sign painter still constituted a social lingua franca equally able to transmit information, seduction, demagogy and illusion. In Mexico City, as in other parts of the Third World, painting was not only a fine art. It was still an essential means of social communication.

Early in 1993 Alÿs started to collaborate with the authors of those street paintings in developing a circuit of artistic production. Borrowing the smartly dressed characters depicted in the signs for tuxedo-rental establishments and tailor shops, along with their communicative style, Alÿs depicted his 'sculpture ideas' on small canvases that usually portrayed a lone man, an archetype of the modern

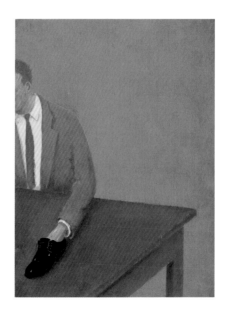

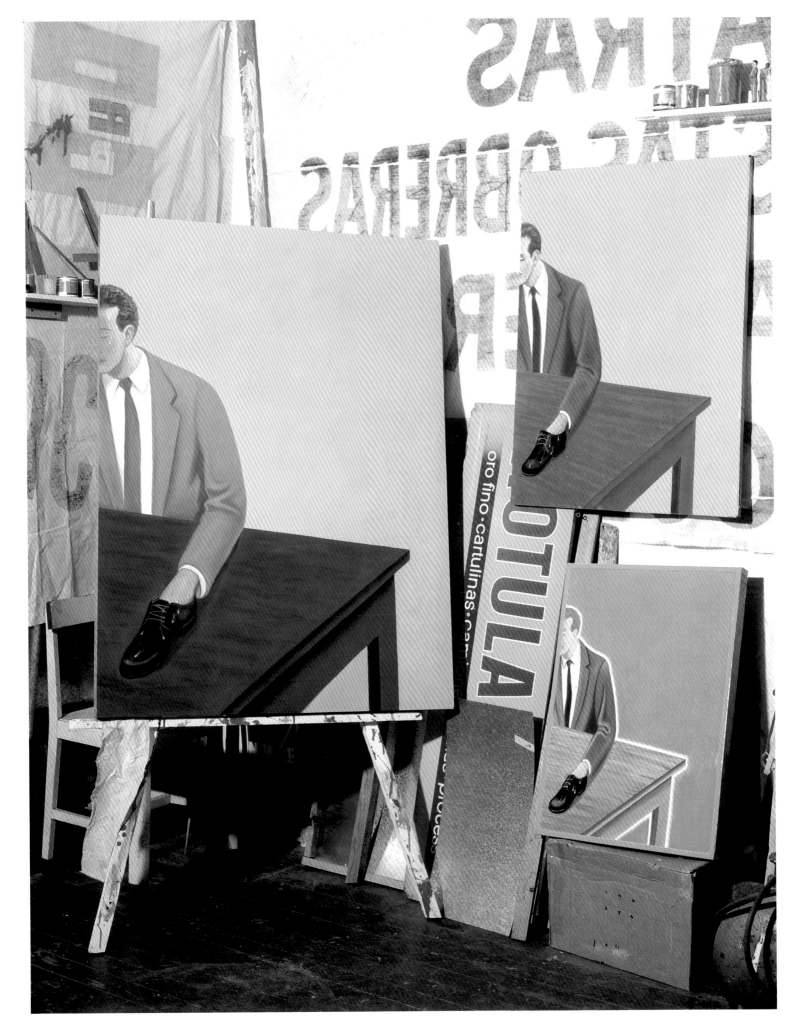

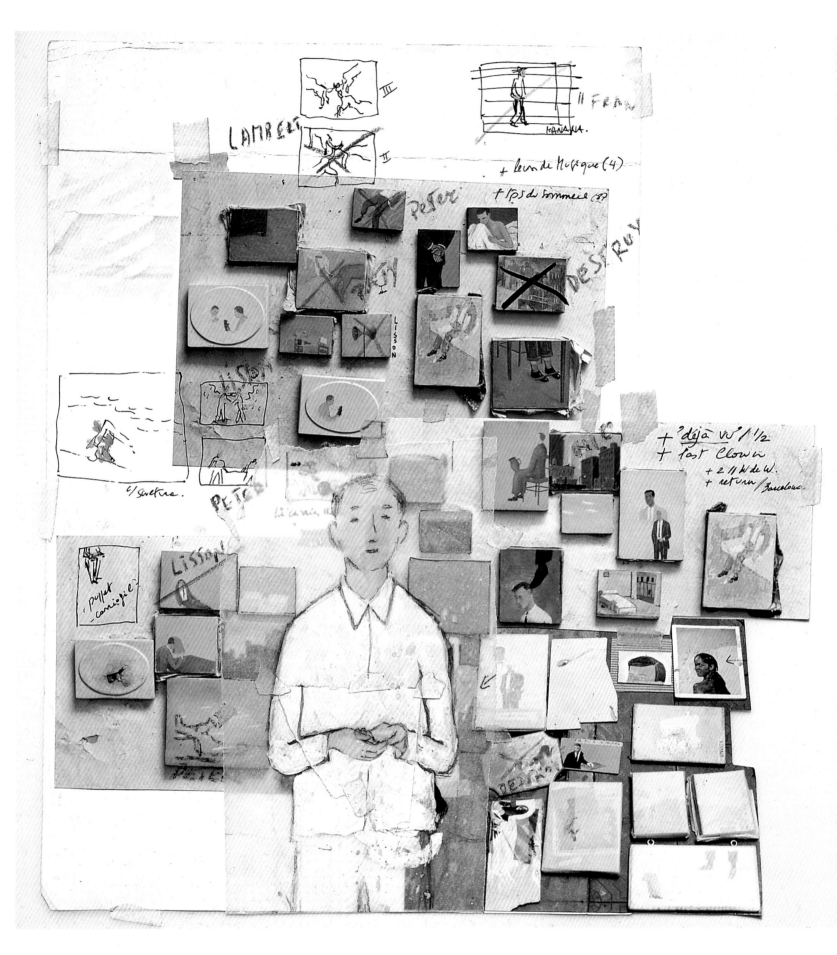

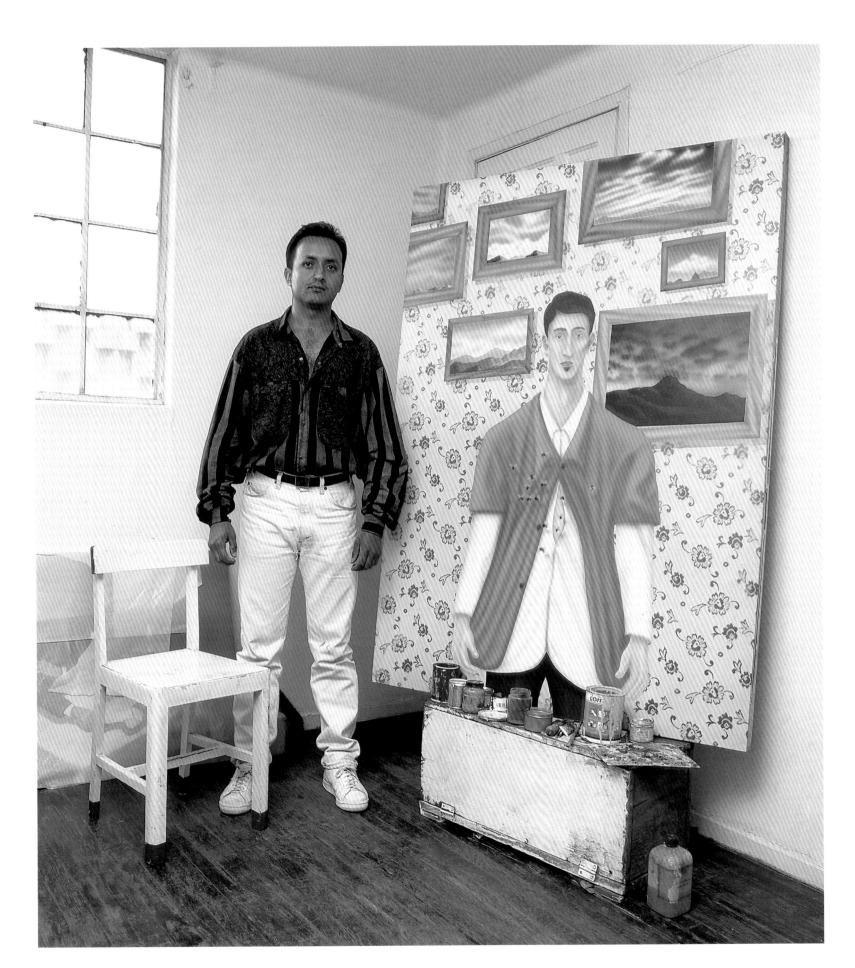

subject, dressed in a suit and tie and involved in a number of sculptural fantasies. These were figurative translations of imaginary transitions between objects and the body, in which body parts and everyday things collided, fused and overlapped with the same unassuming magic of street situations. His character would sit at a table, for example, with a small installation of interconnected objects emanating from his elbows, or would play a ruler over his shoes. The iconography triggers obvious associations with René Magritte, who was originally a commercial artist and was thus conversant in the visual language of advertising. That Alÿs started to paint in a flat and somewhat anti-stylistic fashion emanated from the fact that for him painting was a means of visual communication and intellectual exploration rather than a form of optical enchantment.

It was in an attempt to return his images to those who had inspired them that in 1993 Alÿs decided to produce his paintings through a process of inter-subjective collaboration. He took his small canvases to a handful of commercial sign painters (*rotulistas*, as they are known in Mexico) who were masters of their craft. (One of them, Juan Garcia, had been in charge of painting film billboards, until mechanically produced posters made him redundant.) The *rotulistas* were encouraged to amplify, simplify, reinterpret and improve upon Alÿs's 'originals'. Working on metal boards, they took his basic images (which they described, in the manner of Goya, as *caprichos*, or caprices) and introduced iconographic and formal variants, developing the original theme with the same hermeneutic freedom that copyists employed through the centuries when imitating the prototypes of classical imagery. Going full circle, Alÿs would then systematically re-copy the improved

versions, giving rise to new ideas and variations. The works were classified according to a numerical system that described the different generations and families of the paintings, similar to the geneology of works produced by artists' workshops in Europe during the Middle Ages and the Renaissance. Alÿs saw the *rotulistas*' work as akin to that of an ancient *scuola*, sharing both a common iconography and a set of social relationships. Selling the paintings at a flat rate independent of their actual makers, he hoped that collectors would follow the progression of each series as a kind of narrative, keeping the production line moving forward. How an image would progress was solely determined by its market demand.

In the context of this small circuit of borrowings and collaborations, painting was not only a medium; it became the site of a complex cultural negotiation on the basis of the progression of visual images and their reception by the market.[26] In other words, rather than practising painting as a visual religion, Alÿs turned to the medium as a pragmatic part of living: a means of exchange, communication and participation, a business of personal survival and a field of interpersonal association. Instead of novelty and uniqueness, the collaboration involved the concept that cultural significance lay in the distribution of images – in fact, in the need to reproduce them. This emphasis on the creative side of copying was conveyed in the title Alÿs gave the project: *The Liar/ The Copy of the Liar* (1994). It goes without saying that the project was aimed at calling into question authorship, expression and originality. Alÿs managed to keep this method of production operating for four years, and eventually one of the *rotulistas*, Emilio Rivera, became his assistant as well as a close friend and collaborator.

FRANCISCO GOYA
THE SLEEP OF REASON
PRODUCES MONSTERS, C. 1798
FROM THE SERIES CAPRICHOS
ETCHING AND AQUATINT
22 X 15 CM

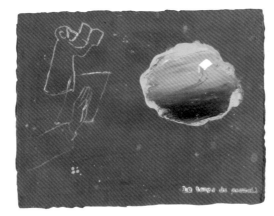
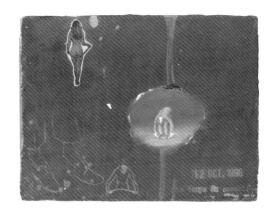
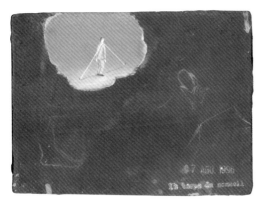
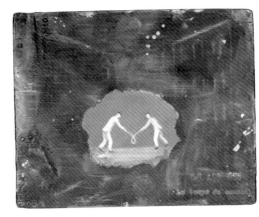

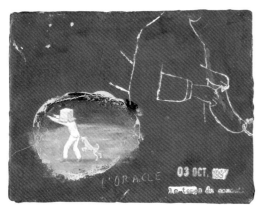

VIVIENDA PARA TODOS
(HOUSING FOR ALL), 1994
PHOTOGRAPHIC DOCUMENTATION
OF AN ACTION, ZÓCALO,
MEXICO CITY

On 21 August 1994, the day of presidential elections
in Mexico, a shelter made of recycled political
propaganda banners was taped together and placed on
top of a subway grating, where the hot air coming
out of the Zócalo metro station held it aloft.

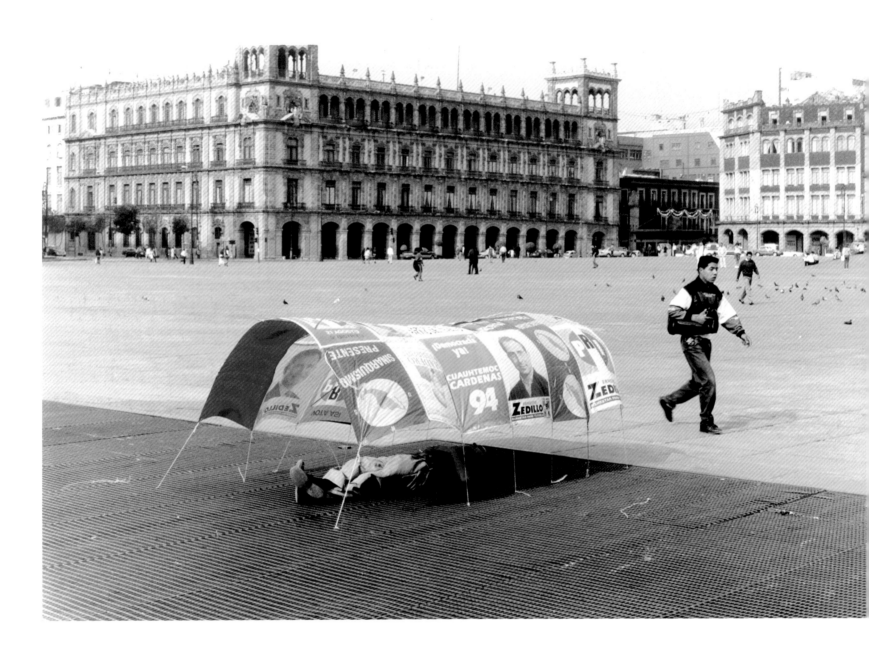

Paintings usually work for Alÿs as carriers of metaphors, cultural references and linguistic and visual associations. They are there to make the artist's symbolic baggage visible: the sexual and physical fantasies evoked by the contact between objects and beings, the political expectations projected on to social behaviours, the literary allusions behind a specific adventure. If his photographs dutifully record the referent of his actions, walks and constructions, painting is there to project them into a wider field of images. In turn, painting also becomes the laboratory in which he re-elaborates his basic repertoire of actions and symbols. In that sense, it is the oneiric field that both reveals the hidden meanings of many of his works and socializes their general condition as fictions.

There is no better example than the series *Le Temps du sommeil*, which Alÿs started producing in the summer of 1996 and continues to rework today. The series consists of approximately one hundred small canvases eleven by fifteen centimetres each, uniformly treated with a dark brown background, on which Alÿs records a number of sculptural scenes. To record their oneiric origin, Alÿs dates them dutifully with a rubber stamp. He then returns several times to the same canvas, adding not only new imagery but also new dates to indicate that it is a palimpsest. The images are a springboard for visual ideas: adventures, reflections and games based on his interaction with sticks, trees, stones, pipes, boxes and pieces of cloth. Reminiscent of the tortured characters of Bosch or the punished souls in the circles of hell, *Le Temps du sommeil* reveals that Alÿs's actions and objects are an allegorical reflection on the human condition. Ultimately, they remind us that no position, action or posture is devoid of a certain moral significance.

The Tequila Effect

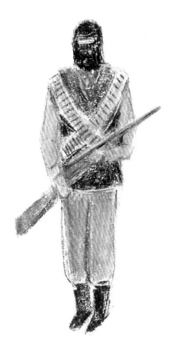

Initially upon his arrival in Mexico, Alÿs did not feel entitled to criticize the local conundrums without understanding the issues involved. Traditionally, Mexican politics have been shrouded in a veil of xenophobia. Inscribed in the constitutional law as well as in public attitudes is an explicit prohibition forbidding foreigners not only from participating in local politics but even from expressing their opinions about them.[27] A principle born from old memories of foreign intervention, this approach has, however, served to empower the censorship of criticism and,

for a while, to brush aside international concerns on matters such as human rights.

Alÿs's first intervention in this field was a reaction to one of the worst crises in Mexico's history. On 1 January 1994, the very same day on which the North American Free Trade Agreement (NAFTA) came into effect, several municipalities of the southern state of Chiapas were taken by the Zapatista Army of National Liberation (EZLN). In the following months a series of assassinations dominated Mexican politics, including the killing of the presidential candidate of the official party, Luis Donaldo Colosio. The troubles continued with the ensuing administration. A dramatic financial crisis in December 1994 was followed by the ill-fated attempt of president Ernesto Zedillo to arrest Subcomandante Marcos and the Zapatista Army leadership in February 1995.

Alÿs, like his Mexican friends, passionately followed all these events, and on election day in August 1994, when Mexican citizens were concentrating on the results of the polling stations, Alÿs constructed a fitting allegory of the country's long wait for political reform. Using found plastic campaign banners, he built a temporary shelter in the centre of Mexico City's main square, known as the Zócalo. This vaulted structure was kept up merely by the force of the air blown from the ventilators of the metro, like Marilyn Monroe's skirt in *The Seven Year Itch*. The title of the installation, *Vivienda para Todos (Housing for All)* (1994), was a brutal satire on Mexican demagogy, being one of the many irresponsible slogans articulated by the Mexican presidential candidates in their campaign. Thus the work physically realized an empty phrase. Conflating both Alÿs's dissatisfaction with architectonics and professional politics as part of the same dream world of power, *Vivienda para Todos* offered an extraordinary combination of immanent critique, black humour and concrete utopianism.

This installation provided Alÿs with a way of translating forms of political resistance into poetic allegory, turning social conflicts into light-hearted political explorations. Soon the social crisis of 1994-95 diverted his attention to the question of the parallel economies that urban populations had developed to survive the mishaps of rising global capitalism. In December 1994 the Mexican peso collapsed to a third of its value. While thousands of millions of dollars flooded out of the country, Mexicans were plunged into a spectacular social crisis, with more than a

million jobs lost in less than six months, the doubling of crime rates and one of the biggest increases in foreign debt in world history. Dubbed 'the Tequila Effect' because it soon affected most South American economies, the crisis was rightly perceived as a hangover of the ridiculous promises of global integration. As in 1976 and 1982, the crisis was a setback of historical proportions that once again caused Mexicans' hopes of an economic take-off to evaporate into thin air.

The brutal economic integration was accompanied by paradoxical local developments. Bartering, for instance, once again became an extensive practice, with people offering goods and services in street ads and even the newspapers to circumvent the lack of credit and cash. Following this trend, Alÿs entered the metro one morning to exchange his sunglasses for any other commodity the passengers felt able to part with. Throughout the day he performed dozens of exchanges, using a camera to document a chain of subterranean trade. *Trueque* (The Swap, 1996) replaced the mobility of Alÿs's walks with the imaginary routes of the objects he exchanged. This interest in the migration of objects through different social layers and across social borders became a central feature in the works he was to produce in the following years.

In Mexico City, an urban centre of twenty million people, the disposal of garbage is not industrialized as it is in the developed world. Trash is scavenged from outside people's homes or from municipal dumps. Alÿs decided to put this informal system of garbage processing to the test. For *The Seven Lives of Garbage* (1995) he placed seven bronze snails in rubbish bags he found in different sites around the city. In the following days and months, he searched for them in flea markets. To date, he has found two, of which he bought one to document the process. The action suggests the extent to which city life is interconnected by means of its informal circuits, symbolized by the slow progression of the snails along different social strata.

These experiences with the circulation of objects and symbols led Alÿs to one of his most daring actions. After the social catastrophe of the mid-1990s, Mexicans found respite in a form of symbolic reprisal. President Carlos Salinas, who governed Mexico during the period of the most rabid neo-liberal modernization (1988–94), was caricatured in hand-crafted objects that were sold in the streets of

Mexico City. In 1995 Alÿs devised a project to smuggle six grams of cocaine from Mexico into the United States hidden in one of these small painted effigies. *Narcosalinas* (1995) reflected on the links between the illegal drugs trade and the globalization project by suggesting the complicity between local southern politics and the drug consumption in the north, both of them expressions of the thrill of power.

PRI, Mexico's ruling party for almost seventy years, was a paradoxical political regime: a post-revolutionary body that conducted the capitalist modernization of a Third-World country behind the ideological facade of populism and demagogy. Such 'dictatorship moderated by corruption' – as the vox populi defined it – had been plunged into a more or less permanent state of crisis ever since a massive pro-democracy student movement was violently suppressed by the army on 2 October 1968, a few days before the start of the Olympic Games. Three decades later, Alÿs evoked these events with *Cuentos Patrióticos (Patriotic Tales)* (1997). For this video he walked around the flagpole of the main square in Mexico City, leading a line of sheep that increased one by one until they formed a full circle. Here Alÿs made explicit reference to one of the defining moments of the 1968 crisis. In August a demonstration organized by the government to protest against the students' alleged desecration of the Mexican flag had backfired when the civil servants forced to attend started to bleat as a sign that they were not there of their own will. *Cuentos Patrióticos* not only pointed out the lasting significance of the 1968 rebellion but exemplified the way in which Alÿs was to approach the critique of politics through the enactment of living parables.

Economy Postponed

Very early on in his artistic practice, Alÿs came to understand that as much as he may have been an external and objective observer in the sites he explored, his works were to a great extent a product of the interference between reality and its record – in other words, art was never entirely 'about' or 'from' a place, but rather a product of an experience of friction and contamination. As his video *If you are a typical spectator, what you are really doing is waiting for the accident to happen* (1996) demonstrated, the mere presence of the camera can activate daily life, provoking people to kick a plastic bottle from one side of a square to the other, until the artist himself, who

NEWS PHOTOGRAPH OF PRO-DEMOCRACY PROTEST IN MEXICO CITY, 1968
FROM THE ARTIST'S ARCHIVE

UNTITLED, 1996
FROM THE SERIES DÉJÀ VU
OIL ON CANVAS
DIPTYCH (PART 2)
17 X 23 CM

In the beginning there is a given situation where many people cross paths.
The protagonist enters the situation with an object. He swaps it for
another. A succession of transactions follows in which each object is
in turn exchanged for another, and so on until the end of his visit.
The protagonist leaves the last object.

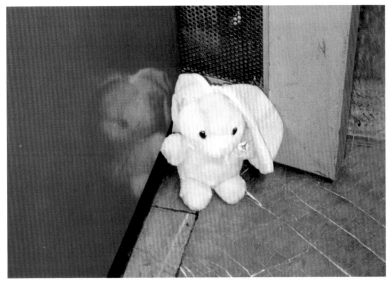

In the beginning there is a given situation where many people cross paths.
The protagonist enters the situation with an object. He swaps it for
another. A succession of transactions follows in which each object is
in turn exchanged for another, and so on until the end of his visit.
The protagonist leaves the last object.

It is said that all garbage in Mexico
City goes through seven stages of sifting
from the moment it is left on the street
until its final destination at the
garbage dump on the outskirts of the city.

On the night of 4 February 1994,
I placed seven small bronze sculptures,
painted seven distinct colours, in seven
different garbage bags. I then dropped
the bags in garbage piles in seven
different districts of the city. In the
following days, months, years, I have
wandered the flea markets in the city
looking for the sculptures to resurface.
To date I have found two of the seven.

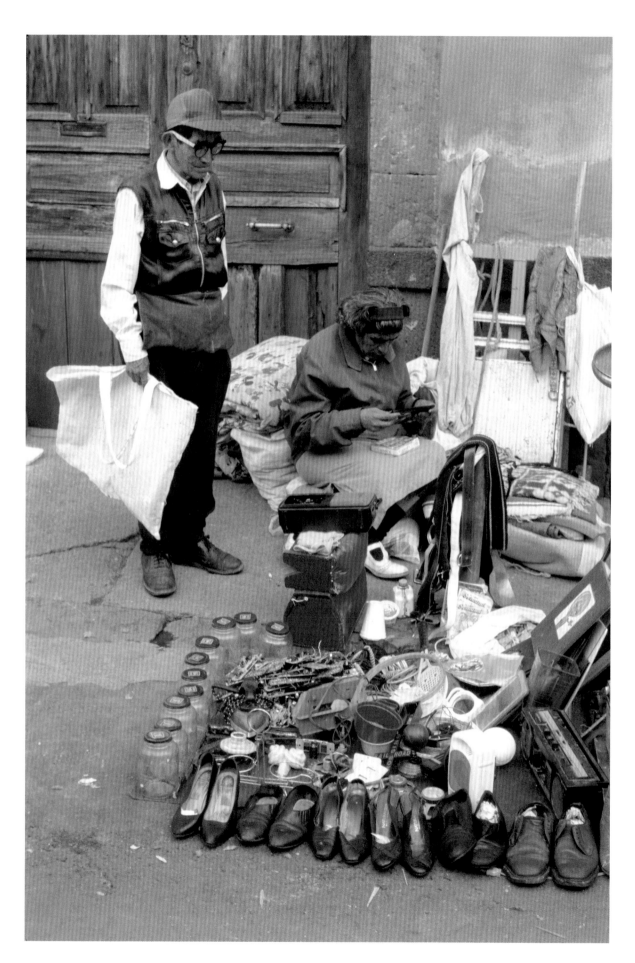

was merely filming the scene, is brought into the work by being hit by a car. Drawing an analogy to Werner Heisenberg's uncertainty principle, Alÿs came to realize that 'you can't observe a phenomenon without, after a while, interfering with the natural course of it.'[28]

Given such interaction, Alÿs turned Mexico City into a living laboratory of the tensions between modernization and its resistance, the entropic forces operating in so-called 'developing societies'. Triggered by a request from the curatorial team of the twenty-fifth São Paulo Biennial to explore the way in which artists had historically been involved in cultural exchange and absorption, in 1996 and 1997 Alÿs produced several works aimed at describing his relation to the ways of living in downtown Mexico City. This time it was not a matter of recording the evidence of the population's silent resistance, but of producing a general allegory of a life ruled by scarce productivity.

All the painful hilarity embedded in the notion of historical failure that Alÿs wanted to discuss is captured in the title of one of his most famous walks: *Paradox of Praxis 1* (1997), subtitled 'Sometimes making something leads to nothing'. In this action, the first of a two-part project that fittingly took the artist a decade to complete, Alÿs pushed a huge block of ice through the streets of Mexico City, from early in the morning to sunset, until the block completely melted. This act, which was documented on video by Alÿs's collaborator, the former sign painter Enrique Huerta, was meant to stand for the widespread personal and social experience of waste of effort in Latin America.

At the same time, it critiqued the pervading Minimalist aesthetic of recent art. By strenuously pushing his block of ice through the streets of the megalopolis, Alÿs created a parable about the thaw of Minimalism: the physical and conceptual erosion of the inert, reductionist Minimalist aesthetic that living cities such as Mexico provoke. The work summarized Alÿs's dissident approach to the traditional concept of public art, and his adoption of an ephemeral sculptural vocabulary that, rather than presenting an object for contemplation, intervenes in the social space to turn sculpture into a means of social research. Streets such as those in Mexico City, with their intense social activity, demonstrate the obsolescence of traditional sculpture as a means to produce a social symbol. As a substitute, Alÿs's proposal consists of the creation of urban myths able to reflect aesthetically and politically on the contemporary conditions of living. With hindsight, *Paradox of Praxis 1* is also important in the sense that it helped Alÿs to explore an aesthetics based on failure.

Fuite en avant

Despite its apparent neutrality, few notions are as ideologically charged as that of national 'under-development'. It was Harry S. Truman who, during his inaugural presidential address of 1949, proposed the idea that the poverty and social turmoil of under-developed nations made them vulnerable to the influence of the Soviet Union, and that bringing progress and technology to the South was necessary

10 00 A M

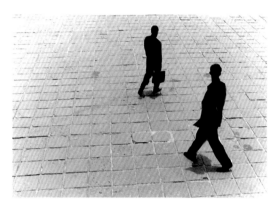

10 01 A M

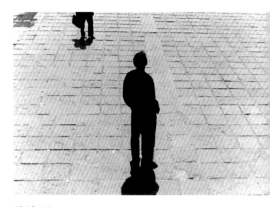

10 10 A M

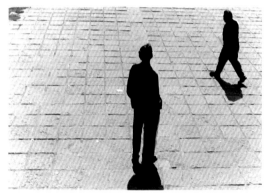

10 20 A M

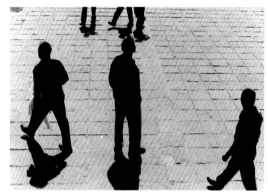

10 30 A M

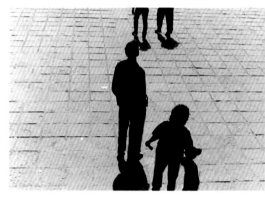

10 32 A M

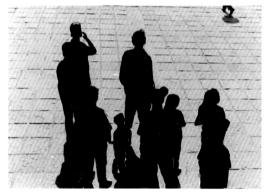

10 36 A M

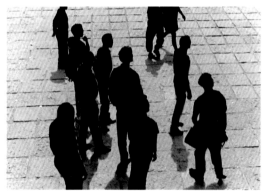

10 36 A M

10 37 A M

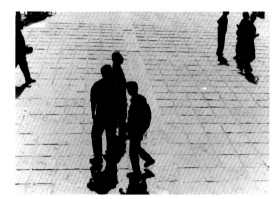

10 38 A M

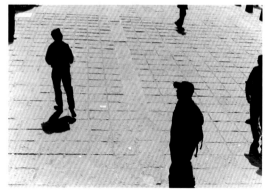

10 38 A M

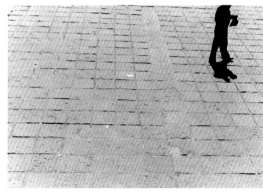

10 39 A.M

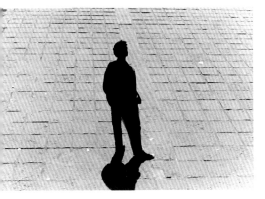

0 15 A.M.

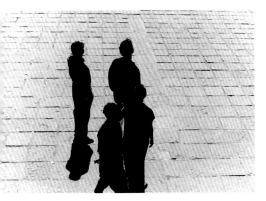

10 35 A.M.

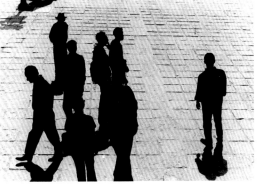

10 37 A.M.

10 39 A.M.

to the security of the Western world. Springing from outmoded discourses around the *mission civilatrice* of Europe towards its colonies, the concept of under-development posited Western societies as the model for other nation states to pursue in their movement from 'tradition' to 'modernity'.

This value system, disguised under the technochratic consensus of international agencies and social critics, poses a linear concept of history that, as Frederic Jameson has pointed out, promotes the 'illusion that the West has something no one else possesses but which they ought to desire for themselves'.[29] Seen in retrospect, however, the twentieth-century project of development was caught up in an eternal paradox: no matter how hard they have tried, 'backward' societies have been unable to match the model of their forerunners.

In 2006, Alÿs translated this thought into images in a 16 mm film made in Patagonia. His initial intention was to chase *ñandús*, South American ostriches, through the plains, as the aboriginal inhabitants of Patagonia are said to have hunted them. The work evolved, however, into a pursuit of mirages. It was a search for 'a point amiss, beyond the horizon line, out where images occur'.[30] In collaboration with artists Rafael Ortega and Olivier Debroise, Alÿs filmed the emergence of the iridescent area at the vanishing point of the road. As the artist put it, this was 'the image of *fuite en avant*, of fleeing forward'.[31] The title of this project, *A Story of Deception*, summarizes his understanding of the seduction of development. If the pursuit of modernity is fatal, this work suggests, it is because it becomes a 'chasing after the vanishing point'.[32]

False Starts (Never Ending)

In a number of his recent works, Alÿs has articulated a catalogue of the different economic practices that derive from the shaky process of modernization in the South. These works highlight the transformation of the apparent linearity of development into a variety of modalities, from repetition, stagnation, oscillation and regression, to forms of action that make effort and energy vanish, or that imply a sudden 'irrational' gain. Underneath their humorous and lyrical presentation, Alÿs has encoded in them a view of time

that differs greatly from the metaphysical ramblings that often accompany artststs' allegedly philosophical approaches to the subject of duration. Alÿs's approach, as he once put it, is a meditation on 'the vicious circle of demand', and the emphasis is on the nature of the time of production, rather than on the status of the product. To borrow a distinction made by the political theorist Hannah Arendt, this is a meditation on the nature of labour as an endless task, marked by the relationship between our bodies and the social system rather than by the condition of the work as an activity that is materialized in its product: 'Unlike working, whose end has come when the object is finished, ready to be added to the common world of things, labouring always moves in the same circle, which is prescribed by the biological process of the living organism.'[33]

Alÿs's first approach to this issue was *Turista*, in which he presented his contemplation of the everyday work of others as a professional activity, thus conflating labour and leisure and questioning the notion of efficiency. In *The Swap* and *The Seven Lives of Garbage*, he recorded the chain of things passing from hand to hand, revealing a whole array of social possibilities encrypted in systems normally considered only in relation to poverty. *Paradox of Praxis 1*, while evoking the sense of an unstoppable waste of energy (and the apparent pointlessness of action) and enacting the disproportionate relationship between effort and effect as often experienced in Latin American economies, also gave rise to its opposite – for ten years, Alÿs, in collaboration with his friend the filmmaker Rafael Ortega, has been working on the second part of this project: *Sometimes doing nothing leads to something*. One of the best works in the series so far is *Looking Up* (2001), which was inspired by a recent media craze for UFOs. Alÿs simply stood in a square, looking intensely up at the sky, until people started to gather around him and gaze up as well. At one point, he walked away, leaving the other spectators behind as if abandoning a residue. Both actions involve, through the enactment either of loss or of a creative excess, an argument against the dogma of efficiency.

The next step for Alÿs was to intervene in the timing of the work's narrative by introducing complex routines that break the obvious continuity of an action. The video installation *Cantos Patróticos (Patriotic Songs)* (1998-99) involves a constant

SONG FOR LUPITA, 1998
IN COLLABORATION WITH LOURDES
VILLAGOMEZ AND ANTONIO HERNANDEZ ROS
45 RPM RECORD WITH SLEEVE
SIDE A, 'MAÑANA,'
4 MIN. 20 SEC
SIDE B, 'THE REHEARSAL'
4 MIN. 22 SEC

REHEARSAL 2, 2001-06
IN COLLABORATION WITH RAFAEL ORTEGA
PHOTOGRAPHIC DOCUMENTATION OF AN ACT,
MEXICO CITY
VIDEO
14 MIN. 30 SEC

Soundtrack:
Franz Shubert's 'Lied der Mignon'

Performers:
A striptease artist, a soprano and
her pianist

Mechanics:
The stripper listens to a rehearsal
session of the soprano with the pianist.

While the pianist plays and the soprano
sings, the stripper undresses.

When the soprano or the pianist loses
track over a musical phrase and stops,
the stripper holds her act.

While the soprano and the pianist
discuss the musical phrase in question,
the stripper dresses up again.

The rehearsal session will go on until
the stripper completes her act.

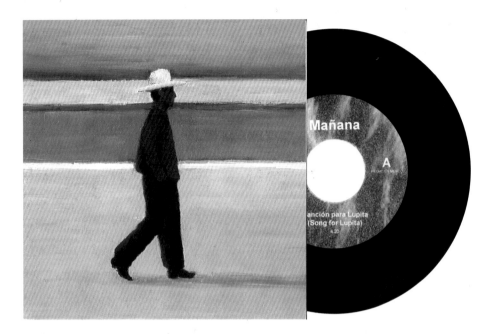

negotiation of duration. The artist hired three musical performers – a street violinist and a two-man Mariachi band – to play a *corrido* (a traditional Mexican song) that Alÿs had written about a boatman who loses his sense of orientation while trying to take illegal immigrants across the river to the United States. 'Afloat between two waters' (like the artist himself) the boatman is unable to find out where 'the start, the finish is / Where the end is, the beginning'. This is, of course, a metaphor for the disorientation provoked by the dream of modernization, understood for societies in the South as 'heading North'. But perhaps more important is the way in which Alÿs challenges the taste for simplicity in much contemporary art with a work made up of layers of social and temporal variables. The music and images revolve around a filmed game of musical chairs, which goes backwards and forwards according to a rhythm defined by a complex edit of the footage of the musicians. The result is an expansion of the time 'in between', a temporality elongated by the intervals that open up when the flow of our expectations is interrupted. The feeling generated by these cycles and waves of expansion is something like the movement of a spiral.

In 1998, Alÿs once again reflected on the notion of development and circularity with a subtle line-drawing animation titled *Song for Lupita*. The work is deceptively simple: a young woman endlessly pours water from one glass to the other as if trapped in an eternal loop, which, according to the artist, follows the principle of 'doing without doing' or 'not doing but doing'. The film is accompanied by a song recorded on 45 rpm vinyl and entitled 'Mañana' (Tomorrow), a word that is redolent of a common tactic against the pressures of efficiency: as the lyrics say, 'Mañana, mañana is soon enough for me.' *Song for Lupita* is, in a way, a meditation on a form of procrastination that is based on the promise of the future.

In all these works, the relationship between image and sound serves as a means to induce an experience of interruption and delay. In the relationship between music and movement, Alÿs was looking for metaphors to describe the tension between the violence of development and the frustration of its arrest, which in turn can be experienced as a form of progress. Those notions were to lead him directly to the idea of the musical and theatrical rehearsal, which involves the constant interruption of the flow of action, and the notion of 'failure' as an inevitable part of any experience of progress. For Alÿs, to use Mikhail Bakhtin's concept, the rehearsal is a 'chronotope',[34] a means of describing a specific articulation of time and space. In a way, the rehearsal has become Alÿs's symbol to describe the notion of a 'Mexican time'.

Location: a high point on the eastern side of the Plaza de la Constitución (Zócalo). The filming begins at dawn with the flag-raising ceremony and ends at dusk with the flag's descent. The camera follows the progression of the shadow of the flagpole over the course of the day. The camera lens describes a lateral movement of three degrees per hour, for a total of thirty-six degrees (each rotation corresponding to the hourly change of tape). The projection of the documentary is to take place at the corresponding local time.

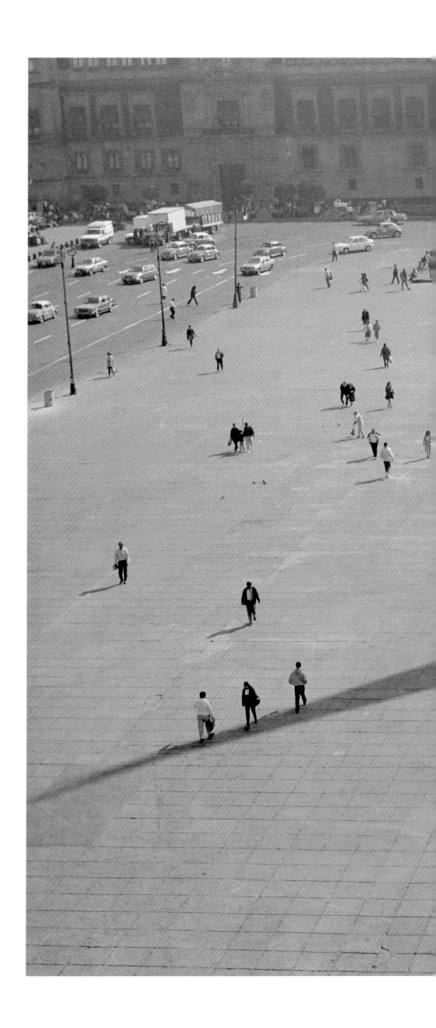

All the *Rehearsals* involve the intrusion of banality into the fabric of illusion, a mismatch between real experience and an ideal model. Some of these works are short videos in which Alÿs uses the rehearsal of a musical score to dictate the action, which is delayed each time the music is interrupted. In *Rehearsal 1* (1999), an old Volkswagen Beetle that fails to climb over a steep hill is reminiscent of the economic crisis in the South. In a more erotic mode, *Rehearsal 2* (2001-06) pictures a stripper who undresses and dresses according to the rehearsal of a Schubert *lieder*, a fitting symbol of the ebb and flow of desire. A sound work like *Rehearsal 8* (2002) offers a recording of the efforts of a school band to learn a patriotic anthem as a symbol of the shaky process of national formation. And, in 2001, Alÿs reworked unused footage and sketches from Alejandro González Iñárritu's film *Amores Perros* (2000), trying to seize the borderline between social documentation and fiction. On the one hand, the *Rehearsal* works emphasize the unfinished, the wish to sidestep the false sense of unity generated by any kind of representation. On the other, they stand as a means of economic critique that hints at the way in which the passage of time is, above all, dependent on the fulfilment of desire – or on its lack of fulfilment. In that sense, the *Rehearsals* evoke *l'étreinte qui ne peut s'achever, l'orgasme à jamais repoussé* (the embrace that cannot be achieved, the orgasm forever delayed), for only in relation to the longing for satisfaction can we understand the impulse of modernization. The rehearsal also stands as a means of social critique, in as much as it exists in an 'ambiguous affair with modernity, forever arousing, and yet always delaying the moment it will happen'.[15]

Tenuous Tenacity

It would be a mistake, however, to assume that Alÿs's works are only a matter of social critique or denunciation. Although they never fail to describe or indicate injustice, their drive is to explore alternative

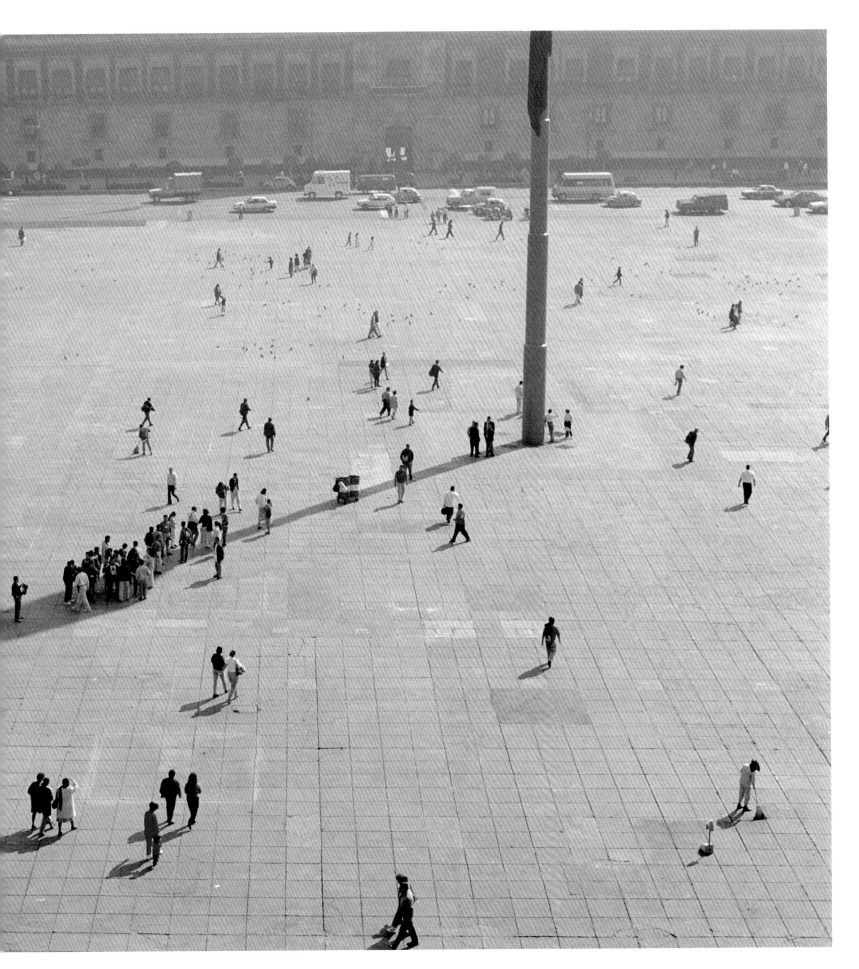

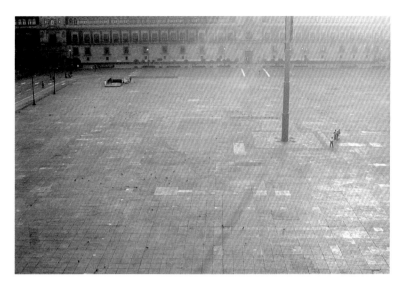

7.30 A.M.

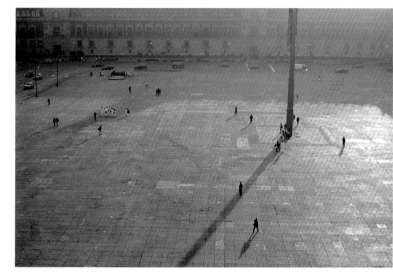

7.45 A.M.

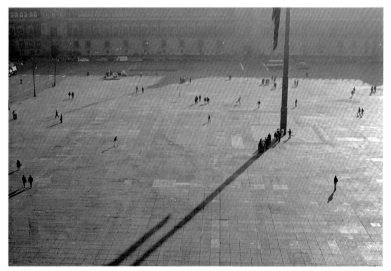

8.00 A.M.

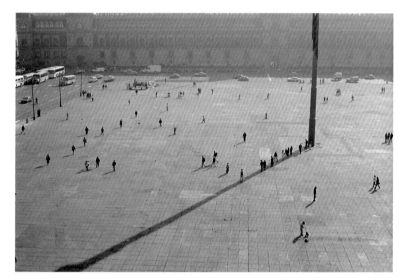

9.00 A.M.

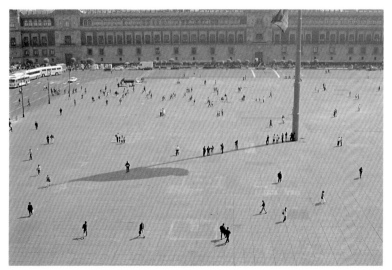

11.00 A.M.

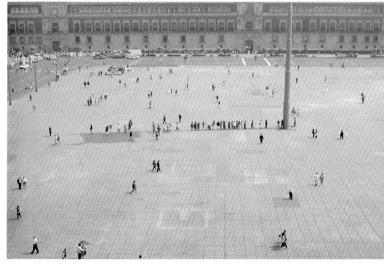

1.00 P.M.

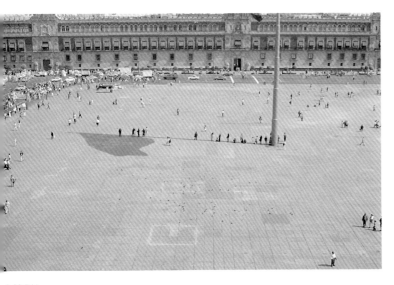

3.30 P.M.

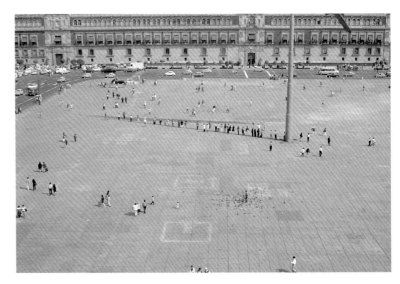

4.30 P.M.

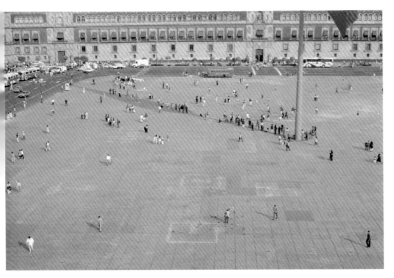

5.30 P.M.

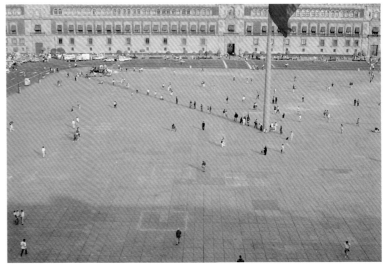

6.00 P.M.

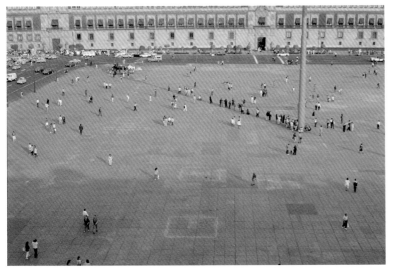

6.15 P.M.

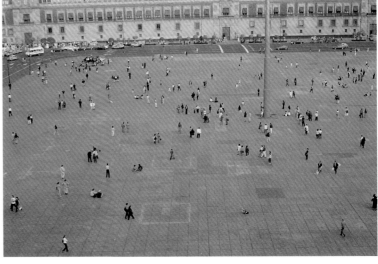

6.45 P.M.

RAFAEL ORTEGA AND FRANCIS ALŸS
1 MINUTE OF SILENCE, 2003
PHOTOGRAPHIC DOCUMENTATION
OF AN EVENT, PANAMA CITY
FLYER ANNOUNCING THE EVENT
32 X 23 CM

In the beginning there is a situation where many people cross paths. If one person were to ask someone else for silence, and someone else to someone else, and so forth, until the whole scene becomes still, then, maybe, one could produce one minute of silence.

With the help of a group of forty-five volunteers we attempted to silence several densely populated situations, with the intention of materializing/sculpting one minute of silence. No specific meaning would be attributed or dedicated to the minute, its space staying open to multiple readings, as many as the individuals willing to participate. Over the course of 4 days we intervened in the National Lottery hall; a grand café in the old town; a populous street squatted by two soccer teams; at rush hour in the middle of a main pedestrian commercial strip; and in a live radio programme. On the second day of the project, bombs started falling on Baghdad, and the minute's original vacuum became naturally charged with the urgency of the moment. What had started as a conceptual plot turned into a minimal act of solidarity. People on the street began collaborating silently, asking others to turn off their radios or TV, to switch off their air conditioners, to stop their engines ... eventually materializing, silently, for one lone minute, a sensation common to us all.

1 minuto

Panamá, marzo 2003

ways of living, practices that open up of the sphere of possibilities. This is the reason that Alÿs constantly fluctuates between production and documentation. On one level, he keeps an eye on the moments and occasions in which urban reality provides a moment of condensation. In 1999, for instance, for twelve hours he recorded the line of people who take refuge under the shade of the flagpole in the Zócalo, drawing attention to an unconscious daily ceremony (*Zócalo*, 1999). In showing how 'social encounters provoke sculptural situations', Alÿs resists the progressive disenchantment of urban space, evoking the function of the polis as place for the expression for collective desires and fears, the stage for mass events and political ceremonies, the site of shared dreams. But in parallel his task is to intervene in social situations to suggest a change in perspective, showing in particular that no matter how slight its effects, action is neither fruitless nor meaningless.

Several of Alÿs's recent works have involved collaboration or interaction with collectives, the members of which may appear either as the participants of an experience proposed by the artist or as characters in a staged anecdote that is used as a means to shake off political passivity. In many instances these works have aimed to introduce an allegorical action into the history of a specific location. In *When Faith Moves Mountains* (2002), for example, Alÿs summoned hundreds of participants to provoke the slight displacement of a sand dune north of Lima, Peru. *Modern Procession* (2002) was a procession to mark the transportation of modern icons from the Museum of Modern Art in Manhattan to its temporary site in Queens. *1 Minute of Silence* (2003)

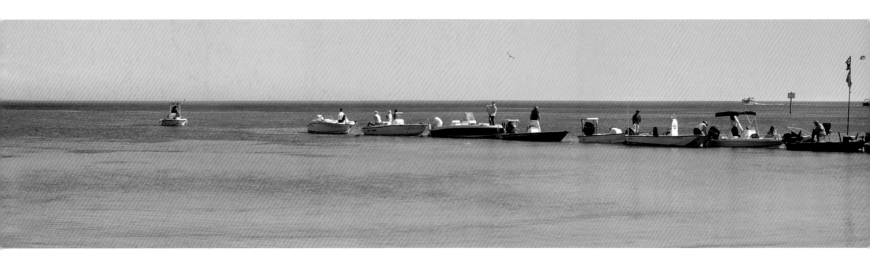

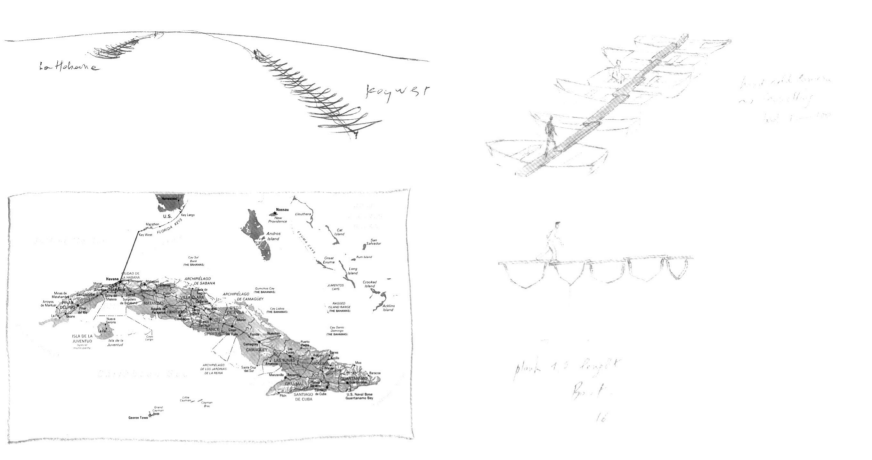

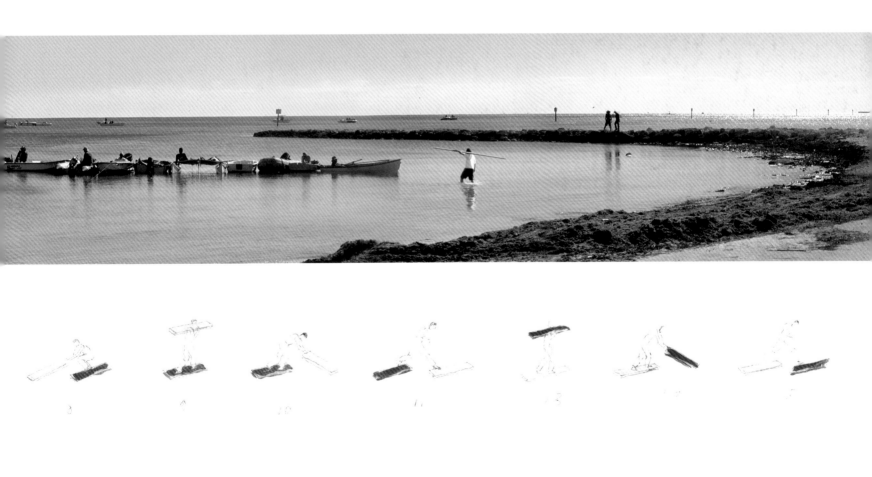

BRIDGE/PUENTE, 2006
IN COLLABORATION WITH TAIYANA PIMENTEL
AND CUAUHTÉMOC MEDINA
PHOTOGRAPHIC DOCUMENTATION OF AN EVENT,
KEY WEST, FLORIDA, AND SANTA FE, HAVANA

On 29 March 2006, 150 boats lined up
from Key West, Florida, and from Santa
Fe, Havana, to send out a floating
bridge between the United States and
Cuba. The two lines headed from opposite
shores towards the same horizon.

aimed to induce an unannounced minute of silence in the streets of Panama City, while in *Bridge/Puente* (2006), Alÿs suggested the feasibility of bridging two regions of conflict with a line of boats coming from two different shores. In all these works Alÿs upholds the emotional, ethical and strategic significance of the emergence of collective agency. After all, what is the purpose of the city if not to 'offer a remedy for the futility of action and speech' by allowing a space of social demonstration? Or as Arendt put it, 'The organization of the polis is a kind of organized remembrance. The polis, properly speaking, is not the city-state in its physical location; it is the organization of the people as it arises out of acting and speaking together, and its true space lies between people living together for this purpose, no matter where they happen to be.'[36] It is this space that Francis Alÿs locates, preserves and activates.

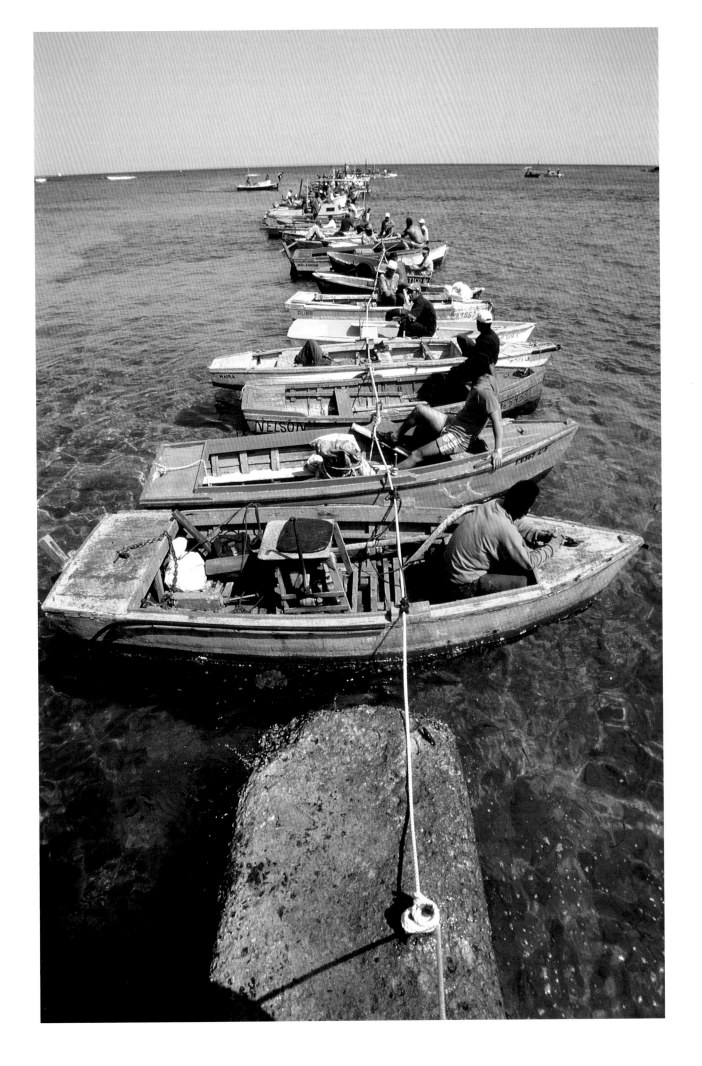

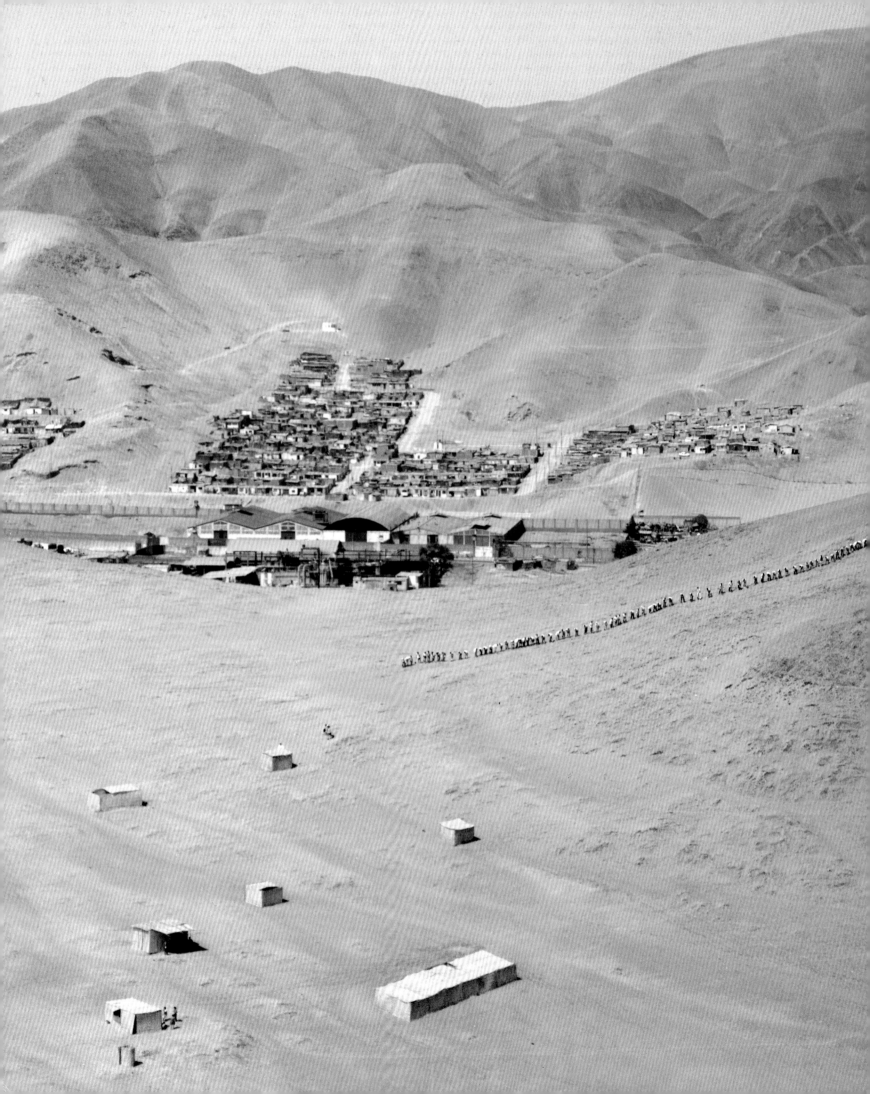

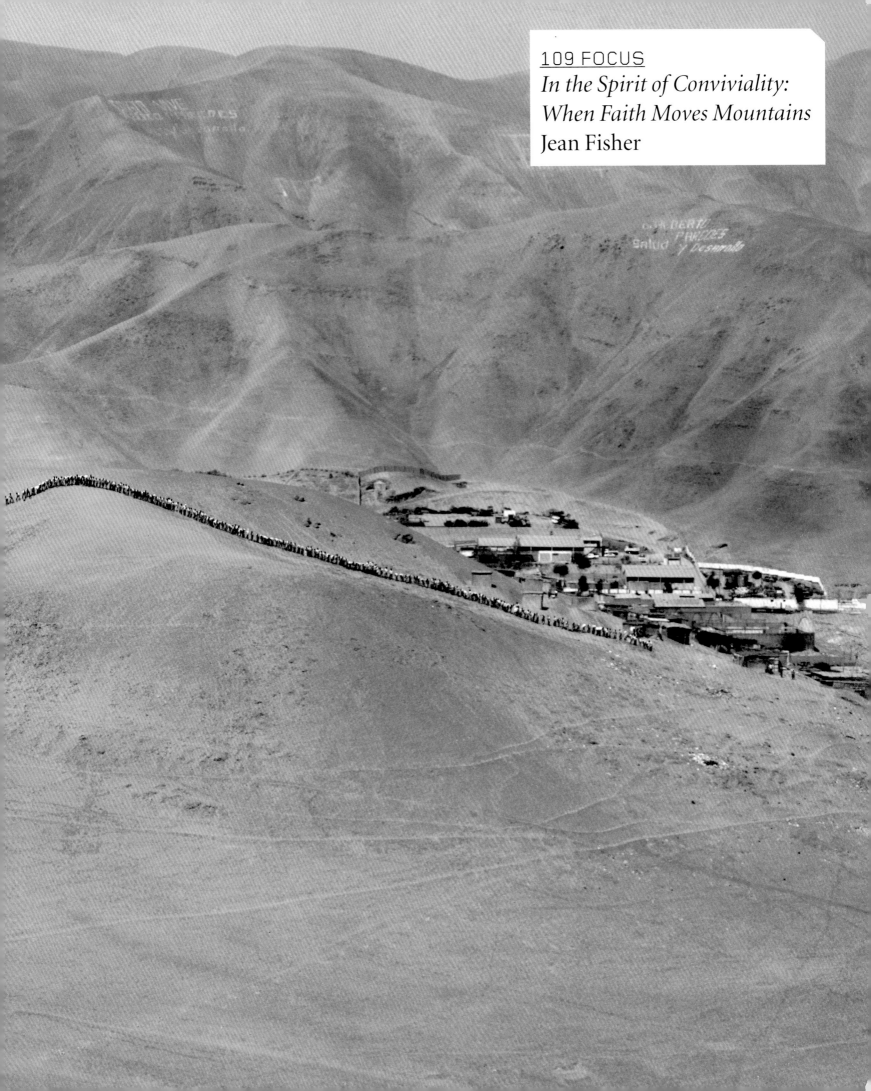

Few commentators would dispute that, on the face of it, <u>When Faith Moves Mountains</u> (2002) was a ludic, if not ludicrous, gesture. A huge deployment of voluntary human labour with nothing to show for it – on site, at least – except some tracks in the sand, sooner or later to be obscured by the forces of wind and gravity. And few artistic gestures have so lucidly laid bare the Sisyphean absurdity of the human condition, caught between utopian aspiration and frail endeavour in the larger space-time schema of the world. The very play of grounded and groundlessness, materiality and immateriality in the work conjures up that abyssal gap between the burden of everyday existence and the weightlessness of the imagination, in which the sheer gravity of the former in most regions of the world, including Peru, lends the latter at times an air of the frivolous. Kant himself may have appreciated the extent to which Alÿs's project colludes with his assessment of art as 'purposiveness without purpose', as may Hans-Georg Gadamer, for whom both art and play were 'movement as movement', setting their own rules in an 'autonomous temporality' – a time-out-of-time – and expressing an overabundance of life.[1] Art – like play, garbage and wastelands in general (notably, the outskirts of cities where most shanty towns of the world are sited) – is an 'excess' or 'unproductive' expenditure, a continuous production of 'otherness', neither reducible to commodification nor wholly subject to the disciplinary mechanisms of the system that engenders it. And, as such, it always presents a latent form of resistance to prevailing structures of power.

We should not, then, underestimate the role of the gratuitous in Alÿs's project. It was a collaboration – a working together – between the artist, the critic, the filmmaker, the volunteers and the local people in a spirit of free will and conviviality, a sharing of a space of existence, if only momentarily, to perform a seemingly inconsequential act. But there is, of course, more to it than this. What grabs our attention here, and what cuts to the heart of what we may mean by art practice nowadays, is the very freedom to think and act upon such a thought. In what sense can praxis – in the classical sense, an act that is an end in itself and pertains to the labour of everyday existence – be at the same time poiesis – an act whose end is not in itself but in the 'pro-duction' (in the sense of a bringing-into-being) of a truth? What kind of truth is at stake in the work? And what can be the relevance of a poetic act in the context of sustained political crisis, such as that experienced in Peru itself, of which the displacement of people and the coming-into-being of Ventanilla, and other pueblos jóvenes like it, is but one of its consequences – a symptom, in fact, of a fundamental void of meaning in the structure of polity to which the work's entire play on displacement alludes? The argument I should like to advance is that the space of freedom opened up by <u>When Faith Moves Mountains</u> provides

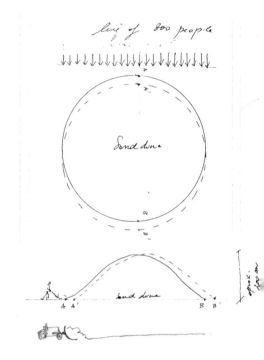

VIRTUES, 1992
OIL AND ENCAUSTIC ON CANVAS
24 X 34 CM

the conditions of possibility for a new thought of the political, here understood not simply as the mechanism of political discourse or the structures of power and the state, but as 'conviviality', or the founding moment of community.

When Faith Moves Mountains was not, of course, without purpose or consequence. We know of it through its meticulous documentation: aerial footage of the overall topography showing the work in progress as a serpentine chain of workers battles up and down the dune in the heat of the noonday sun, and on-the-ground footage of the volunteers, their shovels scraping through the gritty surface and throwing up clouds of sand. We are given a sense of both its material and immaterial conditions. Based on its re-presentation through video, photography and written documentation, knowledge of the work has already been disseminated through art publications, gossip and various interpretative commentaries. This absence of any tangible art object, the displacement – from preparatory work to event to re-presentation (what Alÿs describes as the three successive and distinct lives of the project) – entangles us again in the dilemma of where, between concept and object, 'art' lies, an issue that has been unresolved since the 1960s. But the mythopoeic effect of dissemination is how we know the vast majority of the world's cultural productions, especially site-specific ones, from the Easter Island sculptures to Giotto's Arena Chapel frescoes to the Land Art projects of the late 1960s and 1970s.

In some respects When Faith Moves Mountains invites comparison with these earlier Land Art and Conceptual practices. Just as they were born out of the politicized climate of the 1950s and 1960s, so the forces of globalism have confronted us again with the question of the nature and place of art practices and their relevance to the social and political networks in which we are all now irrevocably entangled. And yet, despite their ambitions to democratize art through its redefinition (as in the case of Joseph Kosuth) or through avoidance of its elitist institutions (as in the case of Land Art), these earlier practices nonetheless produced image-based objects still conventionally encoded as 'art' in exclusive, modernist terms. Typically, Land Art projects sought out remote and seemingly unpopulated landscapes; among the most infamous of these are Michael Heizer's Double Negative (a displacement of 244,900 tonnes of earth in the Nevada desert), Walter de Maria's Lightning Field (400 steel lightning conductors set in a grid over a square mile of the New Mexico desert), and Robert Smithson's Spiral Jetty (over 5,000 tonnes of earth and stone curling into Utah's Great Salt Lake). As with When Faith Moves Mountains, Spiral Jetty is known to us through the documentary film of its making. Similarly, Smithson's concern with entropy meant that it was not intended to survive the forces of nature.

MICHAEL HEIZER
DOUBLE NEGATIVE, 1969-70
244,900 TONNE DISPLACEMENT
RHYOLITE, SANDSTONE
457 X 15 X 9 M
MORMON MESA, OVERTON, NEVADA

HEN FAITH MOVES MOUNTAINS, 2002
N COLLABORATION WITH CUAUHTÉMOC MEDINA
ND RAFAEL ORTEGA
HOTOGRAPHIC DOCUMENTATION OF AN EVENT,
MA, PERU

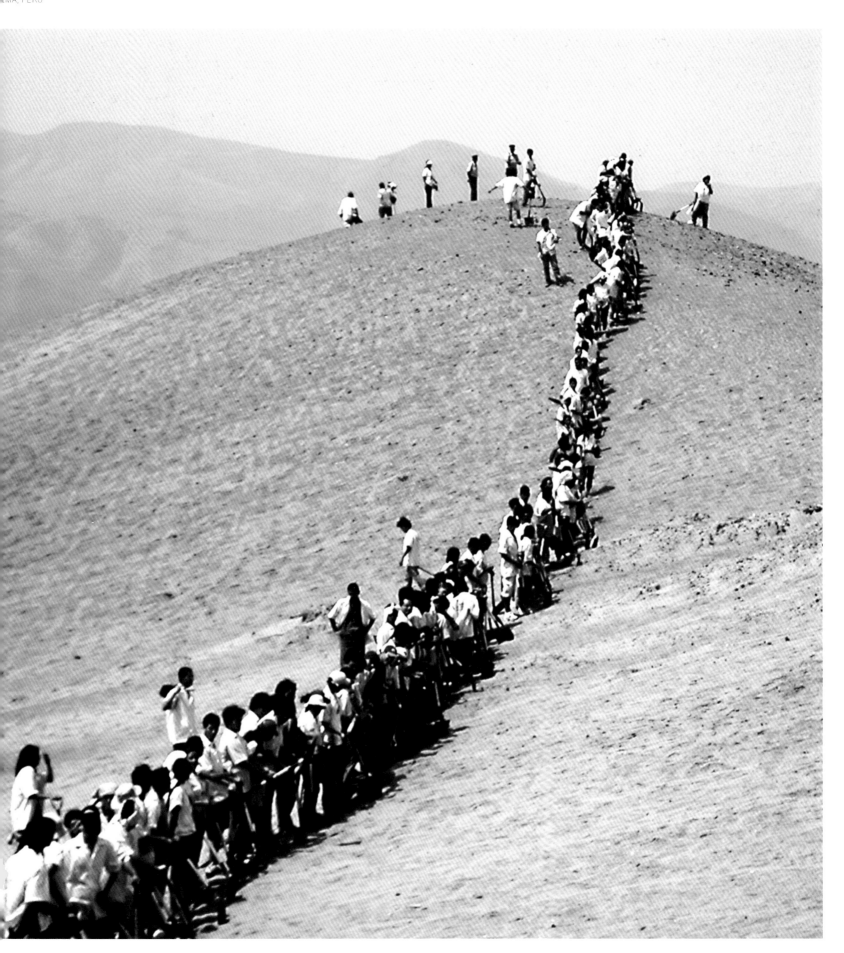

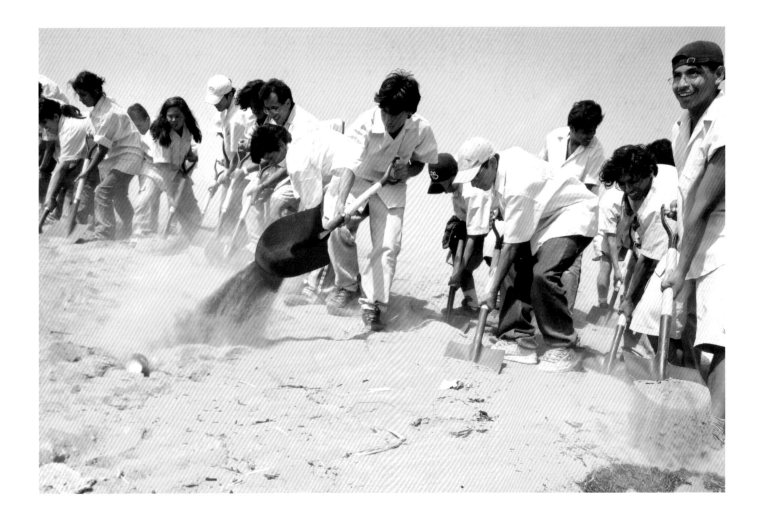

All of these earlier sculptural sites were realized through the use of backhoes
and other heavy earthmoving machinery, in contrast to the shovel and manual
labour of When Faith Moves Mountains. The difference, however, is more
than the macho affluence of the United States versus the material poverty
and labour-intensive necessity of Latin America. To understand the fuller
significance we might think also of Richard Long, who, like his American
counterparts, trekked around what he liked to call 'empty landscape'[2] but
manually moved rocks or driftwood into configurations that nostalgically
invoked a prehistoric or pre-industrial arcadia. Nonetheless, these practices
retain a residue of the colonial mentality that assumes the right to make one's
mark on or exploit the land as material for art no matter whose territory,
'empty' or not, it may be. By contrast, When Faith Moves Mountains was an
act without possession. One crucial distinction, then, between these earlier
practices and Alÿs's project is that the former are authorized, delimited
reconfigurations of nature that draw the world into the orbit of the privileged
subject rather than engage the self with the space and rhythm of the world.
They remain consistent with what Giorgio Agamben describes as
modernism's progressive displacement of poiesis by praxis, which gave rise
to the notion of art as an expression of the artist's creative will and, in the

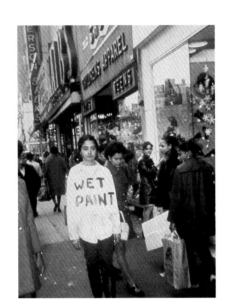

ADRIAN PIPER
CATALYSIS III, 1970-1
PERFORMANCE, NEW YORK

process, detached aesthetics from ethics. And yet, as Agamben continues, 'what the Greeks meant with the distinction between poiesis and praxis was precisely that the essence of poiesis has nothing to do with the expression of a will (with respect to which art is in no way necessary): this essence is found instead in the pro-duction of truth and in the subsequent opening of a world for man's existence and action.'[3]

When Faith Moves Mountains is consistent with Alÿs's tendency to withdraw as the artistic subject of the work. This does not at all mean that he also withdraws responsibility for it, but it does acknowledge that the significance of an artistic event lies in its potential to open a world 'for man's existence and action'. Alÿs shares this reticence with certain Conceptual practices of earlier decades. For instance, his 'paseos', although derived from a different set of parameters, recall Adrian Piper's 1970-71 Catalysis series of absurd street performances; intended to elicit surprised responses from the passers-by, these interventions were, as she has said, not 'art' in so far as she was not posing herself as the object, but 'propositions' about art. Or one might invoke Lawrence Weiner's text 'sculptures' about form or materials, and Luis Camnitzer's text-based work of the late 1960s; rather than impose an image or object, these works were intended to activate the individual imagination of the viewer, since anyone could visualize the work according to his or her own experience. This attentiveness to the way the viewer imaginatively negotiates the work, although still based in formal concerns, is already political in so far as it posits a concept of art as inherently dialogical and non-hierarchical. And yet Alÿs's projects (like Piper's and Camnitzer's subsequent work) extend this propositional dimension of art much further into the socio-political sphere, such that the very absence of tangible object in When Faith Moves Mountains brings the frame, or socio-political context in which the work was produced, into sharper relief. For this reason it also poses some rather difficult questions regarding the ethical responsibility of the artist, questions that also demand that we rethink the aesthetic and the political as not inherently irreconcilable categories of experience.

To make art more answerable to 'real life' has been a persistent drive of the politically conscious artist at least since the 1960s, but politically motivated art has always been caught in a dilemma between the desire for artistic freedom and the demands of political activism, a dilemma in which poiesis has too often ceded to praxis. And yet one has to ask whether this is not a false antinomy based on the old assumption that the aesthetic was necessarily detached from everyday life, which is tantamount to claiming that the creative act could have nothing to say about the truth of existence, a patent absurdity. Art may be an excess of life, but in our encounter with it it brings its world to ours in what Gadamer described as a 'fusion of

horizons'. It is a space of interpenetration between these two worlds in which, rather than one mimicking the other, they are both put into mutual crisis. The need of contemporary art to understand and test the limits of this horizon, which I take to be one of the drives behind <u>When Faith Moves Mountains</u>, was also manifest in Documenta 11 in 2002. The exhibition's curators deliberately set out to interrogate the relation of artistic practices to neo-colonial globalization; against the historical convention of such international events to showcase formally inventive work, they selected practitioners who sought ways by which to confront real social and political issues. The consequence, however, was a slippage between documentary and artistic practices that begged the question of their respective efficacy in producing new truths for understanding reality.

Among the primary goals of the documentary – and of activist art – is persuasion, which means that the language it uses must be unambiguous and already commonly understood; that is, there is an assumption that words and images are directly communicable. But if one reproduces the language of established, hegemonic discourses without challenging the ideological motives that underline both their structures of representation and forms of reception – in effect, their claims to truth – then one ends up conforming to the conservative politics one wants to oppose. Hence the rhetoric of politically motivated art has tended either to reconfirm authority – often by seeking to occupy its place – or to become appropriated and neutralized by it, a problem that dogged activist art of the 1960s and 1970s.

If, however, we take the view that the poetic and political efficacy of art lies not in the transmission of mere information but in insight – what Heidegger called the 'unconcealment' of truth – then its modus operandi must involve a suspension of signification. This may be experienced as liberatory joy or intense anguish, but in either case it mobilizes the feelings and imagination of the viewer, an affectivity that depends less on its status as a physical image per se than as an encounter with an event and a vector of a thought. By this route we come closer to appreciating the subtlety of Alÿs's work. Art, for Heidegger, 'institutes a world', meaning that art as poiesis produces a hitherto unthought configuration of reality. To do this, art needs to provide the conditions of an event, but for it to be an event it cannot, strictly speaking, present what is already known. Thus the radical event of art precipitates a crisis of meaning or, rather, it exposes the void of meaning at the core of a given social situation, which is its 'truth'. This truth is not something already there to be discovered – like the laws of gravity, or how many civilians were killed in the American bombing of Baghdad – but is created in response to a world and a self in a continuous state of

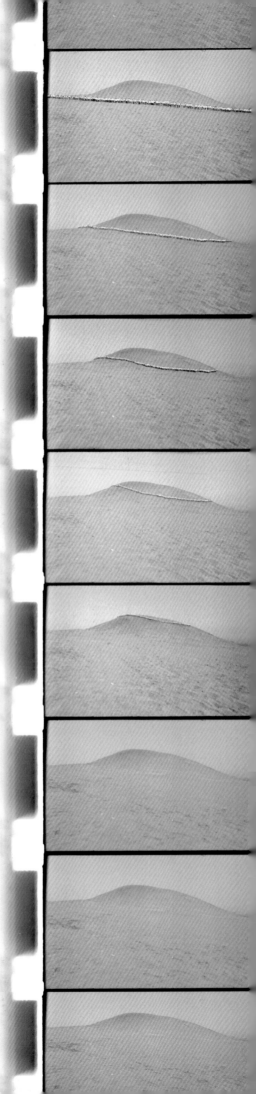

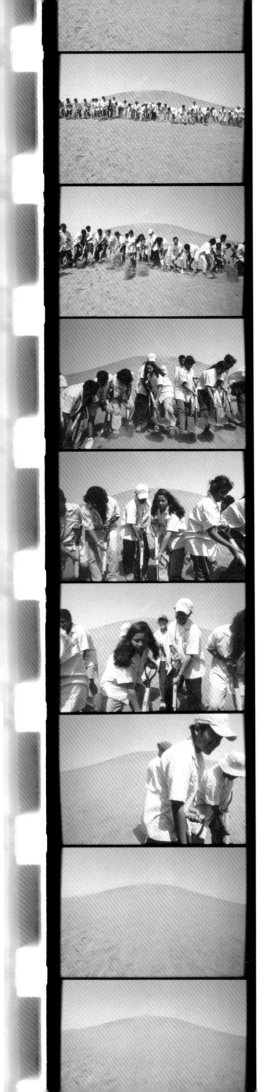

transformation. What this means, as Bakhtin recognized, is that each act performed in the world at each singular moment has its transformative consequences, however localized, and herein lies the ethical responsibility not only of the artist but of us all: that the ethical arises in our answerability to our own actions, not in any prior moral rules.

Typically, Alÿs's work does not attempt to fill this unconscious void with a plethora of images but to hollow it out, and this is the trait we see playfully excavated in, among other works, Magnetic Shoes (1994), The Loop (1997) and Paradox of Praxis 1 (1997). Deleuze maintained that, contrary to conventional opinion, the artist was not so much the patient suffering some form of psychosis in need of treatment, but the 'diagnostician' of civilization, capable of identifying the symptoms of a social pathology prior to any general awareness of it.[4] And it is precisely this moment of artistic insight, when our habitual structures of reality are shown to no longer make sense, that the potential arises for a collective demand for change.

What When Faith Moves Mountains shares with Alÿs's earlier 'demonstration', Cuentos Patrióticos (1997), is the articulation of a poetic metaphor with collective agency.[5] The question is, what is it that links a movement seemingly originating in individual sensibility to a collective response? What is it about When Faith Moves Mountains that enables an apparently absurd thought to gather to it a body of unpaid participants and then touch the imagination of an art world at a considerable distance from its site of execution? Agency is experienced in the decisions subjects and communities make in mapping and positioning themselves relative to sites of power. This is precisely the point of articulation of the ethical – not a given set of rules, which are by no means universal, but something produced in the encounter with an event for which one has no ready-to-hand explanations. This is the moment of the ethical that Bakhtin refers to and that Zygmunt Bauman describes as preceding the moral law.[6] Alain Badiou relates this moment to Lacan's notion of the Real, a realization of a truth – a void of meaning at the core of any situation, which is nonetheless its unacknowledged or hidden foundation.[7] The subject is seized by a realization that alters its existing perception of the world and sense of self within it, producing a 'becoming-other' than itself. The subject is what the intuition produces. Hence, if each act performed creates a new configuration of self and world, then it also animates a new ethical evaluation.[8] Badiou's famous example is Saint Paul's conversion on the road to Damascus, and we might add that both artistic insight and faith, referred to in Alÿs's title, are experiences of the human spirit that exist in excess of scientific proof or of instrumental reason in general. What this means is that art as insight

does not render up a subject of knowledge, since it is precisely the privileged subject that is dissolved here, but access to what Jean-Luc Nancy calls the 'origin': neither the origin of the world nor of a psychological self, but of each moment in its singularity, where artist and viewer find common ground.

Central to all these accounts is the proposition that each singular moment is constitutive of shared existence. As Bakhtin insists, 'To live from within myself, from my unique place in Being, does not yet mean at all that I live only for my own sake; as I approach the other in its own singularity I acknowledge my answerability to that other and to myself as a responsible participant in the always becoming world-as-event.'[9] As Nancy argues, we must forge a different path from the post-Enlightenment privilege of Being, which conceals the fact that 'I' is mutually constituted with others. 'I' is always and already 'us', 'being-together': 'Being does not have meaning. There is no meaning if meaning is not shared.'[10] From this point of view, art's origin and destiny no longer move from and to an autonomous self, the assumption of modernism, but in 'being-together', an essential sharing of existence in which the Western notion of the privileged artistic subject is no longer sustainable.

This spirit of conviviality is, for me, the motivating force behind <u>When Faith Moves Mountains</u>, initiating and uniting community as a shared experience of a thought, from the group of mostly engineering students who participated in the event at the site, to the people of the pueblo jóven who took it upon themselves to protect the site from interference while the work was in progress, to the art world, which receives the idea through the chain of documentation and commentary – a movement connecting the local to the global. In other words, as several commentaries have pointed out, <u>When Faith Moves Mountains</u> initiates a storytelling function, and Alÿs himself has spoken of the work's potential to become a 'fable or urban myth', consistent with the intentions of his work in general.[11] Deleuze calls this 'fabulation', which he emphatically places in the domain of collective utterance.[12] Fabulation concerns neither psychological nor historical memory as such (although it may draw on this) but the event through which teller and listener, or image and viewer, enter into a mutual relation of transformation. For the author, it is the task of the artist to invent new uses of language through which the collective may see the possibility of reinventing itself. Every new community needs its myths and storytellers on which to found its cohesion, or right to exist against the forces of fragmentation, as Patrick Chamoiseau's epic novel <u>Texaco</u>, set in the post-slavery conditions of Africa's descendants in Martinique, perfectly describes.[13] As it happens, both Texaco – the jumble of 'hutches' on the outskirts of City (Fort-de-France) – and the pueblo jóven of Ventanilla on the dunes outside Lima are founded in the

WHEN FAITH MOVES MOUNTAINS, 2002
IN COLLABORATION WITH CUAUHTÉMOC
MEDINA AND RAFAEL ORTEGA
PHOTOGRAPHIC DOCUMENTATION OF AN
EVENT, LIMA, PERU

unpromising shadow of an oil refinery. Sand, an organically inert material, provides little sustenance for life but is nonetheless an ingredient in the material for building foundations. Both When Faith Moves Mountains and Texaco invite us to consider that in repressive regimes the cruellest act is perhaps not to deprive a people of its body but of the ground and will to imagine new possibilities of life. Art, of course, does not produce grand revolutions, but as an event that opens up a new narrative about reality it provides the conditions of possibility for a nascent political consciousness, one born from conviviality, a being-together as a coming-into-being of community: the realization of shared existence.

When Faith Moves Mountains is a reminder that, faced with the ever-increasing instrumentalization of life under globalism, the responsibility of artistic practices is not to relinquish the right to imagine, but to invent new uses of language and new tactics of engagement with community – in other words, not the patronizing notion of 'bringing art to the masses', which still inscribes the attitudes of Western institutions and 'social' art practices, but a reconfiguration of practices capable of penetrating different social spaces and collective imaginaries. Or, as Camnitzer puts it, 'The discussion is not one about the ethics of art-making under dire circumstances, or the measurement of its direness, but about the possibility and duty of sustaining a useful militancy and, further, society's critical ability and sanity. That is, keeping alienation in check, everybody's alienation, no matter what.'[14] To keep alive the will to imagine is also to invent new ethical landscapes, new narratives and new agents of social change. It is utopian without promising Utopia.

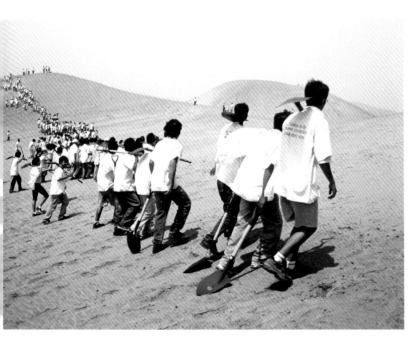

WHEN FAITH MOVES MOUNTAINS, 2002
IN COLLABORATION WITH CUAUHTÉMOC
MEDINA AND RAFAEL ORTEGA
PHOTOGRAPHIC DOCUMENTATION OF AN
EVENT, LIMA, PERU

The Green Line (2004), Alÿs's 'paseo' through Jerusalem, revisits the question posed in When Faith Moves Mountains: what can be the relevance of a poetic act in the context of sustained political crisis?[15] As such, The Green Line functions as an extended and complementary exploration of the earlier work. The difference is that Jerusalem is a more militantly political context than Ventanilla, problematizing any notion of 'aesthetic neutrality'. To perform an act objectively in Jerusalem would be to succumb to the compromised liberal strategy favoured by Western media of reporting a 'balanced view' when the prevailing unequal relations of power demanded an ethical critique. Given that, as an outsider, the artist also could not be partisan, and so direct collaboration with local communities, as in When Faith Moves Mountains, was not an option, what position was available to him? Alÿs's solution was to retrace the map drawing made by Moshe Dayan in 1948, known as the 'green line', that inaugurated the partition of the city, but which topographically represented a contested sixty to eighty metre wide tract of land. Alÿs was filmed walking the 'green line' with a leaky tin of green paint, and the film then combined with recorded commentaries on Alÿs's action by both Palestinian and Israeli interviewees. By making a minimal intervention in a 'cartographic gap' no one can possess and hence from which no one can speak, the artist offered another position from the paradoxical ground of groundlessness.

In both When Faith Moves Mountains and The Green Line, meaning lies not in Alÿs's gesture but in what its absurdity discloses of the historical and sociopolitical framework that surrounds it. A poetic gesture intrinsically does not state a political position from which any determinate meaning can be derived; on the contrary, its value is its capacity to 'put meaning on trial' (as Adorno once said of Beckett's plays), to induce in its interlocutor a momentary loss of control over meaning from which a new insight and configuration of reality can emerge. Both When Faith Moves Mountains and The Green Line speak to questions of human belonging and dispossession, of the cartographies of colonialism. But this is not simply a territorial matter; it touches those relations that dehumanize feeling on both sides of a repressive divide. If the effect of conventional politics and its technologies is to disable human exchange and shrink existence to the limited world of 'interests', the effect of Alÿs's poetics is subversively political in its gift of the gesture as a potential catalyst for working through and reconfiguring reality, from senselessness to sense, impasse to passage, inhuman to human, towards a more expansive politic of solidarity and conviviality.

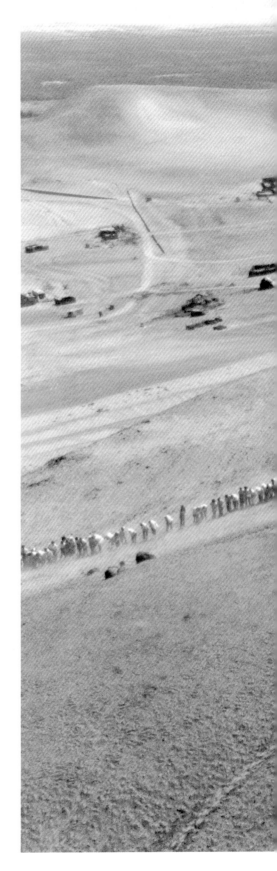

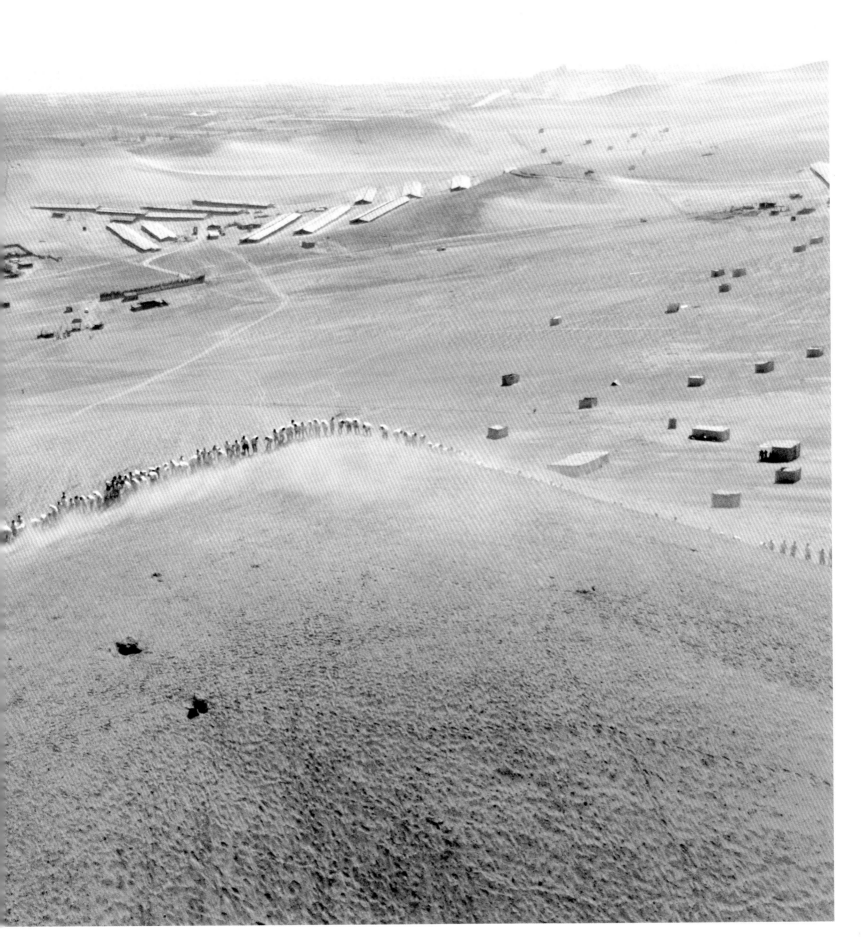

Augusto Monterroso
The Black Sheep (La oveja negra)
1969

Many years ago in a faraway land there lived a Black Sheep.

It was shot.

A century later the sorry flock raised an equestrian statue to it, which looked very fine in the park.

So from then onward whenever a black sheep appeared it was quickly shot so that future generations of common sheep could also practise the art of sculpture.

TRANSLATED FROM SPANISH BY MARION IVERSON

En un lejano país existió hace muchos años una Oveja negra.

Fue fusilada.

Un siglo después, el rebaño arrepentido le levantó una estatua ecuestre que quedó muy bien en el parque.

Así, en lo sucesivo, cada vez que aparecían ovejas negras eran rápidamente pasadas por las armas para que las futuras generaciones de ovejas comunes y corrientes pudieran ejercitarse también en la escultura.

previous pages, UNTITLED, 2002
OIL, ENAMEL AND ENCAUSTIC ON MASONITE
20 X 30 CM

below, UNTITLED, 2006
PHOTOGRAPHIC DOCUMENTATION
OF AN ACTION, MEXICO CITY

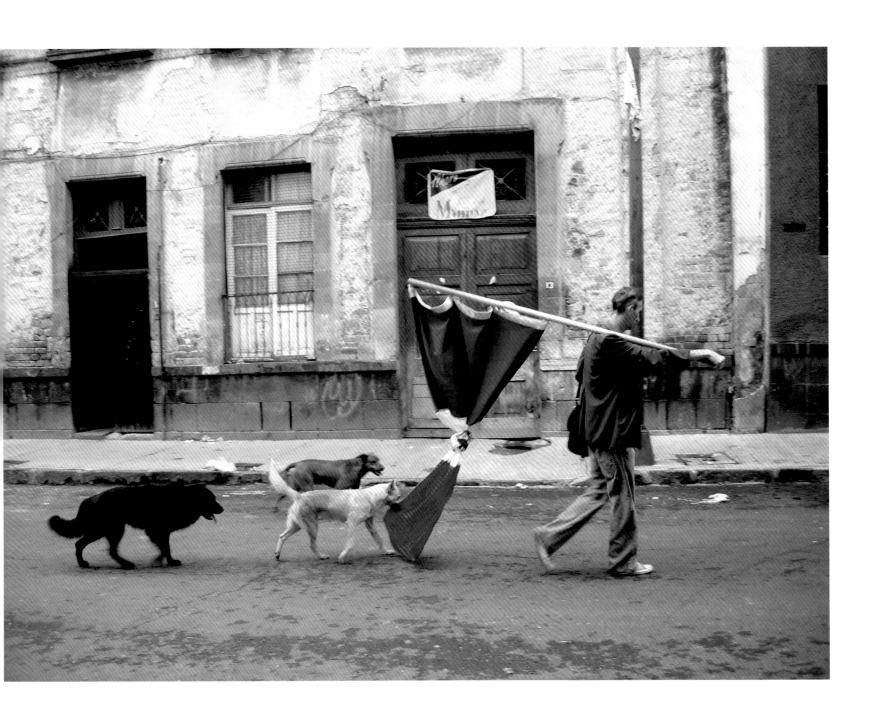

Augusto Monterroso
The Two Tails, or the Eclectic Philosopher
(Las dos colas, o el filósofo ecléctico)
1969

According to legend, every morning in the crowded market of an Ancient City there walked an eclectic philosopher, a renowned observer of Nature, whom many people approached with their most troubling conflicts and doubts.

One time, while a dog was chasing itself in circles and biting its own tail, to the laughter of the children who stood around it, several worried merchants asked the philosopher what all this commotion could mean, and if it might not be an unfortunate omen.

The philosopher explained that by biting its tail the dog was only trying to get rid of its fleas.

With this, the general curiosity was satisfied, and the people left in peace.

On another occasion, a snake charmer was displaying his basket of serpents, one of which was biting its own tail, eliciting seriousness in the children and laughter in the adults.

When the children asked the philosopher what might be the cause, he responded that the serpent that bites its tail represents the Infinite and the Eternal Return of people, facts and things, and this is what serpents mean when they bite their tails.

On this occasion, too, the people left satsified and equally peaceful.

TRANSLATED FROM SPANISH BY MARION IVERSON

Cuenta la leyenda que en el populoso Mercado de una Antigua ciudad se paseaba todas las mañanas un filósofo ecléctico, célebre observador de la Naturaleza, a quienes muchos se acercaban para exponerle los más peregrinos conflictos y dudas.

Cierta vez que un Perro daba vueltas sobre sí mismo mordiéndose la cola ante la risa de los niños que lo rodeaban, varios preocupados mercaderes preguntaron al filósofo a qué podía obedecer todo aquel movimiento, y que si no sería algún funesto presagio.

El filósofo les explicó que al morderse la cola el Perro trataba tan solo de quitarse las Pulgas.

Con esto, la curiosidad general quedó satisfecha y la gente se retiró tranquila. En otra ocasión, un domador de Serpientes exhibía varias en un canasto, entre las cuales una se mordía la cola, lo que provocaba la seriedad de los niños y las risas de los adultos.

Cuando los niños preguntaron al filósofo a qué podía deberse aquello, él les respondió que la Serpiente que se muerde la cola representa el Infinito y el Eterno Retorno de personas, hechos y cosas, y que esto quieren decir las Serientes cuando se muerden la cola.

También en esta oportunidad la gente se retiró satisfecha e igualmente tranquila.

equivalen

entre 2 ondas
×

(Broken
record,

Broken
mirror

Solo //

1998 —

péndulo

1999 —
|
2001

E
E N
E E N S
E E N S A
E N S A Y
E N S A Y O
E N S A Y
E N S A
E N S A
E N
E

2/3

CANTOS
círcle

REHEARSAL
ENSAYO

M

000 — R.E.H.E.A.

2000-6 BOLERO

REHEARSA
ENSAYO

2001

LOOKING

'entre 2 guas'

la demora
delaying the
conclusion

sí pero no) indeterminación BOLERO
no pero sí

NICS of REHEARSAL investigation/
 Time Schemes
n, L hacer / Po concepts of Efficiency,
 deshacer UN Productivity
 Development
OETICS of REH 'Modernity'
ITICS OF REHEA

retaining time
postponing the conclusion) 3 steps fwd

(N ≠ 55) de style — Alauos Pere

Feeling my hair / hair of the dog /

dog watching painter / painter in a bag /

bag in the river / river in frame /

framing the scene / seen through my eyes /

eyes to his mind / mind to my hand /

hand to his brush /

brush for a tail / tail to the nose /

knows as through skin / skin of my hands /

hands feel like gloves / gloves tracing lines /

lines drawing words / words will not do ?

you

do-it-yourself .

gloves in between /

in between words /

1991

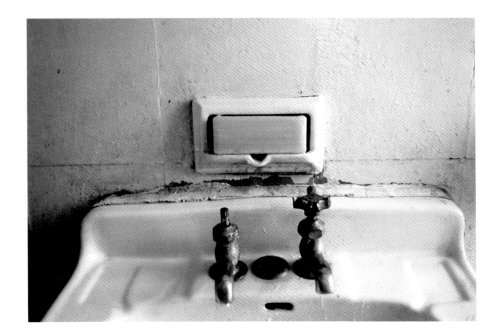

UNTITLED (MEXICO CITY), 1990
COLOUR PHOTOGRAPH

UNTITLED (TLAYACAPAN, MORELOS), 1992
COLOUR PHOTOGRAPH

UNTITLED, 1990
CARDBOARD BOX AND FOUND TOY
35 x 35 x 70 CM

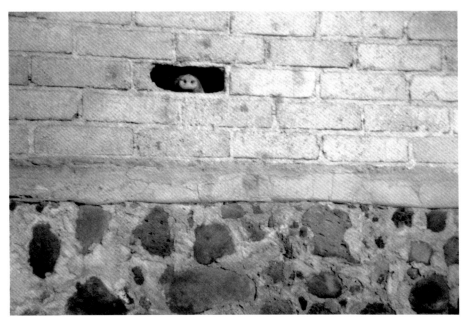

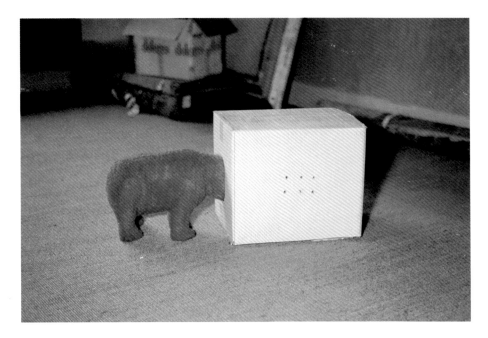

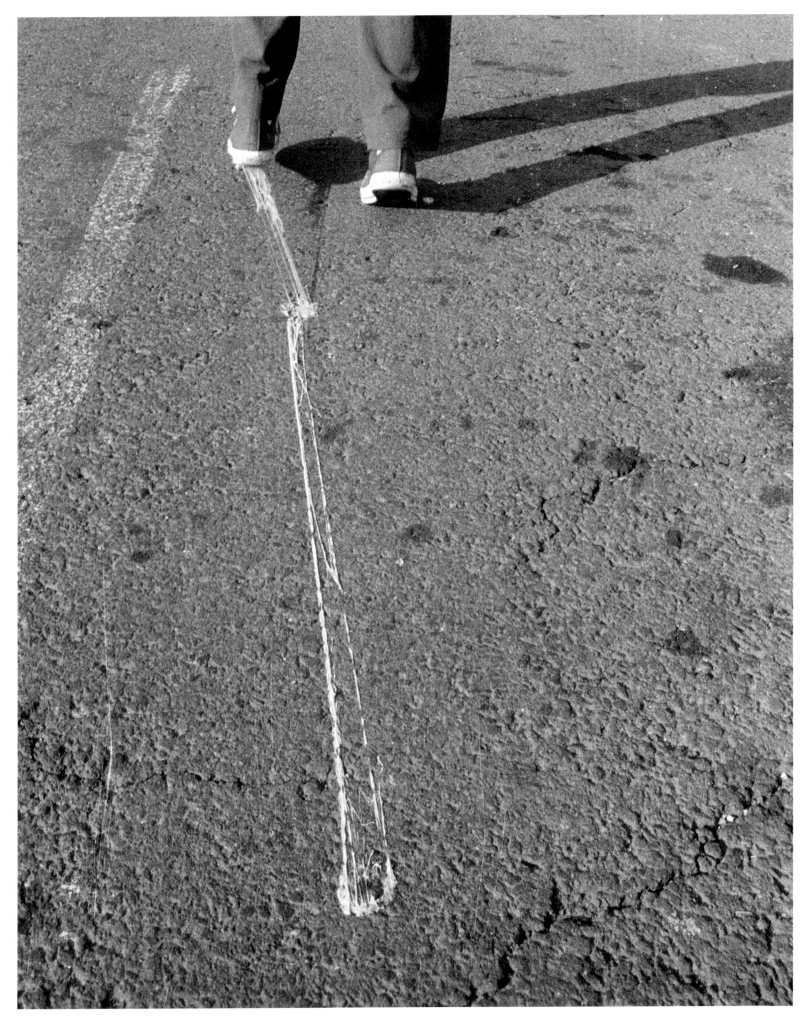

```
AS LONG AS I'M WALKING, I'M NOT CHOOSING
  "    "    "    "        "      , I'M NOT SMOKING
  "    "    "    "        "      , I'M NOT LOSING
  "    "    "    "        "      , I'M NOT MAKING
  "    "    "    "        "      , I'M NOT KNOWING
  "    "    "    "        "      , I'M NOT FALLING
  "    "    "    "        "      , I'M NOT PAINTING
  "    "    "    "        "      , I'M NOT HIDING
  "    "    "    "        "      , I'M NOT COUNTING
  "    "    "    "        "      , I'M NOT ADDING
  "    "    "    "        "      , I'M NOT CRYING
  "    "    "    "        "      , I'M NOT ASKING
  "    "    "    "        "      , I'M NOT BELIEVING
  "    "    "    "        "      , I'M NOT FUCKING
  "    "    "    "        "      , I'M NOT DRINKING
  "    "    "    "        "      , I'M NOT CLOSING
  "    "    "    "        "      , I'M NOT STEALING
  "    "    "    "        "      , I'M NOT MOCKING
  "    "    "    "        "      , I'M NOT FACING
  "    "    "    "        "      , I'M NOT CROSSING
  "    "    "    "        "      , I'M NOT CHANGING
  "    "    "    "        "      , I'M NOT CHEATING
  "    "    "    "        "      , I'M NOT TALKING
  "    "    "    "        "      , I'M NOT REACHING
  "    "    "    "        "      ,
  "    "    "    "        "      ,
  "    "    "    "        "      ,
  "    "    "    "        "      , I WILL NOT REPEAT
  "    "    "    "        "      , I WILL NOT REMEMBER
```

1992

UNTITLED, 2001
PHOTOGRAPHIC DOCUMENTATION
OF AN ACTION, MUSEU SERRALVES,
PORTO

A walk through the gardens of
the Casa Serralves resulted in
two pebbles in my left shoe.

10 Predicaments

1 — walk the painting

2 — memorize the Odyssey

3 — buy milk

4 — steal the dog

5 — water the peacock

6 — lose the sculpture

7 — break step

8 — shoot at random

9 — read the bible

10 —

Every day

I would go out and walk

pacing the grid of Manhattan

there would be no expectations

or destinations

just the walking

and the counting

North to South and South to West

West to East and East to South

South to North and North to West

West to South and South to East

East to West and West to East.

 NYC, sept to dic 2001

PACING, 2001
GRAPHIC DOCUMENTATION
OF AN ACTION, NEW YORK
PENCIL ON NOTEBOOK PAGES
EACH 16 X 22 CM

– doubting dunes

– tuning the wind

– chasing mirages

– phasing tornadoes

– stealing echoes

– sweeping the rain

– deviating the river

– waiting the sun

 the shadow

2005

They say that the Teheulche hunted the
ñandú (Rhea americana) by physically
exhausting the animal. The entire
tribe would walk for weeks, chasing
the flock until the ñandú would give
up or die of exhaustion. We of our time
must chase mirages.

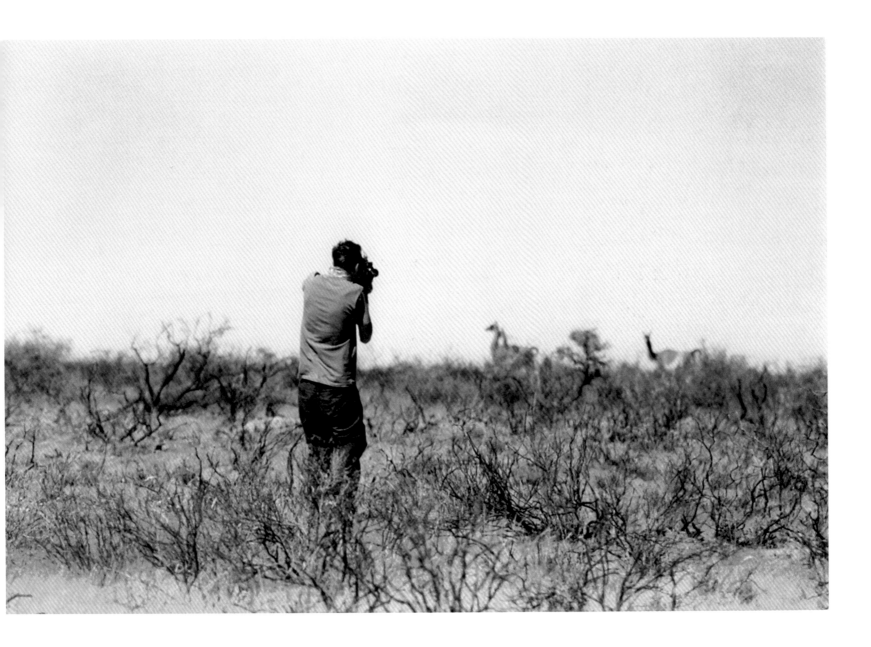

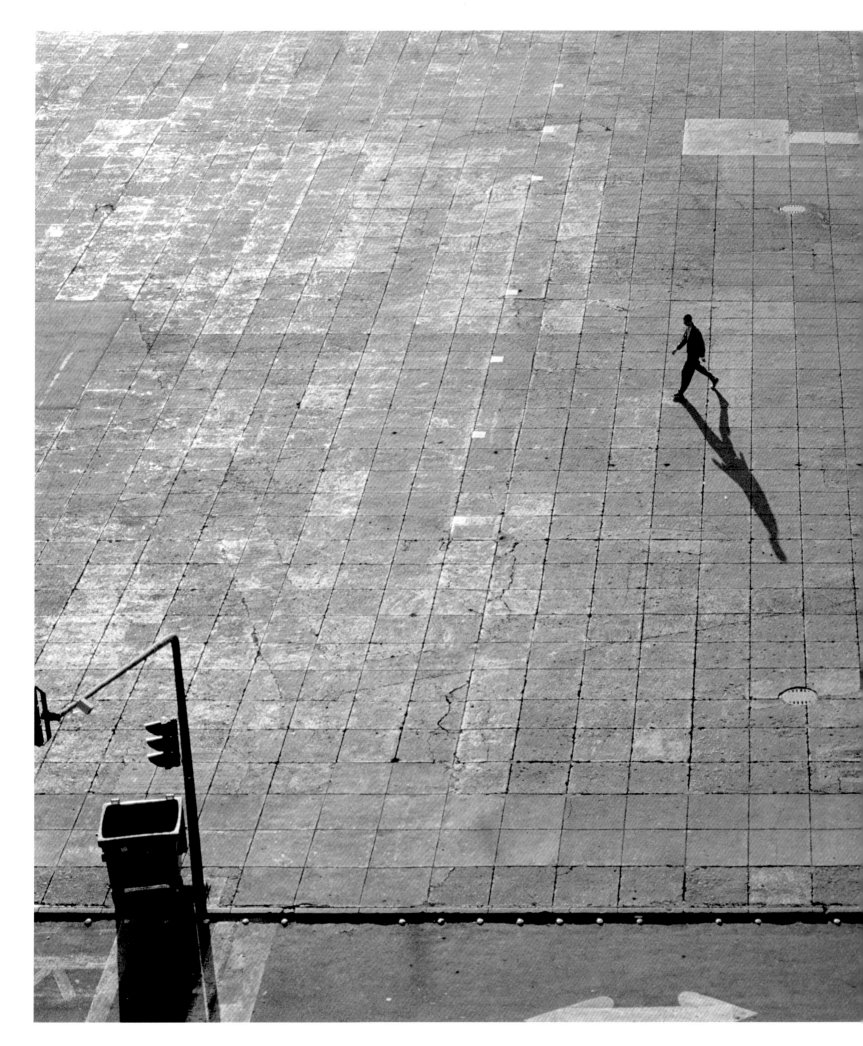

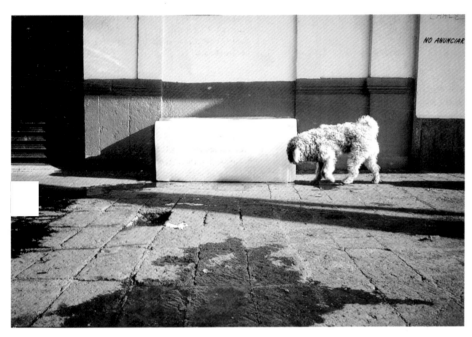

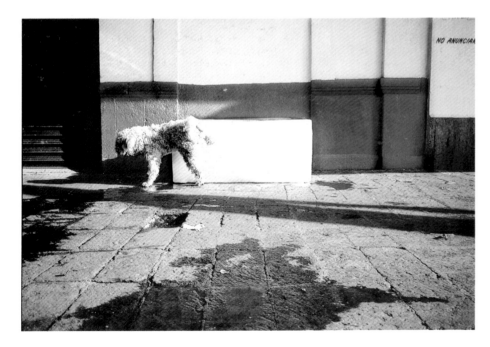

NOTES

<u>SURVEY</u>: PAGES 057–107

1 Francis Alÿs, notes on *Remolinos*, c. 2004.

2 Miguel de Cervantes Saavedra, *Don Quixote, Part 1* (1605), in *The Harvard Classics Chapter VIII*, Harvard University Press, Cambridge, Massachusetts, 1909-14.

3 Francis Alÿs, handwritten note, c. 1990

4 Although he has lost this dissertation, Alÿs has consistently referred to it as the origin of his way of thinking in many areas.

5 Francis Alÿs, handwritten note, c. 1990.

6 Francis Alÿs, subtitle of the artwork *Fairy Tales*, 1995.

7 Francis Alÿs, 'Statement', Mexico City, 1993, in *Walks/Paseos*, Travesías, Mexico City, 1997, p. 15.

8 Francis Alÿs, from an outline of a talk, c. 1992.

9 Francis Alÿs, draft notes, c. 2002.

10 I am quoting both from Francis Alÿs's 'Blueprint for The Collector', which includes the drafts of his statements around this piece and a record of its fabrication, and the texts by Kurt Hollander and Cuauhtémoc Medina in the catalogue of the first exhibition of the object in one of his earliest gallery shows: *Francys Alÿs*, Galería Arte Contemporáneo, Mexico City, 1992.

11 This object, and the documentation of its production, was finally exhibited in the spring of 1992 in Alÿs's solo show at the Galería Arte Contemporáneo in Mexico City, curated by Maria Guerra.

12 Charles Baudelaire, 'El pintor de la vida moderna', in Balzac et al., *El Dandismo*, Prol. Salvador Clotas, Anagrama, Barcelona, 1974, p. 88 (author's translation).

13 Walter Benjamin, 'The Paris of the Second Empire in Baudelaire', in *Walter Benjamin: Selected Writings, Vol. 4, 1938-1940*, Belknap/Harvard University Press, Cambridge, Massachusetts, p. 19.

14 Walter Benjamin, 'On Some Motifs in Baudelaire', in *Walter Benjamin: Selected Writings, Vol. 4, 1938-1940*, p. 329.

15 Attila Kotányi and Raoul Vaneigem, 'Elementary program of the bureau of Unitary Urbanism' (1961), in Ken Knabb (ed.), *Situationist International Anthology*, Bureau of Public Secrets, Berkeley, California, 1981, pp. 65-7. See also, Guy Debord, *The Society of the Spectacle* (trans. Donald Nicholson-Smith), Zone Books, New York, 1994, pp. 119-27.

16 Guy Debord, 'Theory of the dérive', in Libero Andreotti and Xavier Costa (ed.), *Theory of the Dérive and Other Situationist Writings on the City*, Museo d'Art Contemporani de Barcelona-Actar, Barcelona, 1996, pp. 22-7.

17 See 'Unitary Urbanism at the End of the 1950s' (unsigned), in *Situationist International Anthology* (op. cit.), pp. 83-8.

18 Gilles Ivan, 'Formulary for a New Urbanism' (1958), in *Theory of the Dérive and Other Situationist Writings on the City*, op. cit., p. 17.

19 See Guy Debord, 'Two Accounts of the Dérive' (1956), in ibid., p. 31.

20 Francis Alÿs, 'Statement' (1993), in *Walks/Paseos*, op. cit., p. 15.

21 Ibid., pp. 106-7.

22 E-mail from Francis Alÿs, Rangoon, 21 June 1997, to Olivier Debroise.

23 E-mail from Francis Alÿs, Shanghai, 23 June 1997, to Olivier Debroise. See in this volume, p. 52.

24 Olivier Debroise, 'Diario de una deriva VI', 1995, unpublished.

25 Kitty Scott, 'Permutations of a failed idea', in *Francis Alÿs: Le Temps du Sommeil*, Contemporary Art Gallery, Vancouver, 1998, p. 39.

26 'In 1993 I commissioned various sign painters to produce enlarged copies of my smaller original images. Once they had completed several versions, I produced a new 'model', compiled from the most significant elements of each sign painter's interpretation. This second 'original' was in turn used as a model for a new generation of copies by sign painters, and so on, ad infinitum, according to market demand.' Francis Alÿs, in Barry Schwabsky, et. al., *Vitamin P: New Perspectives in Painting*, Phaidon, London & New York, 2002, p. 35.

27 Article 33 of the Constitution of Mexico states that foreigners 'may not, in any manner, involve themselves in the political affairs of the country' and that they can be expelled from the country 'immediately and without the necessity of previous legal action' by the govermnment.

28 Francis Alÿs, 'Statement on Heisenberg's uncertainty principle', c. 1998.

29 Frederic Jameson, *A Singular Modernity: Essay on the Ontology of the Present*, Verso, London, 2002, p. 8.

30 Letter from the artist to curator Olivier Debroise, 15 February 2006, quoted in Olivier Debroise, 'White Spot', in *Francis Alÿs: A Story of Deception/ Historia de un desengaño*, Museo de Arte Latinoamericano de Buenos Aires, 2006, p. 74.

31 Francis Alÿs, 'Fragments of a conversation', in ibid., p. 81.

32 Note on the project in Patagonia, reproduced in ibid., p. 33.

33 Hannah Arendt, *The Human Condition*, University of Chicago, Chicago, 1958, p. 98.

34 Mikhail Bakhtin, 'Forms of Time and of the Chronotope in the Novel: Notes toward a Historical Poetics', in Michael Holquist (ed.), *The Dialogic Imagination*, trans. Caryl Emerson and Michael Holquist, University of Texas Press, Austin, 1981, pp. 84-5.

35 Francis Alÿs, 'Statement on the Politics of Rehearsals', c. 2003.

36 Hannah Arendt, op. cit.

<u>FOCUS</u>: PAGES 109-121

1 Hans-Georg Gadamer, *The Relevance of the Beautiful and Other Essays*, trans. Nicholas Walker, Cambridge University Press, Cambridge, England, 1986, p. 22-23.

2 Richard Long interviewed by Colin Fitzpatrick in *Transcript*, vol. 2, no. 2, 1996: 'There is some comment on the lack of people in my work, but it is just a question of choice, the subject of my work is walking, or making sculpture in empty landscape. Most of the world's surface is still open landscapes. I feel I'm a realist working in the real spaces of the world.'

3 Giorgio Agamben, *The Man Without Content*, trans. Georgia Albert, Stanford University Press, Palo Alto, California, 1999, p. 72.

4 Gilles Deleuze, *The Logic of Sense*, trans. Mark Lester with Charles Stivale, Columbia University Press, New York, 1990, pp. 237-238.

5 For a full analysis of this work see Cuauhtémoc Medina, 'Action/ Fiction', in *Francis Alÿs*, Musée Picasso, Antibes, 2001, pp 16-20.

6 Zygmunt Bauman, *Postmodern Ethics*, Blackwell, Oxford, England, 1993, pp. 47-61.

7 Alain Badiou, *Ethics: An Essay on the Understanding of Evil*, trans. Peter Hallward, Verso, London & New York, 2001, pp. 47-52.

8 A crude illustration of this is the moment in the film Matrix when the hero Neo (Keanu Reeves) becomes aware that his reality has been a fantastic construction of the computer, and henceforth he must reinvent himself and destroy the machine.

9 M. M. Bakhtin, *Toward a Philosophy of the Act*, trans. Vadim Liapunov, University of Texas, Austin, 1993, p. 48. Bakhtin's reading of the ethical as mutual answerability derives from his attempt to reconcile the seemingly insurmountable gap between lived experience and its cultural representation, which is also the trajectory traced through the three 'lives' of *When Faith Moves Mountains*.

10 Jean-Luc Nancy, *Being Singular Plural*, trans. Robert D. Richardson and Anne E. O'Byrne, Stanford University Press, Palo Alto, California, 2000, p. 2.

11 Francis Alÿs, 'A Thousand Words', *Artforum*, Summer 2002, p. 147.

12 Gilles Deleuze, *Cinema 2: The Time-Image*, trans. Hugh Tomlinson and Robert Galeta, The Athlone Press, London, 1989, pp. 215-224. In speaking of the critique of disabling myths in Brazilian Glauber Rocha's cinema, Deleuze says, 'the agitprop is no longer the result of a becoming conscious, but consists of putting everything into a trance, the people and its masters, and the camera itself, pushing everything into a state of aberration.' This echoes Alÿs's desire for the event of *When Faith Moves Mountains* to provoke a 'collective hallucination'.

13 Patrick Chamoiseau, *Texaco*, trans. Rose-Myriam Réjoulis and Val Vinokurov, Vintage International, New York, 1997.

14 Luis Camnitzer, 'Conflict', *Art Nexus*, no. 47, March 2003.

15 *The Green Line* was designed to test the axioms, 'sometimes doing something poetic can become political' and 'sometimes doing something political can become poetic'.

CHRONOLOGY: Francis Alÿs, born 1959 in Antwerp, lives and works in Mexico City.

SELECTED EXHIBITIONS AND PROJECTS
1978–1995

SELECTED ARTICLES AND INTERVIEWS
1978–1995

1978–1983
Francis Alÿs attends Institut d'Architecture de Tournai, Belgium

1983–1986
Francis Alÿs attends Istituto Universitario di Architettura di Venezia, Venice

1986
Francis Alÿs moves to Mexico City

1990
SALÓN DES AZTECAS, Mexico City (solo)

1991
GALERIA ARTE CONTEMPORÁNEO, Mexico City (group)

BLUE STAR ART SPACE, San Antonio, Texas (group)

LATITUDE 53 GALLERY, Edmonton, Canada (group)

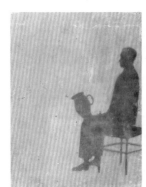

1992
'Francis Alÿs & Melanie Smith',
ESPACE L'ESCAUT, Brussels (solo)

GALERIA ARTE CONTEMPORÁNEO, Mexico City (solo)

'México hoy',
CASA DE LAS AMERICAS, Madrid (group)

1992
Medina, Cuauhtémoc, 'Painter in a Bag', Poliester, no. 2, summer

Springer, José Manuel, 'Garbage and Art in Mexico', Poliester, no. 3, fall

1993
'Rueda como Naturaleza',
MUSEUM DE ARTE MODERNO, Mexico City, toured to INSTITUTO CULTURAL CABAÑAS, Guadalajara (group)

Durante la V bienal, Francis Alÿs calza sus zapatos magnéticos y a través de sus paseos por las calles, recoge cualquier residuo metálico encontrado sobre su camino. Por esta recolección diaria va ampliándose su nuevo territorio, y asimila los barrios que va descubriendo.

Wearing his magnetic shoes, Francis Alÿs takes a daily walk through the streets of Havana and collects any metallic residue lying in his path. Walk by walk, he makes the new surroundings his own.

1994
'The Liar/The Copy of the Liar',
GALERIA RAMIS BARQUET, Monterrey, toured to ARENA MÉXICO ARTE CONTEMPORÁNEO, Guadalajara (solo)

FOODHOUSE, Santa Monica (group)

5th HAVANA BIENNIAL (group)

1994
Hollander, Kurt, 'Francis Alÿs', Flash Art, no. 179, November-December

1995
OPUS OPERANDI, Ghent, Belgium (solo)

'El Soplón',
GALERIA CAMARGO VILAÇA, São Paulo (solo)

JACK TILTON GALLERY, New York (solo)

'Longing and Belonging',
SITE SANTA FE, New Mexico (group)

ESPACE 251 NORD, Liège, Belgium (group)

1995
Jusidman, Yishai, 'Francis Alÿs at Galeria Ramis Barquet', Artforum January

Rubinstein, Raphael, 'Francis Alÿs at Jack Tilton', Art in America, November

Lerner, Jesse, 'The Work of Others', Poliester, no. 11, winter

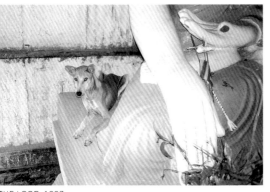

THE LOOP, 1997
PHOTOGRAPHIC DOCUMENTATION OF AN ACTION, BURMA

SELECTED EXHIBITIONS AND PROJECTS
1996–1998

1996
ACME, Santa Monica (solo)

'The Counterfeit Subject' (with Yishai Judisman),
MUSEO DE ARTE CONTEMPORÁNEO DE OAXACA, Mexico (solo)

'NoWhere',
LOUISIANA MUSEUM, Copenhagen (group)

'Pittura',
CASTELLO DI RIVARA, Italy (group)

1997
'Francis Alÿs: Walks/Paseos',
MUSEO DE ARTE MODERNO, Mexico City (solo)

JACK TILTON GALLERY, New York (solo)

'inSITE 1997'
CENTRO CULTURAL, Tijuana, and SAN DIEGO MUSEUM OF ART
(group)

'Antechamber',
WHITECHAPEL ART GALLERY, London (group)

'Addenda',
MUSEUM DHONDT-DHAENENS, Machelen, Belgium (group)

1st BIENAL DE ARTE TRIDIMENSIONAL, Mexico City (group)

2nd BIENNIAL OF SAAREMA, Estonia (group)

'Asi està la cosa',
CENTRO CULTURAL ARTE CONTEMPORÁNEO, Mexico City (group)

1998
'Le Temps du Sommeil',
CONTEMPORARY ART GALLERY, Vancouver (solo)

PORTLAND INSTITUTE FOR CONTEMPORARY ART, Oregon (solo)

24th SÃO PAULO BIENNIAL (group)

'Insertions',
ARKIPELAG, Stockholm (group)

'Loose Threads',
SERPENTINE GALLERY, London (group)

'1er Salón Internacional de Pintura',
MUSEO DE LA CIUDAD, Mexico City (group)

'Longitude de Onda',
MAO, Caracas (group)

3rd BIENAL BARRO DE AMÉRICA, Caracas (group)

'Imaginarios Mexicanos',
MUSEO DE LA CIVILISACIÓN, Quebec (group)

'Mexcellente',
YERBA BUENA CENTER FOR THE ARTS, San Francisco (group)

'Cinco Continentes y una Ciudad',
MUSEO DE LA CIUDAD, Mexico City (group)

SELECTED ARTICLES AND INTERVIEWS
1996–1998

1996
Ferguson, Bruce, 'Francis Alÿs', Flash Art, no. 188, May-June

1997
Darling, Michael, 'Francis Alÿs and the Return to Normality', Frieze,
no. 33, March-April

Guilbaut, Serge, 'Rodney Graham and Francis Alÿs', Parachute,
no. 87, spring

Medina, Cuauhtémoc, 'Francis Alÿs: Tu subrealismo', Third Text,
no. 38, spring

Hollander, Kurt, 'Francis Alÿs', Poliester, no. 18, spring

Rondi, Joëlle, 'Various Places', Art Press, June

Phillips, Andrea, 'A Path is Always Between Two Points',
Performance Research, no. 3, September

Hollander, Kurt, 'Under the Influence', Poliester, no. 20, fall

Rubinstein, Raphael, 'Francis Alÿs at Jack Tilton', Art in America,
November

1998
Gallo, Rubén, 'Francis Alÿs at Jack Tilton', Flash Art, no. 198,
January-February

Gallo, Rubén, 'Francis Alÿs', ArtNexus, no. 27, March

Arriola, Magali, 'Francis Alÿs: The Liar and the Copy of the Liar',
ArtNexus, no. 28, June

Alÿs, Francis, 'The Loop', Untitled, no. 16, summer

Laurence, Robin, 'Geometries of Conjecture', Border Crossings,
no. 4, October

Levin, Kim, 'Voice Choices', The Village Voice, 22-28 October

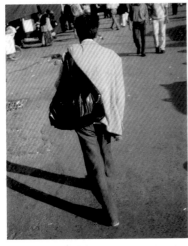

When arriving in ‹Istanbul› (new city), wander, looking for someone who could be you. If the meeting happens, walk beside your doppelgänger until your pace adjusts to his/hers. If not repeat the quest in ‹London›.(next city).

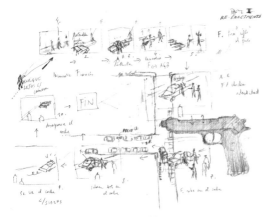

STUDY FOR RE-ENACTMENTS, 2000
PENCIL AND INK ON PAPER

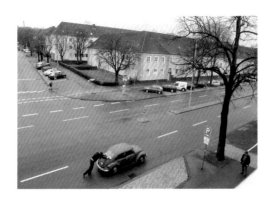

SELECTED EXHIBITIONS AND PROJECTS
1999–2000

1999
'Standby',
LISSON GALLERY, London (solo)

GALERIE PETER KILCHMANN, Zurich (solo)

MARIO FLECHA GALERIA, Girona, Spain (solo)

'Reality and Desire',
FUNDACIÓN JOAN MIRÓ, Barcelona (group)

48th VENICE BIENNALE (group)

1st MELBOURNE BIENNIAL (group)

'Thinking Aloud',
HAYWARD GALLERY, London (group)

'Stimuli',
WITTE DE WITH, Rotterdam (group)

6th ISTANBUL BIENNIAL (group)

'Mirror's Edge',
BILDMUSEET, Umeå, Sweden, toured to VANCOUVER ART GALLERY; CASTELLO DI RIVOLI, Turin; TRAMWAY, Glasgow; CARRILLO GIL MUSEUM, Mexico City (group)

'The Thief',
DIA CENTER FOR THE ARTS, New York (online project)

2000
'Francis Alÿs: The Last Clown',
FUNDACIÓ LA CAIXA, Barcelona: toured to McGILL UNIVERSITY GALLERY, Montreal; PLUG IN, Winnipeg, Canada (solo)

'Mixing Memory and Desire/Wunsch und Erinnerung',
KUNSTMUSEUM LUZERN, Lucerne (group)

'Making Time',
INSTITUTE OF CONTEMPORARY ART, Palm Beach, toured to UCLA HAMMER MUSEUM, Los Angeles (group)

'Age of Influence: Reflections in the mirror of American culture',
MUSEUM OF CONTEMPORARY ART, Chicago (group)

'Dream Machines',
DUNDEE CONTEMPORARY ARTS, toured to MAPPIN ART GALLERY, Sheffield; CAMDEN ARTS CENTRE, London (group)

'Out of Space',
KÖLNISCHER KUNSTVEREIN, Cologne (group)

'Europe: Different Perspectives in Painting'
MUSEO MICHETTI, Francavilla al Mare, Italy (group)

'Versiones del Sur: Latin America',
MUSEO NACIONAL REINA SOFÍA, Madrid (group)

'Residue',
KUNSTHALLE EXNERGASSE, Vienna (group)

7th HAVANA BIENNIAL, Havana (group)

'Uppsala International Contemporary Art Biennial',
EKEBY QVARN ARTSPACE, Uppsala, Sweden (group)

2nd MONTREAL BIENNIAL (group)

SELECTED ARTICLES AND INTERVIEWS
1999–2000

1999
Basualdo, Carlos, 'Head to Toes: Francis Alÿs's Paths of Resistance', Artforum, April

Green, Charles, 'Signs of Life', Artforum, September

Kurjakovic, Daniel, 'Finten des Geistes', Die Weltwoche, no. 37, 16 September

Aranda Marquez, Carlos, 'Frequent Stops: Carrillo Gil Museum, Mexico City', Flash Art, no. 208, October

Romano, Gianni, 'Why not painting?', Flash Art Italia, no. 218, October-November

Yard, S., 'Space on the Run – Life on the Loose: Recent Projects Along the San Diego-Tijuana Frontier', Architectural Design, no. 7-8

Williams, Gilda, '6th Istanbul Biennial', Art Monthly, no. 232, December-January

2000
Medina, Cuauhtémoc, 'Mexican Strategies: Rarefied Painting'; Gianni Romano, 'Webscape', and 'The Thief', Flash Art, no. 210, January-February

Herbert, Martin, 'Francis Alÿs', Time Out London, 19 January

Withers, Rachel, 'Francis Alÿs at Lisson Gallery', Artforum, March

Shier, Reid, 'Pause and Reflect', Vancouver, March

Kontova, Helena, 'Mirror's Edge'; Gianni Romano, 'Streets and Gallery Walls: Interview with Francis Alÿs', Flash Art, no. 211, March-April

Moreau, Patric, 'Mirror's Edge', Camera Austria, no. 70

Craddock, Sacha, 'In and Out of the Sun', Untitled, no. 21, spring

Phillips, Christopher, 'Report from Istanbul: Band of Outsiders', Art in America, April

Glover, Michael, 'Francis Alÿs', ArtNews, April

Benitez Dueñas, Issa Maria, 'Francis Alÿs: Hypotheses for a Walk', ArtNexus, no. 35, April-September

'International Shorts Preview: Athlete's Foot', Artforum, May

Mitchell, Charles Dee, 'Francis Alÿs at Lisson', Art in America, May

Packer, William, 'Screening Time', Financial Times Weekend, 6-7 May

Kent, Sarah, 'Watch this Space', Time Out London, 17 May

Kuoni, Carin, 'Gerüchte, Fährten und Trophäen: auf Spurensuche mit Francis Alÿs', Kunst-Bulletin, no. 6, June

Herbert, Martin, 'Francis Alÿs', Time Out London, 13 June

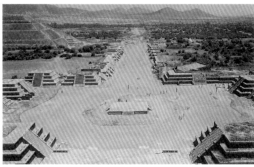

Een wandeling van de pyramide van de maan naar de pyramide van de zon bezorgde me drie kiezelstenen in mijn linkerschoen en twee kiezelsteenen in mijn rechterschoen.
A walk from the Pyramid of the Moon to the Pyramid of the Sun resulted in 3 pebbles in my left shoe and 2 pebbles in my right shoe.

STUDY FOR REHEARSAL II, 2001
OIL AND PENCIL ON TRACING PAPER
38 X 28 CM

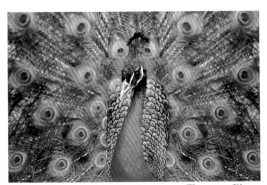

Mr. Peacock will represent Mr. Alÿs at the XLIX Biennale di Venezia.

SELECTED EXHIBITIONS AND PROJECTS
2000–2001

2001
'Francis Alÿs',
MUSÉE PICASSO ANTIBES, France (solo)

'1-866-Free-Matrix',
WADSWORTH ATHENEUM, Hartford, Connecticut (solo)

'L'Attente',
GALERIE PETER KILCHMANN, Zurich (solo)

'Amores Perros vs Camera' (with Alejandro Gonzales Iñarritu),
KUNST-WERKE, Berlin (solo)

'Douglas Gordon & Francis Alÿs',
LISSON GALLERY, London (solo)

'Videoserie in der Black Box: 6 Künstler – 6 Positionen',
SAMMLUNG GOETZ, Munich (group)

'A Walk to the End of the World',
THE FOKSAL GALLERY FOUNDATION, Warsaw (group)

'Loop',
HYPO KUNSTHALLE, Munich, toured to P.S.1 CONTEMPORARY ART CENTER, New York (group)

'The Big Show',
NEW INTERNATIONAL CULTURAL CENTER, Antwerp (group)

7th ISTANBUL BIENNIAL (group)

'God is in the Details: Films et vidéos d'animation',
CENTRE D'ART CONTEMPORAIN GENÉVE, Geneva (group)

'Looking at You: Kunst Provokation Unterhaltug Video',
KUNSTHALLE FRIDERICIANUM, Kassel, Germany (group)

'Francis Alÿs/Rafael Ortega, Pierre Huyghe, Beat Streuli & Gillian Wearing',
IKON GALLERY, Birmingham, England (group)

'Squatters',
MUSEU SERRALVES, Porto, toured to WITTE DE WITH, Rotterdam (group)

49th VENICE BIENNALE (group)

'Da Aversida de Vivemos: Lateinamerikanische Künstler',
MUSÉE D'ART MODERNE DE LA VILLE DE PARIS (group)

'Painting at the Edge of the World',
WALKER ART CENTER, Minneapolis (group)

SELECTED ARTICLES AND INTERVIEWS
2000–2001

2000 (cont.)
Jeffett, William, 'A Note on Francis Alÿs', NY Arts Magazine, July-August

Buchloh, Benjamin, 'Control, By Design', Artforum, September

Moreno, Gean, 'Polis as Playground: Contemporary Artists in Urban Space', Art Papers, no. 5, September-October

'Video Work', Frieze, no. 54, September-October

Medina, Cuauhtémoc, 'Formas politicas recientes: búsquedas radicales en México: Santiago Sierra, Francis Alÿs, Minerva Cuevas', Trans›arts, no. 8

Phillips, Andrea, 'A Dog's Life', Performance Research, no. 2

Mari, Bartomeu, 'Francis Alÿs: Lotgevallen van een grootstedelijk slaapvandelaar', Metropolis M, December

2001
Medina, Cuauhtémoc, 'Entre dos aguas: conversación entre Francis Alÿs', Curare, no. 17, January-June 2001

'Francis Alÿs: Döppelganger', Tate Magazine, spring

DeVuono, Frances, 'Tout le Temps/Every Time: La Biennale de Montréal', New Art Examiner, April

Mahoney, Elizabeth, 'Mirror's Edge', Art Monthly, April

Torres, David, 'Francis Alÿs: Simple passant just walking the dog', Art Press, April

Bishop, Claire, 'Kept in the Dark', Evening Standard, 22 May

Jetzer, Gianni, 'Protest! Respect!', Saiten, June

Alberge, Dalya, 'Portrait of the Artist as a Young Peacock', The Times, London, 6 June

Fallon, Michael, 'Minneapolis', Art Papers, no. 4, July-August

'Auf Plateausohlen zur Menschheit', Kunst-Bulletin, no. 7-8, July-August

Cooke, Lynne, 'Venice Biennale', The Burlington Magazine, no. 1182, September

Lefkowitz, David, 'Edgy Painting at the Edge of the World'; 'This Just In: Painting is Back', New Art Examiner, September-October

Medina, Cuauhtémoc, 'Zones of Tolerance: Teresa Margolles, SEMEFO and Beyond', Parachute, no. 104, October-December

Dorn, Anja, 'Out of Space', Frieze, no. 55, November-December

RAFAEL ORTEGA, FRANCIS ALŸS AND CUAUHTÉMOC MEDINA ON LOCATION OF <u>WHEN FAITH MOVES MOUNTAINS</u> IN LIMA, 2002

On your way to work everyday, Montags auf dem Arbeitsweg,
every morning, every Monday, jeden Morgen, jeden Tag,
sow Marijuana seeds along the way. Marihuana Samen-leg,
Every morning, every Tuesday, jeden Abend, jeden Tag.
on your way to work... Dienstags auf dem Arbeitsweg...

THE MUSEUM
AS MEDIUM

MEXICO CITY
April 22, 2003, 10 AM–5 PM
Centro Multimedia, Centro Nacional de las Artes, Mexico City
Keynote Speaker: James Putnam, Curator, Contemporary Arts and Cultures
Program, British Museum

Lynne Cooke, Curator, Dia Center for the Arts; Abraham Cruzvillegas, Artist;
James Elkins, Professor, Department of Art History and Criticism, School
of the Art Institute of Chicago; Andrea Fraser, Artist; Christine Hill, Artist;
Pablo Helguera, Senior Education Manager, Solomon R. Guggenheim
Museum; Cuauhtémoc Medina, Independent curator and critic; Antonio
Muntadas, Artist; Carmela Parker, Artist; Osvaldo Sanchez, Independent
critic and curator, Mexico City; Fred Wilson, Artist; Julian Zugazagoitia,
Executive Assistant to the Director, Guggenheim Museum.

NEW YORK
May 11, 2003, 10 AM–4:30 PM
Guggenheim Museum, New York
Keynote Speaker: Stephen Jay Gould, Author and Professor of Geology and
Zoology, Harvard University

Francis Alÿs, Artist; Marco Barrera Bassols, Director, Museum of Natural
History, Mexico City; Norman Bartkin, Director of the Graduate Program, Bard
Center for Curatorial Studies; Barbara Bloom, Artist; Nicolas Bourriaud,
Co-director, Palais de Tokyo, Paris; Abraham Cruzvillegas, Artist; Michael
Fehr, Curator; Rafael Lozano-Hemmer, Artist; Christine Hill, Artist; Allan
McCollum, Artist; James Putnam, Curator, Contemporary Arts and Cultures
Program, British Museum; Osvaldo Sanchez, Independent critic and curator,
Mexico City; Nancy Spector, Curator of Contemporary Art, Guggenheim
Museum; Gregory Volk, Independent critic and curator; Fred Wilson, Artist.

2001 (cont.)
'Exploding Cinema: Cinema without Walls',
MUSEUM BOIJMANS VAN BEUNINGEN, Rotterdam (group)

'In Aktion: Performance heute',
KUNSTVEREIN HAMBURG, (group)

2002
'Projects 76: The Modern Procession',
MUSEUM OF MODERN ART, New York (solo)

'Matrix.2',
CASTELLO DI RIVOLI, Turin (solo)

'Walking a Painting',
THE PROJECT, Los Angeles (solo)

'Cuando la fe mueve montañas/When Faith Moves Mountains',
3rd BIENAL IBEROAMERICANA DE LIMA (solo)

'Coartadas',
INSTITUT DU MEXIQUE Á PARIS (group)

'En Route',
SERPENTINE GALLERY, London (group)

'Axis Mexico: Common Objects and Cosmopolitan Actions',
SAN DIEGO MUSEUM OF ART (group)

8th BALTIC TRIENNIAL OF INTERNATIONAL ART, Vilnius (group)

'Mexico: Sensitive Negotiations',
CONSULADO DE MEXICO EN MIAMI (group)

4th SHANGHAI BIENNIAL (group)

'Structures of Difference',
WADSWORTH ATHENEUM MUSEUM OF ART, Hartford, Connecticut
(group)

'20 Million Mexicans Can't Be Wrong',
SOUTH LONDON GALLERY, London, toured to JOHN HANSARD
GALLERY, Southhampton, England (group)

'Mexico City: An Exhibition about the Exchange Rates of Bodies
and Values',
P.S.1 CONTEMPORARY ART CENTER, New York, toured to
KUNST-WERKE BERLIN (group)

'The Museum as Medium',
GUGGENHEIM MUSEUM, New York, and CENTRO NACIONAL DE
LAS ARTES, Mexico City (symposium)

Francis Alÿs is nominated for the Hugo Boss Prize,
Solomon R. Guggenheim Museum, New York

2003
'The Leak',
ARC/MUSÉE D'ART MODERNE DE LA VILLE DE PARIS (solo)

'The Prophet and The Fly',
CENTRO NAZIONALE PER LE ARTI CONTEMPORANEE, Rome,
toured to KUNSTHAUS ZÜRICH; MUSEO NACIONAL REINA SOFÍA,
Madrid; COLLECTION LAMBERT EN AVIGNON (solo)

'OUTLOOK',
Multiple venues, Athens (group)

'Somewhere Better Than This Place: Alternative Social Experience',
CONTEMPORARY ARTS CENTER, Cincinnati (group)

2002
Kantor, Jordan, 'Loop', <u>Artforum</u>, April

Pohlenz, Ricardo, 'Leisure at Jumex', <u>Flash Art</u>, no. 224, May-June

Anton, Saul, 'A Thousand Words: Francis Alÿs talks about When Faith
Moves Mountains', <u>Artforum</u>, summer

Bohlen, Celestine, 'Making a spectacle of MoMA's Big Move',
<u>International Herald Tribune</u>, 29 June

Bhatnagar, Priya, Samuele Menin and Michele Robecchi, 'Focus
Mexico'; Klaus Biesenbach, 'Hunting Men Hunting Dogs: Fear and
Loathing in Mexico City', <u>Flash Art</u>, no. 225, July-September

Edwards, C., 'Muralists, No!', <u>Art Review</u>, September

Gronlund, Melissa, 'Mexico City: An Exhibition About the Exchange
Rates of Bodies and Values', <u>Contemporary</u>, no. 43

Heiser, Jörg, 'Walk on the Wild Side', <u>Frieze</u>, no. 69, September

Wilson, Michael, 'International Preview: Life on the Streets',
<u>The Royal Academy Magazine</u>, no. 76, autumn

Güner, Fisun, 'Everyday Drive-by Shooting', <u>Metro Life</u>,
23 September

Cowan, Amber, 'Move Any Mountain', <u>Sleazenation</u>, October

Dailey, Meghan, 'Mexico City: An Exhibition About the Exchange
Rates of Bodies and Values', <u>Artforum</u>, November

Lavrador, Judicaël, 'Francis Alÿs', <u>Beaux Arts</u>

'Francis Alÿs: The Modern Procession', <u>In>process</u>, no. 3

'Mexico City', <u>Tema Celeste</u>, no. 94 , November-December

'Mexico City: An Exhibition About the Exchange Rates of Bodies and
Values', <u>ArtNexus</u>, no. 46, December

'Postcards from the Edge', <u>The Royal Academy Magazine</u>, no. 77,
winter

2003
Anton, Saul, 'One More Step'; Kitty Scott, 'Francis Alÿs: A Portrait';
Robert Storr, 'Strange Attractor', <u>Parkett</u>, no. 69

Herzog, Samuel, 'Im Wunderland', <u>Neue Zürcher Zeitung</u>, March

Ryser, Emmanuelle, 'Le Belge de Mexico', <u>Accrochage</u>, no. 46, April

Schindler, Anna, 'Der Wert des Lebens', <u>Kunstzeitung</u>, no. 81, May

Jolles, Claudia, 'Brütende Leere', <u>Kunst-Bulletin</u>, no. 5, May

Crowley, Tom, 'Mexico City on the Move', <u>Tema Celeste</u>, no. 97,
May-June

STUDY FOR <u>RAILINGS</u>, 2004
PENCIL ON TRACING PAPER
45 X 55 CM

SELECTED EXHIBITIONS AND PROJECTS
2003–2004

2003 (cont.)
'Stretch: Artists from Canada, USA, Mexico, Cuba, Guatemala, Colombia and Brazil',
THE POWER PLANT, Toronto (group)

4th BIENAL DEL MERCOSUR, Porto Alegre, Brazil (group)

'Szenenwechsel',
MUSEUM FÜR MODERNE KUNST, Frankfurt (group)

1st JAFRE BIENNIAL, Spain (group)

'The Labyrinthine Effect',
AUSTRALIAN CENTER FOR CONTEMPORARY ART, Southbank, Australia (group)

'MULTIPLECITY/CIUDAD MULTIPLE',
Multiple venues, Panama City (group)

'Edén',
LA COLECCIÓN JUMEX in the ANTIGUO COLEGIO DE SAN ILDEFONSO, Mexico City, toured to BIBLIOTECA LUIS ANGEL ARANGO, Bogotá (group)

'El aire es azul/The Air is Blue',
CASA MUSEO LUIS BARRAGÁN, Mexico City (group)

'Animation',
KUNST-WERKE BERLIN (group)

'Imágenes en movimiento/Moving Pictures'
GUGGENHEIM BILBAO (group)

'Fast forward: Media Art – Sammlung Goetz',
ZENTRUM FÜR KUNST UND MEDIENTECHNOLOGIE (ZKM), Karlsruhe, Germany, toured to CENTRO CULTURAL CONDE DUQUE and MUSEO MUNICIPAL DE ARTE CONTEMPORÁNEO, Madrid (group)

2004
'BlueOrange 2004: Francis Alÿs',
MARTIN-GROPIUS-BAU, Berlin, Germany (solo)

'Walking Distance from the Studio',
KUNSTMUSEUM WOLFSBURG, Germany, toured to MUSÉE DES BEAUX-ARTS, Nantes; MUSEO D'ART CONTEMPORANI DE BARCELONA (MACBA); MUSEO DE SAN ILDEFONSO, Mexico City (solo)

'Time Zones: Recent Film and Video',
TATE MODERN, London (group)

'Dedicated to a Proposition',
EXTRA CITY, Antwerp (group)

'2004 Carnegie International',
CARNEGIE MUSEUM OF ART, Pittsburgh (group)

'Who if not we should at least try to imagine the future of all this?',
BASIS VOOR ACTUELE KUNST (BAK), Utrecht, Netherlands (group)

14th BIENNALE OF SYDNEY (group)

'20/20 Vision',
STEDELIJK MUSEUM, Amsterdam (group)

'Densité ± 0',
FRI-ART CENTRE D'ART CONTEMPORAIN, Fribourg, Switzerland, toured to ÉCOLE NATIONALE SUPÉRIEURE DES BEAUX-ARTS, Paris (group)

SELECTED ARTICLES AND INTERVIEWS
2003–2004

2003 (cont.)
Garrett, Craig, 'MultipleCity: Revolution in Panama', <u>Flash Art</u>, no. 230, May-June

Beil, Ralf, 'Kurze Geschichte eines langen Schlafes', <u>Kunst-Bulletin</u>, no. 5, May

Benitez Dueñas, Issa Maria, 'Francis Alÿs: Museo Nacional Centro de Arte Reina Sofia'; Craig Garrett, 'MultipleCity', <u>ArtNexus</u>, no. 50, July-September

'Silly Walks, Serious Concerns: Francis Alys', <u>The Economist</u>, 7 August

Lorés, Maite, 'The Prophet and the Fly', <u>Contemporary</u>, no. 53/54

Von Twickel, Felicitas, 'Spots, Aspekte', <u>ZDF</u>, October

Trainor, James, 'Walking the Walk: the Artist as Flâneur', <u>Border Crossings</u>, no. 4, November

Kreis, Elfi, 'Ein Preis, der Massstäbe setzt', <u>Kunstzeitung</u>, no. 87, November

Green, Charles, 'The Labyrinthine Effect', <u>Artforum</u>, December

Gallo, Rubén, Arriola Magali and Issa Maria Benitez Dueñas, 'Flashback: Francis Alÿs', <u>ArtNexus</u>, no. 51, December-February

2004
Wetterwald, Elisabeth, 'Francis Alÿs: Collection Lambert', <u>Art Press</u>, January

Lafuente, Pablo, 'Francis Alÿs', <u>Frieze</u>, no. 80, January-February

Klaas, Heiko, 'Francis Alÿs', <u>Artist Kunstmagazin</u>, no. 4

Jiménez, Carlos, 'Alÿs, un exilado curioso', <u>El País</u>, 5 February

Stefanowski, Michael, 'Francis Alÿs: BlueOrange Prize', <u>ZDF</u>, 27 February

Loers, Veit, 'Auf Marlenes Spuren', <u>Kunstzeitung</u>, March

Manchester, Clare, 'Ailleurs, ici', <u>Flash Art</u>, no. 235, March-April

Colombo, Paolo, 'A Silent Presence', <u>Tema Celeste</u>, no. 102, March-April

Schindler, Anna, 'Die Arbeit des Künstlers ist das Reisen', <u>Die Welt</u>, 6 March

Lamm, April, 'I Feel Therefore I Am', <u>Modern Painters</u>, spring

Bijutsu Shuppan-Sha, 'Very New Art 2004', <u>Tokyo</u>, vol. 56, April

Stoeber, Michael, 'Soziale Kreaturen: Wie Körper Kunst wird', <u>Kunstforum</u>, May-June

Smith, Trevor, 'Francis Alÿs: Spending Time and Travelling Free', <u>Art & Australia</u>, June-August

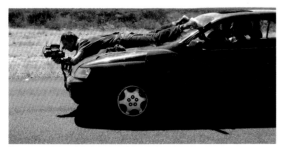

FRANCIS ALŸS FILMING A STORY OF DECEPTION IN PATAGONIA, 2003-06

2004 (cont.)
'Point of View: An Anthology of the Moving Image',
NEW MUSEUM OF CONTEMPORARY ART, New York, toured to
HAMMER MUSEUM AT UNIVERSITY OF CALIFORNIA, Los Angeles
(group)

'Made in Mexico',
INSTITUTE OF CONTEMPORARY ART, Boston, toured to HAMMER
MUSEUM AT UNIVERSITY OF CALIFORNIA, Los Angeles (group)

'Artist's Choice: Mona Hatoum, Here is Elsewhere',
THE MUSEUM OF MODERN ART, New York (group)

'Cordially Invited',
CENTRAAL MUSEUM, Utrecht, Netherlands (group)

'O zero',
OFFICIAL PARA PROYECTOS DE ARTE (OPA), Guadalajara
(group)

TRIENNALE POLIGRÁFICA, San Juan, Puerto Rico (group)

26th SÃO PAULO BIENNIAL (group)

'Revolving Doors',
FUDACIÓN TELEFONICA, Madrid (group)

'Ailleurs, ici',
ARC/MUSÉE D'ART MODERNE DE LA VILLE DE PARIS (group)

'Faces in the crowd: Images of modern life from Manet to today',
WHITECHAPEL ART GALLERY, London, toured to CASTELLO DI
RIVOLI, Turin (group)

Francis Alÿs is awarded the Kunstpreis BlueOrange,
Bundesverband der Deutschen Volksbanken und Raiffeisenbanken,
Berlin

2004 (cont.)
Knight, Christopher, 'Mexico Joins Global Club', Geo Topics, 23 June

Manchester, Clare, 'Densité ± 0', Flash Art, no. 237, July-September

Storr, Robert, 'Francis Alÿs', Villeurbane Semaine, no. 12, July

'Gegen den Strich. Neue Formen der Zeichnung in der Staatlichen
Kunsthalle', Kunst-Bulletin, no. 7-8, July-August

Wetterwald, Elisabeth, 'La rivoluzione non siamo noi: Pierre Joseph
et Francis Alÿs', Parachute, no. 115, July-September

'Nine to Five: Das Protokoll eines Künstleralltags', Monopol, no. 3,
August-September

Mendelssohn, Joanna, 'The Biennale of Sydney', Tema Celeste,
no. 105, September-October

Tappeiner, Maria, 'Francis Alÿs', Kulturzeit, 2 September

Pinto, Roberto, 'Subjectivity, passion and excess in everyday life',
Work in Progress, no. 10, autumn

Becker, Christoph, 'Veränderungen in der Sammlung: Schwestern
treffen Brüder', Kunsthaus Zürich Magasin, no. 4 October

Gardener, Belinda Grace, 'Wolfsburg/Berlin: Francis Alÿs',
Kunstzeitung, no. 98, October

Lafuente, Pablo, 'Art on Parade', Art Monthly, no. 280, October

'Ambulantes', Art Press, November

Gioni, Massimiliano, 'Ojos bien cerrados', Matador, no. 9

Krepler, Ute, 'Francis Alÿs', Kunst und Markt, no. 2

Cooke, Lynne, 'Best of 2004'; Bettina Funcke, 'Francis Alÿs: Martin-
Gropius-Bau and Kunstmuseum Wolfsburg',
Artforum, December

Diez, Renato, 'Hugo Boss Prize', Arte, no. 376, December

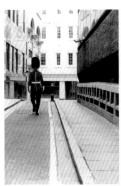

2005
'Francis Alÿs: (to be continued) 1992–',
ARTSPACE, Auckland (solo)

'Sometimes doing something poetic can become political and
sometimes doing something political can become poetic',
THE ISRAEL MUSEUM, Jerusalem (solo)

'Seven Walks',
ARTANGEL and NATIONAL PORTRAIT GALLERY, London (solo)

'Monopolis: Antwerp',
WITTE DE WITH, Rotterdam (group)

'The Hours: Visual Arts of Contemporary Latin America',
IRISH MUSEUM OF MODERN ART, Dublin (group)

'Eindhoven-Istanbul',
VAN ABBEMUSEUM, Eindhoven, Netherlands (group)

'Ecstasy: In and About Altered States',
MUSEUM OF CONTEMPORARY ART, Los Angeles, (group)

'Crowd of the Person',
CONTEMPORARY MUSEUM, Baltimore (group)

'Here Comes the Sun',
MAGASIN 3, Stockholm (group)

2005
Siegel, Katy, '2004 Carnegie International', Artforum, January

Lasnier, Jean-François 'Francis Alÿs: Marcher, Créer', Beaux Arts,
no. 248, February

Volk, Gregory, 'Report From Pittsburgh: Let's Get Metaphysical',
Art in America, March

Boase, Gair, 'Faces in the Crowd at Whitechapel Art Gallery',
Flash Art, no. 241, March-April

Bonami, Francesco, 'The Legacy of a Myth Maker', Tate Etc., spring

Arriola, Magali, 'Francis Alÿs', Spike Kunstmagazin, no. 4, summer

'Francis Alÿs & Stanley Brown', Tema Celeste, no. 110, July-August

Laddaga, Reinaldo, 'Almost Brothers', Flash Art, no. 243,
July-September

Debroise, Olivier, 'The Loop: Diary of a Drifting', Exit, no. 19, August-
October

Pignatti, Lorenza, 'Francis Alÿs at MACBA Barcelona', Tema Celeste,
no. 111, September-October

SELECTED EXHIBITIONS AND PROJECTS
2005–2006

SELECTED ARTICLES AND INTERVIEWS
2005–2006

2005 (cont.),
'inSITE 2005',
CENTRO CULTURAL, Tijuana, and SAN DIEGO MUSEUM OF ART
(group)

'General Ideas: Rethinking Conceptual Art 1987–2005',
CCA WATTIS INSTITUTE OF CONTEMPORARY ARTS,
San Francisco (group)

'Roaming Memories',
LUDWIG FORUM FÜR INTERNATIONALE KUNST, Aachen,
Germany (group)

GLASGOW INTERNATIONAL (group)

'Irreducible: Contemporary Short Form Video',
MIAMI ART CENTRAL (group)

'Odd Lots: Revisiting Gordon Matta-Clark's Fake Estates',
WHITE COLUMNS and QUEENS MUSEUM OF ART,
New York (group)

'Police',
LANDESGALERIE AM OBERÖSTERREICHISCHEN
LANDESMUSEUM, Linz, Austria (group)

'Point of View: A Contemporary Anthology of the Moving Image',
HERBERT F. JOHNSON MUSEUM OF ART at CORNELL UNIVERSITY,
Ithaca, New York (group)

'What's New Pussycat?'
MUSEUM FÜR MODERNE KUNST, Frankfurt (group)

PERFORMA 05,
Multiple venues, New York (group)

2005 (cont.)
Scott, Andrea K., 'High Interest Rate', Time Out New York,
8–15 September

Irving, Mark, 'A Walk on the Wild Side', The Times, London,
24 September

Balcells, María José, 'Francis Alÿs at MACBA', Flash Art, no. 244,
October

Buck, Louisa, 'Soldiers as Social Allegory: Interview with Francis
Alÿs', Art Newspaper, no. 14, October

Arriola, Magali, 'Beaux Gestes', Art Review, no. 10, October–
November

Robecchi, Michele, 'The Celebrated Walking Blues: A Conversation
with Francis Alÿs', Contemporary, no. 78

'The Shock of the Live', Art Review, November

Huberman, Anthony, 'Missing in Action', Art Review, November

O'Reilly, Sally, 'Odd Lots: Revisiting Gordon Matta-Clark's Fake
Estates', Modern Painters, November

Lafuente, Pablo, 'Francis Alÿs', Art Monthly, no. 291, November

'Painting the Town: Live from New York: Performa 2005',
Time Out New York, November 3–9

Comer, Stuart, 'London'; Chrissie Iles, 'Best of 2005', Artforum,
December

Sepúlveda, Luz, 'Group Shows: Only the Characters Change',
ArtNexus, no. 55

Kennedy, Katie, 'Shooting Gallery: An introduction to guns in
contemporary art', Small Arms Survey 2005: Weapons at War,
Graduate Institute of International Studies, Geneva

2006
'A Story of Deception: Patagonia 2003–2006',
PORTIKUS, Frankfurt, toured to MUSEO DE ARTE
LATINOAMERICANO DE BUENOS AIRES (MALBA) (solo)

'Diez cuadras alrededor del estudio'
ANTIGUO COLEGIO DE SAN ILDEFONSO, Mexico City (solo)

'The Sign Painting Project (1993–1997): A Revision',
SCHAULAGER, Basel (solo)

'Black Box: Francis Alÿs',
HIRSHHORN MUSEUM AND SCULPTURE GARDEN,
Washington DC (solo)

'Mapping the City',
STEDELIJK MUSEUM VOOR ACTUELE KUNST (SMAK), Ghent
(group)

IDEAL CITY/INVISIBLE CITIES,
Multiple venues, Zamosc, Poland, and Potsdam, Germany (group)

'SNAFU: Medien, Mythen, Mind Control',
KUNSTHALLE HAMBURG (group)

'Raconte-moi/Tell me',
CASINO LUXEMBOURG (group)

'Dark Places',
SANTA MONICA MUSEUM OF ART, California (group)

2006
Cerio, Gregory, 'Contemporary Art: The New Blue Chips',
Home & Garden, January

Gleadell, Colin, 'Contemporary Sales Set All-Time Records',
ArtNews, January

Robecchi, Michele, 'Francis Alÿs: Seven Walks', Rodeo Magazine,
no. 12, January–February

Marrón, Lorena, 'Francis Alÿs: Soy como un perro callejero',
La Tempestad, no. 47, March–April

Escalante, Gabriel, 'Diez cuadras alrededor del estudio: Francis
Alÿs en el Colegio de San Ildefonso', Rim Magazine, no. 8, spring

Charpenel, Patrick, and María Minera, '5 piezas fundamentales
del arte contemporáneo en México según Patrick Charpenel',
dF por Travesías, no. 48, April

Calera-Grobet, Antonio, 'Todo lo que entendí o malentendí alrededor
de la obra de Francis Alÿs', Arte al Día, no. 27, April–May

Godfrey, Mark, 'Walking the Line: The Art of Francis Alÿs',
Artforum, May

Chaplin, Julia, 'Art on the Edge in Mexico City', The New York Times,
25 June, and International Herald Tribune, 26 June

Scharrer, Eva, 'Francis Alÿs und Tacita Dean im Schaulager',
Kunst-Bulletin, no. 7–8, July–August

THE HISTORIC CENTRE
OF MEXICO CITY

TEXT
CARLOS MONSIVÁIS
IMAGES
FRANCIS detto ALŸS

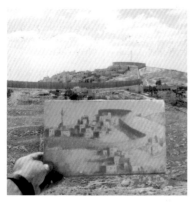

Vista of Absurdo, Jerusalem, June 2004

Francis Alÿs

SOMETIMES DOING SOMETHING
POETIC CAN BECOME POLITICAL
AND
SOMETIMES DOING SOMETHING
POLITICAL CAN BECOME POETIC

A Project by Francis Alÿs
A Film by Francis Alÿs and Julien Devaux

February 11 through
March 17, 2007

Reception
February 11, 2007, 6 to 8 pm

David Zwirner

525 West 19th Street
New York, NY 10011
212 727 2070 telephone
212 727 2072 fax
www.davidzwirner.com

2006 (cont.)
'Satellite of Love',
WITTE DE WITH and TENT, Rotterdam (group)

'Die 90er',
NEUES MUSEUM WESERBURG, Bremen, Germany (group)

'Version Animée',
CENTRE POUR L'IMAGE CONTEMPORAINE, Geneva (group)

'Printemps de Septembre 2006',
LES ABATTOIRS – FONDS REGIONAL D'ART CONTEMPORAIN
(FRAC) MIDI-PYRÉNÉES, Toulouse (group)

'Sisyphe',
MUSÉE DES ARTS CONTEMPORAINS GRAND-HORNU, Hornu,
Belgium (group)

2007
'Politics of Rehearsal',
HAMMER MUSEUM at UNIVERSITY OF CALIFORNIA,
Los Angeles (solo)

'Sometimes doing something poetic can become political and
sometimes doing something political can become poetic',
DAVID ZWIRNER, New York (solo)

MUSEO DE ARTE DE LIMA (solo)

'Fabiolas' (organized by the DIA FOUNDATION),
THE HISPANIC SOCIETY OF AMERICA, New York (solo)

'Fantasmagoría: Dibujos Animados',
FUNDACIÓN ICO, Madrid (group)

'Commitment',
CULTURE CENTER STROMBEEK, Belgium (group)

'Doppelgänger',
MUSEO DE ARTE CONTEMPORÁNEA (MARCO), Vigo, Spain (group)

52nd VENICE BIENNALE (group)

'Idylle',
DOMUS ARTIUM 2002 (DA2), Salamanca, Spain, toured to
NATIONAL GALLERY, Prague (group)

'Discrepancias',
UNIVERSIDAD NACIONAL AUTÓNOMA DE MÉXICO, Mexico City
(group)

2006 (cont.)
Gopnik, Blake, 'Here & Now', Washington Post, 23 July

Goldberg, RoseLee, 'Be Here Now', Contemporary, no. 89

2007
Herbert, Martin, 'The Distance Between: The Political
Peregrinations of Francis Alÿs', Modern Painters, no. 84, March

Hollander, Kurt, 'Thoughtful Wandering of a Man with a Can',
The New York Times, 13 March

BIBLIOGRAPHY

MONOGRAPHS, EXHIBITION CATALOGUES AND SURVEYS

Alÿs, Francis, Kurt Hollander and Cuauhtémoc Medina, Francis Alÿs, Galeria Arte Contemporáneo, Mexico City, 1992

Alÿs, Francis, and Cuauhtémoc Medina, Fabiola: Una investigación de Francis Alÿs en colaboración con Curare Espacio Crítico para las Artes, Curare, Mexico City, 1994

Alÿs, Francis, and Thomas McEvilley, Francis Alÿs: The Liar, The Copy of the Liar, Arena Mexico Arte Contemporáneo, Guadalajara, and Galeria Ramis Barquet, Mexico City, 1994

Alÿs, Francis, Bruce W. Ferguson, Serge Guibault, Kurt Hollander, Cuauhtémoc Medina, Ivo Mesquita, Kitty Scott, Laureana Toledo and Pablo Vargas Lugo, Walks/Paseos, Museo de Arte Moderno, Mexico City, 1997

Alÿs, Francis, and Kitty Scott, Francis Alÿs: Le Temps du Sommeil, Contemporary Art Gallery, Vancouver, 1998

Alÿs, Francis, Cuauhtémoc Medina, Thierry Davila and Carlos Basualdo, Francis Alÿs, Musée Picasso, Antibes, France, 2001

Alÿs, Francis, and Catherine Lampert, Francis Alÿs, The Prophet and the Fly, Turner, Madrid, 2003

Alÿs, Francis, and Annelie Lutgens, Francis Alÿs: Walking Distance from the Studio, Hatje Cantz, Ostfildern-Ruit, 2004

Alÿs, Francis, and Andreas Bee, Time is a Trick of the Mind, Museum für Moderne Kunst and Revolver, Frankfurt, 2004

Alÿs, Francis, Lynne Cooke, Alejandro Diaz, Tom Eccles, Susan K. Freedman, Dario Gamboni, RoseLee Goldberg, Laurence Kardish, Harper Montgomery, Francesco Pellizzi and Robert Storr, Francis Alÿs: The Modern Procession, Public Art Fund, New York, 2004

Alÿs, Francis, Cuauhtémoc Medina, Susan Buck-Morss, Gustavo Buntinx, Lynne Cooke, Corinne Diserens and Gerardo Mosquera, When Faith Moves Mountains, Turner, Madrid, 2005

Alÿs, Francis, Robert Harbison, James Lingwood and David Toop, Seven Walks, Artangel and National Portrait Gallery, London, 2005

Alÿs, Francis, Corinne Diserens and Cuauhtémoc Medina, Diez Cuadras Alrededor del Estudio, Antiguo Colegio de San Ildefonso, Mexico City, 2006

Alÿs, Francis, Olivier Debroise, Eduardo F. Costantini and Marcelo E. Pacheco, A Story of Deception: Historia de un desengaño, Patagonia 2003-2006, Colección Costantini, MALBA, Buenos Aires, 2006

Alÿs, Francis, Nikola Dietrich and Olivier Debroise, A Story of Deception: Patagonien 2003-2006, Portikus and Revolver, Frankfurt, 2006

Alÿs, Francis, and Carlos Monsiváis, Centro Histórico de la Ciudad de México, Turner, Madrid, 2006

Alÿs, Francis, et al., Sometimes doing something poetic can become political and sometimes doing something political can become poetic, David Zwirner Gallery, New York, 2007

Badia, Montse, Revolving Doors, Fundación Telefónica, Madrid, 2004

Barth, Franck, and Dirck Möllmann, SNAFU: Medien, Mythen, Mind Control, Hamburger Kunsthalle, Hamburg, 2005

Basualdo, Carlos, et al., Cream, Phaidon, London, 1998

Basualdo, Carlos, Da Adversida de Vivemos, Musée d'Art Moderne de la Ville de Paris, 2001

Basualdo, Carlos, Los Usos de la Imagen: Fotografía, film y video en La Colección Jumex, Malba-Jumex with Espacio Fudación Telefónica, Buenos Aires, 2004

Bee, Andreas, and Fritz Emslander, Gegen den Strich. Neue Formen der Zeichnung, Staatliche Kunsthalle Baden-Baden, 2004

Berger, Tobias, Centre Of Attraction, 8th Baltic Triennial of International Art, Vilnius, 2002

Biesenbach, Klaus, Mexico City: An Exhibition about the Exchange Rates of Bodies and Values, P.S.1, New York, and Kunstwerke Berlin, 2002

Biesenbach, Klaus, Die zehn Gebote, Deutsches Hygiene Museum, Dresden, 2004

Biesenbach, Klaus, Hubert Beck, Christopher Pleister and Luminita Sabau, BlueOrange 2004: Francis Alÿs, Martin-Gropius-Bau, Berlin, 2004

Brioschi, Eva, Collectors 1: Collezione la Gaia, Centro Sperimentale per le Arti Contemporanee, Caraglio, Italy, 2006

Carlos, Isabel, et al., On Reason and Emotion, 14th Biennale of Sydney, 2004

Cinema Without Walls, 30th International Rotterdam Film Festival, 2000

Collins, Thom, Somewhere Better Than This Place, Contemporary Arts Center, Cincinnati, 2003

Colombo, Paolo, The Passion and the Wave, 6th Istanbul Biennial, 1999

Davila, Thierry, Marcher, créer, déplacements, flâneurs, Dérives dans l'art de la fin du XXe siècle, Les Éditions du Regard, Paris, 2003

Dean, Tacita, and Jeremy Millar, Art Works: Place, Thames & Hudson, London, 2005

De Certeau, Michel, et al., Strangers: The First ICP Triennial of Photography and Video, ICP, New York, and Steidl, Göttingen, Germany, 2003

Dennison, Lisa, Nancy Spector and Joan Young, Moving Pictures: Contemporary Photography and Video from the Guggenheim Museum Collections, Guggenheim Museum, New York, 2002

Drück, Patrizia, and Inka Schube, Social Creatures: How Body Becomes Art, Hatje Cantz, Ostfildern, and Sprengel Museum Hannover, 2004

Engberg, Juliana, The Labyrinthine Effect, Australian Center for Contemporary Art, Southbank, Australia, 2003

Enwezor, Okwui, Mirror's Edge, BildMuseet, Umeå, Sweden, 1999

Ferreira d'Oliveira, Caroline and Marianne Lanavère, Densité ±0, Ecole Nationale Supérieure de Beaux-Arts, Paris, 2004

Fogle, Douglas, et al., Painting at the Edge of the World, Walker Art Center, Minneapolis, 2001

Fricciones: Latin America, Museo Nacional Reina Sofía, Madrid, 2000

Gallo, Rubén, New Tendencies in Mexican Art, Palgrave MacMillan, New York, 2004

Goetz Meets Falckenberg, Kulturstiftung Phoenix Art, Hamburg, 2005

Greenberg, Kerryn, and Eva Meyer-Hermann, Eindhoven-Istanbul, Van Abbemuseum, Eindhoven, Netherlands, 2005

Grigoteit, Ariane, 25: Twenty-five Years of the Deutsche Bank Collection, Deutsche Bank Art, Frankfurt, 2005

Grigoteit, Ariane, Visuell/Blind Date, Deutsche Bank Art, Frankfurt, 2005

Grigoteit, Ariane, Toshio Hara, Tessen von Heydebreck, Christiane Meixner, Jonathan Napack and Mark Rappolt, Tokyo Blossoms: Deutsche Bank Collection Meets Zaha Hadid, Deutsche Bank Art, Frankfurt, 2006

Grosenick, Uta, et al., Art Now, Taschen, Cologne, 2002

Hasegawa, Yuko, Egofugal, 7th International Istanbul Biennial, 2001

Hertz, Betti-Sue, Axis Mexico: Common Objects and Cosmopolitan Actions, San Diego Museum of Art, 2002

Herzog, Hans-Michael, Sebastián Lopéz and Eugenio Valdés Figueroa, The Hours: Visual Arts of Contemporary Latin America, Daros-Latinamerica, Zurich, and Hatje Cantz, Ostfildern-Ruit, 2005

Hollander, Kurt, Francis Alÿs: Other People's Cities, Other People's Work, Galería Camargo Vilaça, São Paulo, 1995

Joachimides, Christos, et al., Outlook, Adam Editions, Pergamos S.A., Athens, 2003

Kastner, Jeffrey, Sina Najafi, Frances Richard and Jeffrey A. Kroessler, Odd Lots: Revisiting Gordon Matta Clark's 'Fake Estates', Cabinet Books, Queens Museum of Art and White Columns, New York, 2005

Kontova, Helena, Hou Hanru, Angela Rosenberg, Andreas Schlaegel and Gianni Romano, Fuori Uso: The Bridges, Giancarlo Politi Editore, Milan, 2000

Loock, Ulrich, and Daniel Kurjakovic, Mixing Memory and Desire, Neues Kunstmuseum Luzern, Lucerne, 2000

Marí, Barthomeu, Vicente Todoli and Miguel von Hafe-Perez, Squatters, Museu Serralves, Porto, and Witte de With, Rotterdam, 2001

Martin, Patricia (ed.), Edén, La Colección Jumex, Mexico City, 2004

Medina, Cuauhtémoc, Francis Alÿs, 49th Biennale di Venezia, Venice, 2001

Medina, Cuauhtémoc, Francis Alÿs: Before Language, Carnegie Museum of Art, Pittsburgh, 2004

Morgan, Jessica, Gregor Muir and Maeve Polkinhorn, Time Zones: Recent Film and Video, Tate Modern, London, 2004

Nittve, Lars, et al., NoWhere, Louisiana Museum, Copenhagen, 1996

Out of Space, Kölnischer Kunstverein, Cologne, 2000

Romano, Gianni, Barbara Casavecchia, Martin Maloney, Wim Peeters, Lane Relyea and Cuauhtémoc Medina, Europe: Diferent Perspectives in Painting, Giancarlo Politi Editore, Milan, 2000

Santamaria, Guillermo, Fuera de Campo, Ex Teresa Arte Actual, Mexico City, 2003

Schimmel, Paul, Ecstasy: In and About Altered States, Museum of Contemporary Art, Los Angeles, 2005

Schöpp, Manuela, Tätig sein, Neue Gesellschaft für Bildende Kunst, Berlin, 2004

Schwabsky, Barry, et al., Vitamin P: New Perspectives in Painting, Phaidon, London, 2002

Schwenk, Bernhart, Re-Enactment, Pinakothek der Moderne e.V., Munich, 2002

Tercera Bienal Iberoamericana de Lima, Municipalidad Metropolitana de Lima, 2002

Thériault, Michèle, Francis Alÿs: The Last Clown, Sala Montcada de la Fundació 'la Caixa', Barcelona, and Galerie de l'UQAM, Montreal, 2000

Urbaschek, Stephan, and Katharina Vossenkuhl, Fast Forward, Media Art Sammlung Götz, Munich, and ZKM, Karlsruhe, 2003

Varadinis, Mirjam, Parkett: 20 Years of Artists' Collaborations, Kunsthaus Zurich and Parkett Publishers, Zurich, 2004

Vicario, Gilbert, Made in Mexico, Institute of Contemporary Art, Boston, 2004

Weidner, Corinna, and Hans Winkler, Legal/Illegal, NGBK, Berlin, and Schmetterling Verlag, Stuttgart, 2004

ARTICLES AND REVIEWS

Alberge, Dalya, 'Portrait of the Artist as a Young Peacock', The Times, London, 6 June 2001

Alÿs, Francis, 'The Loop', Untitled, no. 16, summer 1998

'Ambulantes', Art Press, November 2004

Anton, Saul, 'A Thousand Words: Francis Alÿs talks about When Faith Moves Mountains', Artforum, summer 2002

Anton, Saul, 'One More Step', Parkett, no. 69, 2003

Aranda Marquez, Carlos, 'Frequent Stops: Carrillo Gil Museum, Mexico City', Flash Art, no. 208, October 1999

Arriola, Magali, 'Beaux Gestes', Art Review, October 2005

Arriola, Magali, 'Francis Alÿs', Spike Kunstmagazin, no. 4, summer 2005

Arriola, Magali, 'Francis Alÿs: The Liar and the Copy of the Liar', ArtNexus, no. 28, June 1998

'Auf Plateausohlen zur Menschheit', Kunst-Bulletin, no. 7-8, July-August 2001

Balcells, María José, 'Francis Alÿs at MACBA', Flash Art, no. 244, October 2005

Basualdo, Carlos, 'Head to Toes: Francis Alÿs's Paths of Resistance', Artforum, April 1999

Becker, Christoph, 'Veränderungen in der Sammlung: Schwestern treffen Brüder', Kunsthaus Zurich Magasin, no. 4, October 2004

Beil, Ralf, 'Kurze Geschichte eines langen Schlafes', Kunst-Bulletin, no. 5, May 2003

Benitez Dueñas, Issa Maria, 'Francis Alÿs: Hypotheses for a Walk', ArtNexus, no. 35, April-September 2000

Benitez Dueñas, Issa Maria, 'Francis Alÿs: Museo Nacional Centro de Arte Reina Sofia', ArtNexus, no. 50, July-September 2004

Bhatnagar, Priya, Samuele Menin and Michele Robecchi, 'Focus Mexico', Flash Art, no. 225, July-September 2002

Biesenbach, Klaus, 'Hunting Men Hunting Dogs: Fear and Loathing in Mexico City', Flash Art, no. 225, July-September 2002

Bijutsu Shuppan-Sha, 'Very New Art 2004', Tokyo, vol. 56, April 2004

Bishop, Claire, 'Kept in the Dark', Evening Standard, 22 May 2001

Boase, Gair, 'Faces in the Crowd at Whitechapel Art Gallery', Flash Art, no. 241, March-April 2005

Bohlen, Celestine, 'Making a spectacle of MoMA's Big Move', International Herald Tribune, 29 June 2002

Bonami, Francesco, 'The Legacy of a Myth Maker', Tate Etc., spring 2005

Buchloh, Benjamin, 'Control, By Design', Artforum, September 2000

Buck, Louisa, 'Soldiers as Social Allegory: Interview with Francis Alÿs', The Art Newspaper, no. 14, October 2005

Calera-Grobet, Antonio, 'Todo lo que entendí o malentendí alrededor de la obra de Francis Alÿs', Arte al Día, no. 27, April-May 2006

Cerio, Gregory, 'Contemporary Art: The New Blue Chips', Home & Garden, January 2006

Chaplin, Julia, 'Art on the Edge in Mexico City', The New York Times, 25 June 2006

Chaplin, Julia, 'Contemporary Art: In Mexico City, an edgy (and busy) art scene emerges', International Herald Tribune, 26 June 2006

Charpenel, Patrick, and María Minera, '5 piezas fundamentales del arte contemporáneo en México según Patrick Charpenel' dF por Travesías, no. 48, April 2006

Colombo, Paolo, 'A Silent Presence', Tema Celeste, no. 102, March-April 2004

Comer, Stuart, 'London', Artforum, December 2005

Cooke, Lynne, 'Venice Biennale', The Burlington Magazine, no. 1182, September 2001

Cooke, Lynne, 'Best of 2004', Artforum, December 2004

Cowan, Amber, 'Move Any Mountain', Sleazenation, October 2002

Craddock, Sacha, 'In and Out of the Sun', Untitled, no. 21, spring 2000

Crowley, Tom, 'Mexico City on the Move', Tema Celeste, no. 97, May-June 2003

Dailey, Meghan, 'Mexico City: An Exhibition About the Exchange Rates of Bodies and Values', Artforum, November 2002

Darling, Michael, 'Francis Alÿs and the Return to Normality', Frieze, no. 33, March-April 1997

Debroise, Olivier, 'The Loop: Diary of a Drifting', Exit, no. 19, August-October 2005

DeVuono, Frances, 'Tout le Temps/Every Time: La Biennale de Montreal', New Art Examiner, no. 7, April 2001

Diez, Renato, 'Hugo Boss Prize', Arte, no. 376, December 2004

Dorn, Anja, 'Out of Space', Frieze, no. 55, November-December 2001

Edwards, C, 'Muralists, No!', Art Review, September 2002

Escalante, Gabriel, 'Diez cuadras alrededor del estudio: Francis Alÿs en el Colegio de San Ildefonso', Rim Magazine, no. 8, spring, 2006

Fallon, Michael, 'Minneapolis', Art Papers, no. 4, July-August 2001

Ferguson, Bruce, 'Francis Alÿs', Flash Art, no. 188, May-June 1996

'Francis Alÿs: Doppelganger', Tate Magazine, spring 2001

'Francis Alÿs & Stanley Brown', Tema Celeste, no. 110, July-August 2005

'Francis Alÿs: The Modern Procession', In>process, no. 3, 2002

Funcke, Bettina, 'Francis Alÿs: Martin-Gropius-Bau, Kunstmuseum Wolfsburg', Artforum, December 2004

Gallo, Rubén, Arriola Magali and Issa Maria Benítez Dueñas, 'Flashback: Francis Alÿs', ArtNexus, no. 51, December-February 2003

Gallo, Rubén, 'Francis Alÿs at Jack Tilton', Flash Art, no. 198, January-February 1998

Gallo, Rubén, 'Francis Alÿs', ArtNexus, no. 27, March 1998

Gardener, Belinda Grace, 'Wolfsburg/Berlin: Francis Alÿs', Kunstzeitung, no. 98, October 2004

Garrett, Craig, 'MultipleCity: Revolution in Panama', Flash Art, no. 230, May-June 2003

Garrett, Craig, 'MultipleCity', ArtNexus, no. 50, July-September 2003

'Gegen den Strich. Neue Formen der Zeichnung in der Staatlichen Kunsthalle', Kunst-Bulletin, no. 7-8, July-August, 2004

Gioni, Massimiliano, 'Ojos bien cerrados', Matador, no. 9, 2004

Gleadell, Colin, 'Contemporary Sales Set All-Time Records', ArtNews, January 2006

Glover, Michael, 'Francis Alÿs', ArtNews, April 2000

Godfrey, Mark, 'Walking the Line: The Art of Francis Alÿs', Artforum, May 2006

Goldberg, RoseLee, 'Be Here Now', Contemporary, no. 89, 2006

Gopnik, Blake, 'Here & Now', Washington Post, 23 July 2006

Green, Charles, 'Signs of Life', Artforum, September 1999

Green, Charles, 'The Labyrinthine Effect', Artforum, December 2003

Gregos, Katerina, 'Outlook', Tema Celeste, no. 101, January-February 2004

Gronlund, Melissa, 'Mexico City: An Exhibition About the Exchange Rates of Bodies and Values', Contemporary, September 2002

Guilbaut, Serge, 'Rodney Graham and Francis Alÿs', Parachute, no. 87, spring 1997

Heiser, Jörg, 'Walk on the Wild Side', Frieze, no. 69, September 2002

Herbert, Martin, 'Francis Alÿs', Time Out London, 19 January 2000

Herbert, Martin, 'Francis Alÿs', Time Out London, 13 June 2000

Herbert, Martin, 'The Distance Between: The Political Peregrinations of Francis Alÿs', Modern Painters, no. 84, March 2007

Herzog, Samuel, 'Im Wunderland', Neue Zürcher Zeitung, March 2003

Hollander, Kurt, 'Francis Alÿs', Flash Art, no. 179, November-December 1994

Hollander, Kurt, 'Francis Alÿs', Poliester, no. 18, spring 1997

Hollander, Kurt, 'Under the Influence', Poliester, no. 20, fall 1997

Hollander, Kurt, 'Thoughtful Wandering of a Man with a Can', The New York Times, 13 March 2007

Huberman, Anthony, 'Missing in Action', Art Review, November 2005

'Ich will ein Zeichen setzen', Art Hamburg, no. 11, November 2004

Iles, Chrissie, 'Film Best of 2005', Artforum, December 2005

'International Shorts Preview: Athlete's Foot', Artforum, May 2000

Irving, Mark, 'A Walk on the Wild Side', The Times, London, 24 September 2005

Jeffett, William, 'A Note on Francis Alÿs', NY Arts Magazine, July-August 2000

Jetzer, Gianni, 'Protest! Respect!', Saiten, June 2001

Jiménez, Carlos, 'Alÿs, un exilado curioso', El País, 5 February 2004

Johnston, Ken, 'Francis Alÿs', The New York Times, 24 October 1997

Jolles, Claudia, 'Brütende Leere', Kunst-Bulletin, no. 5, May 2003

Jusidman, Yishai, 'Francis Alÿs at Galería Ramis Barquet', Artforum, January 1995

Kantor, Jordan, 'Loop', Artforum, April 2002

Kennedy, Katie, 'Shooting Gallery: An introduction to guns in contemporary art', Small Arms Survey 2005: Weapons at War, Graduate Institute of International Studies, Geneva, 2005

Kent, Sarah, 'Watch this Space', Time Out London, 17 May 2000

Klaas, Heiko, 'Francis Alÿs', Artist Kunstmagazin, no. 4, 2004

Knight, Christopher, 'Mexico Joins Global Club', Geo Topics, 23 June 2004

Kontova, Helena, 'Mirror's Edge', Flash Art, no. 211, March-April 2000

Kreis, Elfi, 'Ein Preis, der Massstäbe setzt', Kunstzeitung, no. 87, November 2003

Krepler, Ute, 'Francis Alÿs', Artinvestor, Kunst und Markt, no. 2, 2004

Kuoni, Carin, 'Gerüchte, Fährten und Trophäen: auf Spurensuche mit Francis Alÿs', Kunst-Bulletin, no. 6, June 2000

Kurjakovic, Daniel, 'Finten des Geistes', Die Weltwoche, no. 37, 16 September 1999

Laddaga, Reinaldo, 'Almost Brothers', Flash Art, no. 243, July-September 2005

Lafuente, Pablo, 'Art on Parade', Art Monthly, no. 280, October 2004

Lafuente, Pablo, 'Francis Alÿs', Art Monthly, no. 291, November 2005

Lafuente, Pablo, 'Francis Alÿs', Frieze, no. 80, January-February 2004

Lamm, April, 'I Feel Therefore I Am', Modern Painters, spring, 2004

Lasnier, Jean-François 'Francis Alÿs: Marcher, Créer', Beaux Arts, no. 248, February, 2005

Laurence, Robin, 'Geometries of Conjecture', Border Crossings, no. 4, October 1998

Lavrador, Judicaël, 'Francis Alÿs', Beaux Arts, 2002

Lefkowitz, David, 'Edgy Painting at the Edge of the World', New Art Examiner, September-October 2001

Lerner, Jesse, 'The Work of Others', Poliester, no. 11, winter 1995

Levin, Kim, 'Voice Choices', The Village Voice, 22-28 October 1998

Loers, Veit, 'Auf Marlenes Spuren', Kunstzeitung, March 2004

Lorés, Maite, 'The Prophet and the Fly', Contemporary, no. 53/54, 2003

Mahoney, Elizabeth, 'Mirror's Edge', Art Monthly, no. 245, April 2001

Manchester, Clare, 'Ailleurs, ici', Flash Art, no. 235, March-April 2004

Manchester, Clare, 'Densité ± 0', Flash Art, no. 237, July-September 2004

Mari, Bartomeu, 'Francis Alÿs: Lotgevallen van een grootstedelijk slaapvandelaar', Metropolis M, December 2000

Marrón, Lorena, 'Francis Alÿs: Soy como un perro callejero', La Tempestad, no. 47, March-April 2006

Medina, Cuauhtémoc, 'Painter in a Bag', Poliester, no. 2, summer 1992

Medina, Cuauhtémoc, 'Francis Alÿs: Tu subrealismo', Third Text, no. 38, spring 1997

Medina, Cuauhtémoc, 'Mexican Strategies: Rarefied Painting', Flash Art, no. 210, January-February 2000

Medina, Cuauhtémoc, 'Formas políticas recientes: Búsquedas Radicales en México: Santiago Sierra, Francis Alÿs, Minerva Cuevas', Trans›arts, no. 8, 2000

Medina, Cuauhtémoc, 'Entre dos aguas: conversación entre Francis Alÿs', Curare, no. 17, January-June 2001

Medina, Cuauhtémoc, 'Zones of Tolerance: Teresa Margolles, SEMEFO and Beyond', Parachute, no. 104, October-December 2001

Mendelssohn, Joanna, 'The Biennale of Sydney', Tema Celeste, no. 105, September-October 2004

'Mexico City: An Exhibition About the Exchange Rates of Bodies and Values', ArtNexus, no. 46, December 2002

'Mexico City', Tema Celeste, no. 94, November-December 2002

Mitchell, Charles Dee, 'Francis Alÿs at Lisson', Art in America, May 2000

Moreau, Patric, 'Mirror's Edge', Camera Austria, no. 70, 2000

Moreno, Gean, 'Polis as Playground: Contemporary Artists in Urban Space', Art Papers, no. 5, September-October 2000

'Nine to Five: Das Protokoll eines Künstleralltags', Monopol, no. 3, August-September 2004

O'Reilly, Sally, 'Odd Lots: Revisiting Gordon Matta-Clark's Fake Estates', Modern Painters, November 2005

Packer, William, 'Screening Time', Financial Times Weekend, 6-7 May 2000

'Painting the Town: Live from New York: Performa 2005', Time Out New York, 3-9 November 2005

Phillips, Andrea, 'A Dog's Life', Performance Research, no. 2, June 2000

Phillips, Andrea, 'A Path is Always Between Two Points', Performance Research, no. 3, September 1997

Phillips, Christopher, 'Report from Istanbul: Band of Outsiders', Art in America, April 2000

Pignatti, Lorenza, 'Francis Alÿs at MACBA Barcelona', Tema Celeste, no. 111, September-October 2005

Pinto, Roberto, 'Subjectivity, passion and excess in everyday life', Work in Progress, no. 10, autumn 2004

Pohlenz, Ricardo, 'Leisure at Jumex', Flash Art, no. 224, May-June 2002

'Postcards from the Edge', The Royal Academy Magazine, no. 77, winter 2002

Robecchi, Michele, 'The Celebrated Walking Blues: A Conversation with Francis Alÿs', Contemporary, no. 78, 2005

Robecchi, Michele, 'Francis Alÿs: Seven Walks', Rodeo Magazine, no. 12, January-February 2006

Romano, Gianni, 'Streets and Gallery Walls: Interview with Francis Alÿs', Flash Art, no. 211, March-April 2000

Romano, Gianni, 'Webscape', Flash Art, no. 210, January-February 2000

Romano, Gianni, 'Why not painting?' Flash Art Italia, no. 218, October-November 1999

Rondi, Joëlle, 'Various Places', Art Press, June 1997

Rubinstein, Raphael, 'Francis Alÿs at Jack Tilton', Art in America, November 1995

Ryser, Emmanuelle, 'Le Belge de Mexico', Accrochage, no. 46, April 2003

Scharrer, Eva, 'Francis Alÿs und Tacita Dean im Schaulager', Kunst-Bulletin, No. 7-8, July-August, 2006

Schindler, Anna, 'Der Wert des Lebens', Kunstzeitung, no. 81, May 2003

Schindler, Anna, 'Die Arbeit des Künstlers ist das Reisen', Die Welt, 6 March 2004

Scott, Andrea K., 'High Interest Rate', Time Out New York, 8-15 September 2005

Scott, Kitty, 'Francis Alÿs: A Portrait', Parkett, no. 69, 2003

Sepúlveda, Luz, 'Group Shows: Only the Characters Change', ArtNexus, no. 55, 2005

Shier, Reid, 'Pause and Reflect', Vancouver, March 2000

Siegel, Katy, '2004 Carnegie International', Artforum, January 2005

'Silly Walks, Serious Concerns: Francis Alÿs', The Economist, 7 August 2003

Smith, Trevor, 'Francis Alÿs: Spending Time and Travelling Free', Art & Australia, June-August 2004

Springer, José Manuel, 'Garbage and Art in Mexico', Poliester, no. 3, fall 1992

Stefanowski, Michael, 'Francis Alÿs: BlueOrange Prize', ZDF, 27 February 2004

Stoeber, Michael, 'Soziale Kreaturen: Wie Körper Kunst wird', Kunstforum, May-June 2004

Storr, Robert, 'Strange Attractor', Parkett, no. 69, 2003

Storr, Robert, 'Francis Alÿs', Villeurbane Semaine, no. 12, July 2004

Tappeiner, Maria, 'Francis Alÿs', Kulturzeit, 2 September 2004

'The Shock of the Live', Art Review, November 2005

'The Thief', Flash Art, no. 210, January-February 2000

'This Just In: Painting is Back', New Art Examiner, September-October 2001

Torres, David, 'Francis Alÿs: Simple passant just walking the dog', Art Press, April 2001

Trainor, James, 'Walking the Walk: the Artist as Flâneur', Border Crossings, no. 4, November 2003

'Video Work', Frieze, no. 54, September-October 2000

Volk, Gregory, 'Report From Pittsburgh: Let's Get Metaphysical', Art in America, March 2005

Von Twickel, Felicitas, 'Spots, Aspekte', ZDF, October 2003

Wetterwald, Elisabeth, 'Francis Alÿs: Collection Lambert', Art Press, January 2004

Wetterwald, Elisabeth, 'La rivoluzione non siamo noi: Pierre Joseph et Francis Alÿs', Parachute, no. 115, July-September 2004

Williams, Gilda, '6th Istanbul Biennial', Art Monthly, no. 232, December 1999-January 2000

Wilson, Michael, 'International Preview: Life on the Streets', The Royal Academy Magazine, no. 76, autumn 2002

Withers, Rachel, 'Francis Alÿs at Lisson Gallery', Artforum, March 2000

Yard, S., 'Space on the Run - Life on the Loose: Recent Projects Along the San Diego-Tijuana Frontier', Architectural Design, no. 7-8, 1999

ARC/MUSÉE D'ART MODERNE DE LA VILLE DE PARIS

THE ART INSTITUTE OF CHICAGO

CARNEGIE MUSEUM OF ART, Pittsburgh

CENTRO NAZIONALE PER LE ARTI CONTEMPORANEE, Rome

DES MOINES ART CENTER, Iowa

FONDACION LA CAIXA, Barcelona

FONDACION TELEFONICA, Madrid

FONDS NATIONAL D'ART CONTEMPORAIN, France

FONDS REGIONAL D'ART CONTEMPORAIN (FRAC) RHONE-ALPES, Villeurbanne, France

SOLOMON R. GUGGENHEIM MUSEUM, New York

21st CENTURY MUSEUM OF CONTEMPORARY ART, Kanazawa, Japan

KUNSTHAUS ZÜRICH

THE ISRAEL MUSEUM, Jerusalem

LOS ANGELES MUSEUM OF CONTEMPORARY ART

LOS ANGELES COUNTY MUSEUM OF ART

LOUISIANA MUSEUM, Copenhagen

MIDDLESBOROUGH ART GALLERY, ENGLAND

THE MUSEUM OF MODERN ART, New York

MUSEUM MODERNER KUNST, Frankfurt

MUSÉE NATIONAL D'ART MODERNE, CENTRE POMPIDOU, Paris

NATIONAL GALLERY OF CANADA, Ottawa

PINAKOTHEK DER MODERNE KUNST, Munich

STEDELIJK MUSEUM, Amsterdam

TATE, London

VAN ABBEMUSEUM, Eindhoven, Netherlands

WADSWORTH ATHENEUM, Hartford, Connecticut

WALKER ART CENTER, Minneapolis

ILLUSTRATED WORKS

COMPARATIVE IMAGES

PHAIDON PRESS LTD.
REGENT'S WHARF
ALL SAINTS STREET
LONDON N1 9PA

PHAIDON PRESS INC.
180 VARICK STREET
NEW YORK, NY 10014

WWW.PHAIDON.COM

First published 2007
© 2007 Phaidon Press Limited
All works of Francis Alÿs
are © Francis Alÿs

ISBN:
978-0-7148-4321-6

A CIP catalogue record of
this book is available from
the British Library.

Designed by Melanie Mues,
Mues Design, London

Printed in Hong Kong

PUBLISHER'S
ACKNOWLEDGEMENTS

Special thanks to Jorge Golem,
Mexico City; Susan Sherrick and
Wendy White at David Zwirner
Gallery, New York; Tom Cole and
Lisa Rosendahl at Lisson Gallery,
London; Cynthia Krell at Galerie
Peter Kilchmann, Zurich; Andrés
Garay Nieto, Mexico City.
We would also like to thank
International Editors Co.,
Barcelona, for its kind
permission to reprint texts.
Photographers: Thierry Bal,
Michel Blancsubé, Dennis
Cowley, Pip Day, Ian Dryden,
Mario Flecha, Andrés Garay
Nieto, Wolfgang Günzel, Enrique
Huerta, Kurt Hollander, Rachel
Leah Jones, Cuauhtémoc
Medina, Victoria Muniz Barreto,
Raphael Ortega, Emilio Rivera,
Melanie Smith, Laureana Toledo,
Jesus Sánchez Uribe, Eric Weiss,
Lourdes Villagomez

ARTIST'S
ACKNOWLEDGEMENTS

Francis Alÿs would like to thank
the following: Cuauhtémoc
Medina, Russell Ferguson,
Jean Fisher, Craig Garrett,
Michele Robecchi, Gilda Williams,
Bella Hubert, Susan Sherrick,
Jorge Golem, Louise de Smedt,
Rafael Ortega, Julien Devaux,
Taiyana Pimentel, Lourdes
Villagomez, Antonio Hernandez
Rios, Juan Garcia, Felipe
Sanabria, Olivier Debroise,
Honoré d'O, Kitty Scott,
Alejandro Aguinaco, Emilio
Rivera and Enrique Huerta.

CONTEMPORARY ARTISTS

Contemporary Artists is a series of authoritative and extensively illustrated studies of today's most important artists. Each title offers a comprehensive survey of an individual artist's work and a range of art writing contributed by an international spectrum of authors, all leading figures in their fields, from art history and criticism to philosophy, cultural theory and fiction. Each study provides incisive analysis and multiple perspectives on contemporary art and its inspiration. These are essential source books for everyone concerned with art today.

VITO ACCONCI FRAZER WARD, MARK C. TAYLOR, JENNIFER BLOOMER / DOUG AITKEN DANIEL BIRNBAUM, AMANDA SHARP, JÖRG HEISER / FRANCIS ALŸS RUSSELL FERGUSON, CUAUHTÉMOC MEDINA, JEAN FISHER / UTA BARTH PAMELA M. LEE, MATTHEW HIGGS, JEREMY GILBERT-ROLFE / CHRISTIAN BOLTANSKI DIDIER SEMIN, TAMAR GARB, DONALD KUSPIT / LOUISE BOURGEOIS ROBERT STORR, PAULO HERKENHOFF (WITH THYRZA GOODEVE), ALLAN SCHWARTZMAN / CAI GUO-QIANG DANA FRIIS-HANSEN, OCTAVIO ZAYA, TAKASHI SERIZAWA / MAURIZIO CATTELAN FRANCESCO BONAMI, NANCY SPECTOR, BARBARA VANDERLINDEN MASSIMILIANO GIONI / VIJA CELMINS LANE RELYEA, ROBERT GOBER, BRIONY FER / RICHARD DEACON JON THOMPSON, PIER LUIGI TAZZI, PETER SCHJELDAHL, PENELOPE CURTIS / TACITA DEAN JEAN-CHRISTOPHE ROYOUX, MARINA WARNER, GERMAINE GREER / MARK DION LISA GRAZIOSE CORRIN, MIWON KWON, NORMAN BRYSON / PETER DOIG ADRIAN SEARLE, KITTY SCOTT, CATHERINE GRENIER / STAN DOUGLAS SCOTT WATSON, DIANA THATER, CAROL J. CLOVER / MARLENE DUMAS DOMINIC VAN DEN BOOGERD, BARBARA BLOOM, MARIUCCIA CASADIO / JIMMIE DURHAM LAURA MULVEY, DIRK SNAUWAERT, MARK ALICE DURANT / OLAFUR ELIASSON MADELEINE GRYNSZTEJN, DANIEL BIRNBAUM, MICHAEL SPEAKS / PETER FISCHLI AND DAVID WEISS ROBERT FLECK, BEATE SÖNTGEN, ARTHUR C DANTO / TOM FRIEDMAN BRUCE HAINLEY, DENNIS COOPER, ADRIAN SEARLE / ISA GENZKEN ALEX FARQUHARSON, DIEDRICH DIEDERICHSEN, SABINE BREITWIESER ANTONY GORMLEY JOHN HUTCHINSON, SIR ERNST GOMBRICH, LELA B. NJATIN, W. J. T. MITCHELL / DAN GRAHAM BIRGIT PELZER, MARK FRANCIS, BEATRIZ COLOMINA / PAUL GRAHAM ANDREW WILSON, GILLIAN WEARING, CAROL SQUIERS / HANS HAACKE WALTER GRASSKAMP, MOLLY NESBIT, JON BIRD / MONA HATOUM GUY BRETT, MICHAEL ARCHER, CATHERINE DE ZEGHER / THOMAS HIRSCHHORN BENJAMIN H. D. BUCHLOH, ALISON M. GINGERAS, CARLOS BASUALDO JENNY HOLZER DAVID JOSELIT, JOAN SIMON, RENATA SALECL / RONI HORN LOUISE NERI, LYNNE COOKE, THIERRY DE DUVE / ILYA KABAKOV BORIS GROYS, DAVID A. ROSS, IWONA BLAZWICK / ALEX KATZ CARTER RATCLIFF, ROBERT STORR, IWONA BLAZWICK / ON KAWARA JONATHAN WATKINS, 'TRIBUTE', RENÉ DENIZOT / MIKE KELLEY JOHN C. WELCHMAN, ISABELLE GRAW, ANTHONY VIDLER / MARY KELLY MARGARET IVERSEN, DOUGLAS CRIMP, HOMI K. BHABHA / WILLIAM KENTRIDGE DAN CAMERON, CAROLYN CHRISTOV-BAKARGIEV, J. M. COETZEE / YAYOI KUSAMA LAURA HOPTMAN, AKIRA TATEHATA, UDO KULTERMANN / CHRISTIAN MARCLAY JENNIFER GONZALEZ, KIM GORDON, MATTHEW HIGGS / PAUL MCCARTHY RALPH RUGOFF, KRISTINE STILES, GIACINTO DI PIETRANTONIO / CILDO MEIRELES PAULO HERKENHOFF, GERARDO MOSQUERA, DAN CAMERON / LUCY ORTA ROBERTO PINTO, NICOLAS BOURRIAUD, MAIA DAMIANOVIC / RAYMOND PETTIBON ROBERT STORR, DENNIS COOPER, ULRICH LOOCK / RICHARD PRINCE ROSETTA BROOKS, JEFF RIAN, LUC SANTE / PIPILOTTI RIST PEGGY PHELAN, HANS ULRICH OBRIST ELIZABETH BRONFEN / ANRI SALA MARK GODFREY, HANS ULRICH OBRIST, LIAM GILLICK / DORIS SALCEDO NANCY PRINCENTHAL, CARLOS BASUALDO, ANDREAS HUYSSEN / THOMAS SCHÜTTE JULIAN HEYNEN, JAMES LINGWOOD, ANGELA VETTESE / ROMAN SIGNER GERHARD MACK, PAULA VAN DEN BOSCH, JEREMY MILLAR LORNA SIMPSON KELLIE JONES, THELMA GOLDEN, CHRISSIE ILES / NANCY SPERO JON BIRD, JO ANNA ISAAK, SYLVÈRE LOTRINGER / JESSICA STOCKHOLDER BARRY SCHWABSKY, LYNNE TILLMAN, LYNNE COOKE / WOLFGANG TILLMANS JAN VERWOERT, PETER HALLEY, MIDORI MATSUI / LUC TUYMANS ULRICH LOOCK, JUAN VICENTE ALIAGA, NANCY SPECTOR, HANS RUDOLF REUST / JEFF WALL THIERRY DE DUVE, ARIELLE PELENC, BORIS GROYS, JEAN-FRANÇOIS CHEVRIER GILLIAN WEARING RUSSELL FERGUSON, DONNA DE SALVO, JOHN SLYCE / LAWRENCE WEINER ALEXANDER ALBERRO AND ALICE ZIMMERMAN, BENJAMIN H. D BUCHLOH, DAVID BATCHELOR / FRANZ WEST ROBERT FLECK, BICE CURIGER, NEAL BENEZRA